"A BIBLE FOR COLLECTORS!"—Fine Woodworking

"An interesting chapter in American design that Cathers' book covers with authority and grace."—AIA Journal

"Instructs us on how to date and evaluate mission pieces, down to hardware . . . provides a catalogue of more than 100 pieces of furniture, examined in detail for structure, history and style. Enriched by some 200 photographs . . . this book is a bargain even if mission oak comes dear."—Antique Monthly

"A valuable guide to the two major mission designers . . . full of illustrations and advice."—House Beautiful

"A handsome and generously illustrated book . . . a work of genuine scholarship . . . a major tool for collectors and dealers."
—Spinning Wheel

"Intelligent and informed . . . this is a book not to pass up."
—Antiques Journal

ABOUT THE AUTHOR: DAVID M. CATHERS is advertising director for a major New York publishing company. He and his wife are long-time collectors of Stickley furniture.

FURNITURE OF THE AMERICAN ARTS AND CRAFTS MOVEMENT

STICKLEY AND ROYCROFT MISSION OAK

BY DAVID M. CATHERS

PHOTOGRAPHY BY PETER CURRAN

A PLUME BOOK
NEW AMERICAN LIBRARY
TIMES MIRROR
NEW YORK AND SCARBOROUGH, ONTARIO

NAL books are available at quantity discounts
when used to promote products or services. For
information please write to Premium Marketing Division,
The New American Library, Inc., 1633 Broadway,
New York, New York 10019.

The hardcover edition of this book was published by
The New American Library, Inc.,
and simultaneously in Canada by
The New American Library of Canada Limited.

 PLUME TRADEMARK REG. PAT. U.S. OFF. AND FOREIGN COUNTRIES
REGISTERED TRADEMARK—MARCA REGISTRADA
HECHO EN WESTFORD, MASS., U.S.A.

SIGNET, SIGNET CLASSICS, MENTOR, PLUME, MERIDIAN and NAL BOOKS
are published *in the United States* by The New American Library, Inc.,
1633 Broadway, New York, New York 10019,
in Canada by The New American Library of Canada Limited,
81 Mack Avenue, Scarborough, Ontario M1L 1M8

First Plume Printing, November, 1982

1 2 3 4 5 6 7 8 9

PRINTED IN THE UNITED STATES OF AMERICA

Acknowledgments

I owe thanks to many people who offered information, assistance, and encouragement vital to the writing of this book:

To my wife, Beth Cathers, for her insights in to the furniture;

To Vance Jordan and Todd Volpe of the Jordan-Volpe Gallery for making their vast inventory of Arts and Crafts furniture available to me for study;

To Peter Curran for his meticulous photographic work that adds so much to this book;

To Alfred Audi, current president of the L. & J.G. Stickley Furniture Company, for making available to me his collection of original L. & J.G. Stickley and Gustav Stickley catalogs, business records, and photographs;

To Barbara Wiles, Gustav Stickley's daughter, for spending so much time with me reminiscing about her father and his era;

To Charles F. Hamilton for his extremely helpful information about the Roycroft Shops;

To Coy Ludwig for generously supplying me with vital early Gustav Stickley source materials;

To Robert Judson Clark for introducing me to the Arts and Crafts movement;

To the many collectors who allowed us to photograph their pieces;

And to Ann Watson, my editor, whose invaluable suggestions made this a better book than it would have been without her help.

Contents

"Craftsman furniture is . . . as perfectly finished as was the work of the old cabinet-makers in the days of the handicrafts. One of its chief claims to beauty is its fine plainness, but this means neither crudity nor lack of finish, any more than the strong and massive designs mean clumsiness. In this lies the difference between Craftsman furniture and the many imitations of it found on the market under various names."

—GUSTAV STICKLEY

"Simplicity requires perfection in all details, while elaboration is easy in comparison with it."

—C.F.A. VOYSEY,
English Arts and Crafts
architect and designer

ABOUT THE AUTHOR: DAVID M. CATHERS is advertising director for a major New York publishing company. He and his wife are long-time collectors of Stickley furniture.

Introduction

For a brief period, beginning in 1900 and ending in 1916,[1] "mission oak" furniture, a severely plain and rectilinear style which was visually enriched only by expressed structural features and the warm tones of the wood, flourished in this country. The best of it was handcrafted and well made, an expression of the international Arts and Crafts movement that dominated much of the decorative arts in those years. In America, the best Arts and Crafts furniture was designed and manufactured by Gustav Stickley (1857–1942), of Syracuse, New York, owner of Craftsman Workshops. He was also the foremost American proponent of the Arts and Crafts movement. Two of his younger brothers, Leopold (1869–1957) and J. George (1871–1921), who worked in the Syracuse suburb of Fayetteville, also became major mission oak producers, generally copying their brother's work. Yet they also created important designs of their own, and their standards of construction and finish sometimes equaled his. Elbert Hubbard (1856–1915), whose Roycroft Shops produced a wide range of artistically bound books and handmade household goods in the Arts and Crafts spirit, also made furniture in this style.

Although mission oak was an extremely popular style in its day, it would be a mistake to think of it as just another style which caught the public's fancy in the early years of this century. It was recognized even then as an important American contribution to the international Arts and Crafts movement. J. Newton Nind has pointed out, "He [Gustav Stickley] is entitled to the distinction of having originated and brought to the recognition in the trade the one distinctively American School of Design."[2] In other words, mission oak furniture is clearly an American manifestation of the Arts and Crafts movement, and as such shares common philosophical roots with the movement in England and on the Continent. This movement, which came into being in the late nineteenth century, started as a reaction against the debased standards of design and the shabby workmanship characteristic of the industrially produced household products of that time. The Arts and Crafts movement was an

attempt to revive handcraftsmanship and good design, to raise every-day household objects to the plane of fine art. For a period of twenty years it succeeded, and it was then eclipsed by new styles until its recent rediscovery.

Modern reassessment of Gustav Stickley's importance and influence did not come until 1966 with the publication of John Crosby Freeman's book THE FORGOTTEN REBEL: GUSTAV STICKLEY AND HIS CRAFTSMAN MISSION FUR-NITURE. This book offered details of the development of Stickley's style, included illustrations of Craftsman furniture and interiors, reproduced a few pages from Stickley's 1909 catalog, and attempted to place mission oak furniture within the context of the American Arts and Crafts movement. It also contained detailed biographical information about Stickley and a chronology of his career. One of the most useful aspects of Freeman's book was that it recognized mission oak as an important American furniture style—a status then accorded it only by the few early collectors.

In 1970 the Metropolitan Museum of Art in New York City launched an exhibition entitled "19th Century America: Furniture and Other Decorative Arts." Here for the first time objects of the American Arts and Crafts movement were given the attention they deserved. Because of the wide scope of this important exhibition, only a few pieces of Stickley furniture were shown: a V-back armchair, a fall-front desk, a Morris chair, and a side chair. Only a few paragraphs on Stickley could be included in the exhibition catalog, but the show was nevertheless an important contemporary acknowledgment of the significance of his furniture. It signaled the end of the half century during which this furniture was in eclipse.

The true rediscovery of mission oak furniture—indeed, of the entire American Arts and Crafts movement—really began with Robert Judson Clark and the 1972 exhibition he developed for Princeton University. This pioneering exhibition established the American Arts and Crafts movement of 1876 to 1916 as a valid historical style that played a significant role in the development of the applied arts of this country. It showed the enormous and varied creativity of the American artisans of the period who produced furniture, lighting, textiles, glass, pottery, and fine book bindings. The catalog of the exhibition included the first detailed information on Arts and Crafts furniture. It also launched many new collectors, who began to seek examples of this newly rediscovered furniture. The increased demand for the furniture in recent years has started a price escalation, and pieces which sold for hundreds of dollars in the early 1970s fetch thousands of dollars today.

Nine years have elapsed since the opening of the Princeton show, and the exhibition catalog has become the established bible of all American Arts and Crafts collectors. However, since the book surveys the entire movement, it is able to devote only a few pages to each craft. Further, in the years since the exhibition a great deal of Stickley and Roycroft furniture has surfaced. Consequently, we now know much more about the extent and variety of this furniture than was known in 1972.

For this reason, and because of the greatly increased interest in Stickley and Roycroft, it is clear that a book devoted solely to the furniture is needed. It is our hope that this book will fill that need.

It is aimed primarily at the collector. In the past few years we have had the opportunity to examine many hundreds of examples of this furniture, and our main purpose is to give photographic documentation of the best pieces and to explain how they must be viewed.

We discuss the background and influences that shaped this style, and show construction details and various marks and signatures to help the collector identify and date specific examples. Our emphasis is on the furniture itself, and not on the biographical details of the men who produced it; biography is not within the scope of this study.

Much of this book is devoted to the work of Gustav Stickley, who was not only the most important designer and manufacturer but also an accomplished propagandist in the cause of the American Arts and Crafts movement and a forceful entrepreneur as well. He published his magazine, THE CRAFTSMAN, for fifteen years, published books of his house and interior designs, and issued catalogs and numerous pamphlets to promote his furniture and his philosophy. Working with these original source materials, we have discovered a great deal about the man and his work. His brother Leopold also issued catalogs, but these simply showed his furniture; if he wrote anything about his designs or the Arts and Crafts movement in general, we have been unable to locate it. Consequently, we must understand him primarily by his works and by what the furniture trade press reported about it. And Elbert Hubbard, the guiding spirit of Roycroft, was every bit Gustav Stickley's equal as a self-promoter, but he was more concerned with spreading the Hubbard gospel than with offering insights into the origins or structural details of Roycroft furniture.

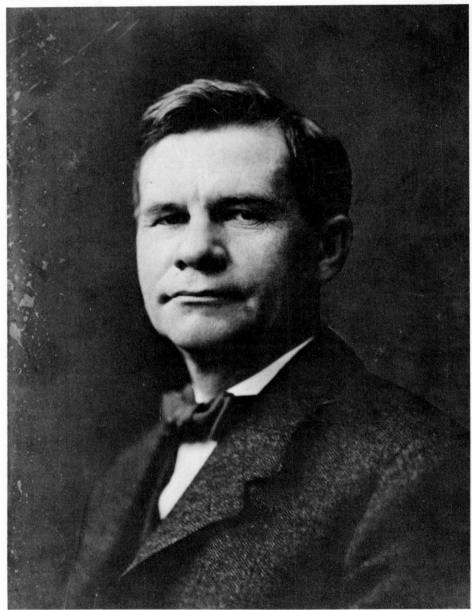

Gustav Stickley in 1910, when his Craftsman enterprises were at their peak.
COURTESY OF MR. AND MRS. GEORGE W. FLACCUS

My idea . . . is that the first cost of the furniture to the purchaser is only a part of its value, which will steadily increase with age and use. It is not a question of buying a chair or a table that will fall to pieces or go out of fashion in a few years, so that it has to be replaced with another that in time suffers the same fate, but of buying a piece of furniture that will be a permanent part of the home surroundings and that in fifty or a hundred years will be worth many times its first cost, for the time is coming when good oak furniture will be as valuable on account of its permanent worth and also its scarcity as the fine old Spanish mahogany pieces are now.[3]

Gustav Stickley[4] wrote these words in 1909, and while he was of course a furniture manufacturer selling his product, he was nonetheless writing honestly. His furniture WAS built with great care and craftsmanship and meant to last, to become family heirlooms. Gustav Stickley believed his furniture was constructed on enduring principles, that his chairs, tables, and desks were first and foremost meant to be functional, serviceable pieces of furniture, immune to the shifting vagaries of fashion. Further, his words show an amazing prescience, for time has proved him right: his furniture today, over seventy years later, is highly valued and sought after.

When Stickley wrote these words, his business operations were thriving. His furniture and decorative accessories were distributed across the country. He was just four years away from opening the Craftsman Building, a twelve-story office tower in New York City devoted entirely to his enterprises. Mission oak furniture, and not just Gustav Stickley's, had become the rage in America.

One of the measures of the popularity of mission oak may be found in the fact that in 1900, soon after Stickley introduced his Craftsman designs to the trade at the semiannual furniture exhibition in Grand Rapids, other manufacturers began to produce their own mission designs. In 1902, his brothers Leopold and J. George set up their own mission oak manufacturing concern in Fayetteville, New York. Charles P. Limbert, the Grand Rapids furniture manufacturer, got on the mission bandwagon in 1903. So did many lesser manufacturers.

A trade magazine, the Grand Rapids FURNITURE RECORD, reported in 1902 that "it is undeniable that the people of today desire their furniture plain, the popularity of . . . mission furniture furnishing abundant evidence of this taste. The severely simple, yet graceful and utilitarian appearing mission, may be a fad as some critics affect to believe, yet it is certain to leave its impression on the furniture styles of the future."[5]

Throughout the first decade of this century and into the early years of the second the desire for mission oak held strong. The furniture trade

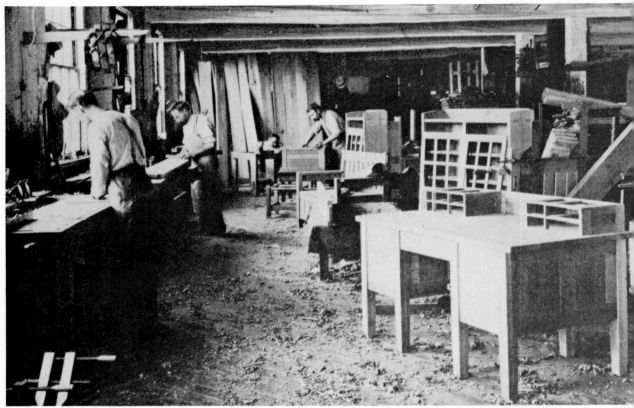

Stickley's Craftsman Workshops, as illustrated in the October 1902 issue of THE CRAFTSMAN.

press repeatedly reported on the constant demand for it. The Limbert Company, for example, was doing such great volume that it had to convert its showroom to a shipping room.[6]

A trade journal of the time, FURNITURE WORLD, discussed the continuing appeal of mission oak furniture: "Mission furniture has fairly overrun shop, club, townhouse and country house. It has become so thoroughly a part of hearth and home that we have almost forgotten how comparatively recent is its popularity. When we stop to consider some of the furniture monstrosities . . . mission has replaced, we conclude that it deserves its name in more senses than one, for it certainly fulfills a mission in contributing to the beauty of simplicity."[7] One year later, the same publication told its readers that mission oak furniture was at the height of its popularity.[8]

Business was growing for Stickley, too. In late 1903, FURNITURE WORLD reported he had built a huge new drying kiln, capable of accommodating 130,000 feet of lumber at a time, to dry and season the oak he

used to make his Craftsman furniture.[9] A few years earlier Stickley had acquired the Crouse Stables in Syracuse and converted it into the first Craftsman Building, complete with editorial offices for his magazine THE CRAFTSMAN, a metalworking shop, and a fabric and needlework department. He continued to make the furniture in his cabinet shop in the Syracuse suburb of Eastwood. In 1904, he reported in his pamphlet "What Is Wrought in the Craftsman Workshops" that he employed about two hundred men in various branches of cabinetmaking at his Eastwood cabinet shop. Clearly, Stickley's business was booming.

The desire for mission furniture held strong throughout the decade. In 1909, FURNITURE JOURNAL told its readers that there was "apparently no diminution in the demand for mission furniture."[10] That same year, J. Newton Nind wrote that mission had made a great impact on American furniture manufacturers and that its great popularity was a surprise to both dealers and producers.[11]

Another indication of the popularity of this furniture is the number of manufacturers who claimed, during the first few years of the century, to have been originators of the style; among them were Joseph McHugh, the Nelson-Matter Company of Grand Rapids, and the Michigan Chair Company. As late as 1914, "The Home Furnisher," a Milwaukee department store's promotional handout, was assuring its readers that "Mission furniture is still in vogue."

At the height of mission oak's popularity, it is easy to understand Gustav Stickley's confidence in the continued importance and value of his Craftsman furniture, yet by 1915 he was bankrupt, and his Arts and Crafts empire had collapsed around him like a house of cards. AMERICAN CABINET MAKER AND UPHOLSTERER reported the details of Stickley's approaching bankruptcy under the heading "Stickley's Creditors Meet":

> A meeting of the creditors of Gustav Stickley, the Craftsman, Inc. 6 East 39 Street, New York, held on April 3 in room 235, Post Office Building, New York, was called at the request of the receiver who desired to obtain views of the creditors with regard to carrying on the business, in order to give the debtor corporation time to submit an offer of settlement.
>
> Attorneys for the company stated that the liabilities in round figures amount to about $185,000 and that the assets with inventory about $233,000, without considering some of the assets which will represent value in the event of the continuation of the business, such as fixtures and fittings in which a considerable amount of money has actually been invested, but which would represent little or no value in the event of liquidation. It was also stated that the receiver has about $5,000 cash as a result of his running the business since he was placed in possession.

> The committee are to make a thorough investigation of the causes lead-
> ing up to the embarrassment of the company, to ascertain the actual
> financial situation and to make a report and recommendation to all the
> creditors within ninety days.
>
> The committee are entirely representative of the interest of the creditors,
> and their advice and recommendations should be followed by the credi-
> tors.[12]

In 1917 Stickley was forced to sell Craftsman Farms, his 650-acre
estate in Morris Plains, New Jersey, and that event was reported in
AMERICAN CABINET MAKER AND UPHOLSTERER, which described the place as
"one of the most interesting developments in the suburbs of New
York." The main house at Craftsman Farms was built along the lines of a
deluxe log cabin. There were three cottages and a number of farm
buildings. Stickley had spent many years accumulating the land and
developing the estate, and was said to have expended $350,000 on
it.[13]

On January 21, 1918, he held a bankruptcy sale at the Craftsman
Building in New York City, offering the contents of the building at huge
discounts. The Stickley Manufacturing Company, his plant on Burnet
Avenue in Eastwood, New York, where his furniture was made, was
taken over by his brothers Leopold and J. George.

In 1909, Gustav Stickley had asserted that his furniture would "in fifty
or a hundred years be worth many times its first cost." Yet just six years
later he was out of business and his prediction, if anyone remembered
it, would have seemed little more than a fatuous dream.

To some degree, Stickley put himself out of business by overextend-
ing his operations. His daughter, Barbara Stickley Wiles, believed that
he precipitated his bankruptcy by expanding into the Craftsman Build-
ing and thereby greatly increasing his operating costs at a bad time.
This move took place on the eve of World War I. Barbara's husband,
Ben Wiles, argued with Gustav that people would be less concerned
with household furnishings in wartime and that the coming days of
austerity did not offer much hope for the expanded operation. Ben
Wiles left Stickley's employ at this time, because, as he said, "There is
no reason for us both to go under."

Of course it was more than bad timing that put Gustav Stickley out of
business. His many imitators saw to that. The first mission oak furniture,
made by Gustav Stickley, by his brothers Leopold and J. George, and by
the Roycroft Shops, was generally of high quality. It was well designed,
carefully constructed of quartersawn white oak, and beautifully finished
in rich warm tones. But as the furniture grew in popularity, countless

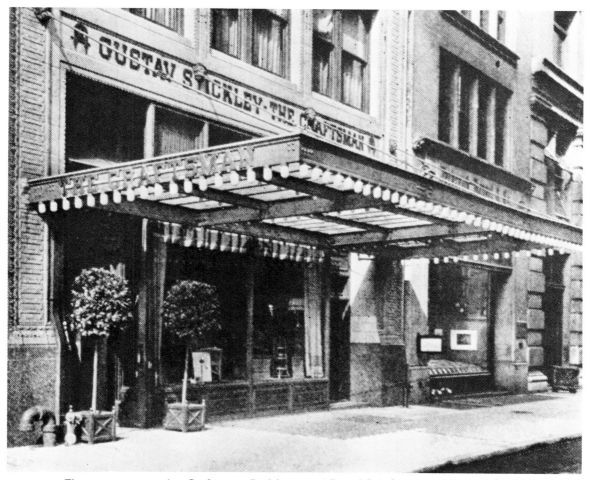

The entrance to the Craftsman Building at 6 East 39th Street in New York as it appeared about 1914. Stickley dreamed that it would become the mecca of the American Arts and Crafts movement, but in reality it was an ill-conceived business move which helped cause his financial collapse.

imitators began producing shoddy mission oak furniture in great quantity. This cheapened product, which to the untutored eye was little different from the work of Stickley and Roycroft, sold for less and eventually came to dominate the market.

The imitators who pulled business away from Stickley and contributed

to the failure of his business were an ever-present problem which he repeatedly attacked. As he wrote in the introduction to his 1909 catalog:

> Restrained by law from using my registered name, Craftsman, these manufacturers get as near to it as they can and variously style their products Mission, Handcraft, Arts and Crafts, Craftstyle, Roycroft, and Quaint. To add to the confusion some of the most persistent of these imitators bear the same name as myself, and what is called, 'Stickley Furniture' is frequently through misrepresentation on the part of salesmen and others, sold as Craftsman furniture or just the same thing.[14]

Further, changing public taste spelled the end of mission oak furniture. One theme which sounds repeatedly through Stickley's writing is that since his designs were based on principles of sound construction rather than on the whims of style, they could never go out of fashion. Writing in his 1906 pamphlet, "Chips from the Craftsman Workshops," he said that his designs were based upon his "close adherence to principles that do not change." But despite his many protests, the fact remains that mission oak was very much a stylistic craze that developed and then faded during the first sixteen years of this century. It is equally clear, his public statements notwithstanding, that Gustav Stickley recognized these shifting tastes and attempted to respond to new trends.

For example, Stickley introduced an oak dining-room set in 1914 which, as incredible as this may sound, was derivative of the elaborate Sheraton style—but made of fumed oak and with hammered copper hardware.[15] (See "The Craftsman" for September 1914) He also decorated some of his mission designs with black lacquer highlighted with stripes and floral motifs in brick red, blue, and green.[16] (See "The Craftsman" for June 1915) In fact, Stickley bombarded his readers throughout 1915 and 1916 with ads and articles on his Chinese Chippendale and with all sorts of historical pastiche worked up in his Eastwood workshops. Even Mary Fanton Roberts's "One Man's Story," an emotional article on Stickley's bankruptcy in THE CRAFTSMAN for June 1916, is in reality little more than a puff for Chromewald furniture, Stickley's Colonial rehash served up in blues, grays, and browns. The advent of Chromewald represented an unmistakable sign of the decline of Stickley's furniture designs, and indeed of his "Craftsman movement" as a whole.

Stickley's new direction was reported to the trade in AMERICAN CABINET MAKER AND UPHOLSTERER in 1915. "As an originator of mission furniture, Gustav Stickley's standing is eminent for quality and design. This season

NEW CHROMEWALD BEDROOM FURNITURE

"CHROMEWALD" is the name given to Gustav Stickley's new designs, which are being shown on the third and fourth floors of our New York salesrooms for the first time: Chromewald is not like the usual painted furniture of a smooth one-toned surface; but is full of rich variation due to the manner of rubbing color into the rich Craftsman finish.

THE CLOVER LEAF TABLE shown above may be had in a rich shade of blue with the antique brown finish showing through or in any of the other Chromewald shades: It is just the thing for a living room. 26 inches high, 26 inches wide. Brown **$12.00**, Color **$14.00**.

WINDSOR CHAIRS adapt themselves with unusual grace to color: Through historic associations and their own inherent beauty they are admirably fitted for summer cottage use. Brown **$10.00**, Blue and Gray **$12.00**.

CHROMEWALD DRESSER, 36 inches high, 46 inches wide, 21 inches deep. Brown **$62.00**, Color **$68.00**.

Bedrooms furnished in Chromewald are not only extremely satisfying to look upon but distinctly original: Endless color contrasts or harmonies may be worked out.

Write for name of Local Dealer

Stickley hoped his Chromewald line would appeal to the changing taste of the American consumer as Arts and Crafts furniture gave way to the new taste for Neo-Colonial design. Yet these designs proved to be a failure from both an aesthetic and a business point of view.

some startlingly different designs were shown—matched dining room suites in oak and cuban mahogany that are low in price because of quantity in production. . . "[17]

The failing popularity of Stickley's Craftsman furniture was even cited in THE CRAFTSMAN, in an article in the September 1916 issue on his Chromewald line. Clearly, the Chromewald line was Stickley's last desperate attempt to keep from going under by capitalizing on the growing popularity of "Colonial" furniture. Nor was he the only mission oak furniture manufacturer to respond to this new trend. In that same year, Charles P. Limbert began producing an offshoot of mission oak that was lighter in both weight and color. By 1916, Limbert had introduced a line of Neo-Colonial period reproductions in addition to his mission line, and by 1917 ceased mission oak furniture production altogether. During the same years, L. & J.G. Stickley also began to curtail its mission production and produce more traditional designs. Only rarely do the company's trade ads of this period mention mission oak. Still, this firm produced the furniture until 1923.

How Mission Furniture Was Named

In this chapter, we have referred to the furniture as "mission oak." The term is not completely satisfactory, and it was never used by the style's leading proponent, Gustav Stickley. On the other hand, L. & J.G. Stickley and Roycroft did use it, and the term entered the language in 1900 and has continued to be common usage.

We are frequently asked how this furniture came to be called mission. There are two prevailing theories. The first is that it was called mission because it had a mission—to be used. The second theory is that the style derived from furniture found in the Franciscan missions of California.

Much as he may have disliked the term, Gustav Stickley gave some support to both theories of its derivation. Writing in "Chips from the Craftsman Workshops" in 1906, for example, he said that his furniture was designed to fill its "mission of usefulness" as well as it possibly could, and similar statements about his furniture's "mission" recur in other of his writings. Further, in 1904 THE CRAFTSMAN published a long series of articles on the Franciscan missions in the American Southwest. It seems very likely that this series in Stickley's own magazine increased the identification of mission furniture with the Franciscans.

In a 1904 newspaper interview, Stickley showed his willingness, at that time, to have his work associated on a philosophical basis at least with furniture found in the California missions:

> The chairs and other furniture made by me are very different from any of the furniture used in the missions of California. I never called it by the mission name and never suggested that it should be so called. The reason for the name, however, is clear. The old mission architecture is simple, dignified, frankly adapted to its purpose, and without frills or furbelows of any kind. That is exactly the fact in regard to my furniture. There is no seeking for flashy or cheap adornments. Nothing is stuck on. It is simple, dignified, and frank. And in this close similarity to the old mission style you have the reason for the name. Not, as so many people have imagined, in that I was copying the old mission furniture brought here from Spain, or from Mexico, or made here under the direction of the padres.[18]

Stickley tried for years to get people to adopt the term "Craftsman furniture," but his efforts met with a general lack of success. It is interesting to note that he evidently was not completely satisfied with that term either. In 1904 he sponsored a contest among the readers of THE CRAFTSMAN to come up with a new name for his product. He had run ads in the furniture trade magazines the year before, offering $175 to anyone coming up with a new and better name for the "Art of the Craftsman Workshops." This contest was a failure, as he announced in a later issue of THE CRAFTSMAN, and thus he continued to use the Craftsman name.

Stickley wrote a short piece for the May 1909 issue of THE CRAFTSMAN entitled "How Mission Furniture Was Named":

> The general belief is that the first pieces were discovered in the California missions, and that these served as models for all the "mission" furniture that followed.
>
> This is an interesting story, but the fact is no less interesting, because of the commercial cleverness that saw and took advantage of the power of a more or less sentimental association.
>
> A number of years ago, a manufacturer made two very clumsy chairs, the legs of which were merely 3-inch posts, the backs straight, and the whole construction crude to a degree. They were shown at a spring exhibition of furniture, where they attracted a good deal of attention as a novelty. It was at just that time that the California missions were exciting much attention, and a clever Chicago dealer, seeing the advertising value that lay in the idea, bought those pieces and advertised them as having been found in the California missions. Another dealer . . . saw these chairs, and was inspired with the idea that it would be a good thing to make a small line of this

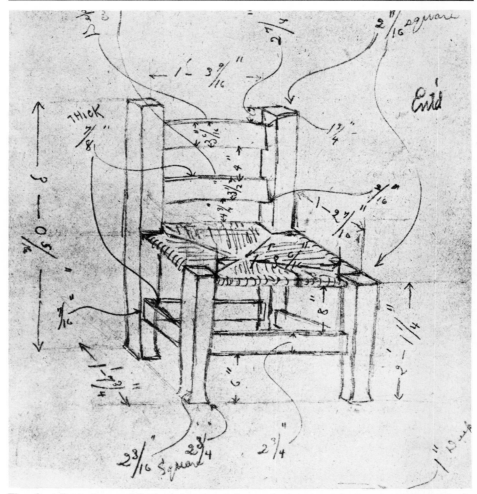

The first "mission oak" chair, derived from designs made for the Swedenborgian church in San Francisco in 1894 and later used by Joseph P. McHugh as the basis for his mission line of furniture.

furniture and name it "mission" furniture. The illusion was carried out by the fact that he put a Maltese cross wherever it would go between the rails of the back and down at the sides; in fact, it was woven into the construction so that it was the prominent feature and naturally increased the belief in the ecclesiastical origin of the chair. The mingling of novelty and romance instantly pleased the public, and the vogue of "mission" furniture was assured.

One of the first to make mission furniture was the New York furniture manufacturer Joseph P. McHugh. He also seems to have been the first to use the term. In the summer of 1900, AMERICAN CABINET MAKER AND UPHOLSTERER carried this short notice: "Joseph P. McHugh has patented a folding chair, which is designed along the lines of the old mission chairs, samples of which he brought home from Lower California a year or two ago."[19] This notice was followed by an extraordinary outburst of publicity for McHugh's mission furniture in trade magazines and arts-oriented periodicals. McHugh's publicity efforts don't seem to have made his line of furniture a great success, but they did implant the term "mission" in the minds of American furniture manufacturers, dealers, and consumers. McHugh clearly considered himself the originator of mission oak and of the term. As late as 1915 he was still insisting that he had been first. He wrote:

> In the early part of 1894, an interior decorator of San Francisco sent me a simple rush-seated chair similar to some used by a local architect to take the place of pews in a church of that city; certain details of the form and construction attracted me, and I set about making a variety of pieces which suggested the motive of the single model.
> The name McHugh mission furniture, which I used to distinguish the style, seemed appropriate, in view of the purpose for which the single chair had been used, and the part of the country from which it had been sent to me.
> Commencing with the satisfactory sale in New York, the furniture was shortly ordered from far away points, by reason of the illustrations made by Walter John Hill Dudley—these I sent out freely to actual users, decorators, architects and trade schools. . . .[20]

It seems clear that McHugh's claim of being the originator of mission oak furniture was legitimate. However, by fixing the date of the first chair at 1894, he is conveniently—if unconvincingly—early: McHugh apparently revised the record by three or four years in order to establish his primacy. And while being the first may have been important to McHugh, the fact is that his mission designs were inept and their execution substandard. It remained for Gustav Stickley, and to a lesser extent L. & J.G. Stickley and the Roycroft Shops, to create the only enduring large body of work in the mission style.

Soon after the turn of the century, because of McHugh's publicity efforts and the increasing popularity of Stickley's designs, little could be written about the furniture without invoking the Franciscan missions. For example: "The good old fathers of the Spanish missions," enthused FURNITURE WORLD, "would doubtless have been filled with amazement if

they could have foreseen the infinite variety of uses to which the simple style of furniture that satisfied their limited wants is put today. . . ."[21]

Thus the term "mission" lent an aura of charm and romance to the furniture, and certainly helped sell it. However, "Arts and Crafts furniture," as we will show in the next chapter, is clearly a more accurate term for the style.

[1] These dates correspond to the introduction of Gustav Stickley's furniture in 1900 and his final business collapse in 1916. They are the years of mission's greatest popularity.
[2] In Herbert E. Binstead, THE FURNITURE STYLES (Chicago: Trade Periodicals, 1909), p. 170.
[3] Gustav Stickley, "Catalog of Craftsman Furniture," 1909.
[4] The original family name was Stoekel, a German name which was Anglicized by Stickley's forebears when they came to this country. Stickley's first name was originally spelled "Gustave," but he later dropped the final "e." This change was noted in Robert Judson Clark's THE ARTS AND CRAFTS MOVEMENT IN AMERICA 1876–1916 (Princeton, N.J.: Princeton Univ. Press, 1972), p. 38, where the date of the change was given as 1904. However, it actually occurred in March or April, 1903, as a careful study of THE CRAFTSMAN will show.
[5] FURNITURE RECORD, June 1902, p. 48.
[6] AMERICAN CABINET MAKER AND UPHOLSTERER, April 12, 1902.
[7] FURNITURE WORLD, Sept. 10, 1903.
[8] Ibid., Nov. 3, 1904.
[9] Ibid., Nov. 26, 1903.
[10] FURNITURE JOURNAL, Jan. 11, 1909.
[11] Nind wrote in Binstead, THE FURNITURE STYLES.
[12] AMERICAN CABINET MAKER AND UPHOLSTERER, April 10, 1915.
[13] Ibid., Aug. 25, 1917.
[14] "Catalog of Craftsman Furniture," 1909. It was obviously maddening to Stickley that all four of his brothers imitated his designs and competed for the same customers. Besides Leopold and J. George, Charles Stickley in Binghamton, New York produced a mission line called "Moderncraft" with many direct copies of Gustav's work. Albert Stickley in Grand Rapids also made mission furniture under the brand name "Quaint." Both Moderncraft and Quaint are characterized by shabby workmanship and inept design.
[15] THE CRAFTSMAN, September 1914.
[16] Ibid., June 1915.
[17] AMERICAN CABINET MAKER AND UPHOLSTERER, Jan. 2, 1915.
[18] From an interview in the SAN FRANCISCO CHRONICLE, quoted in FURNITURE WORLD, June 30, 1904, p. 15.
[19] AMERICAN CABINET MAKER AND UPHOLSTERER, July 14, 1900. (Just one week earlier, Stickley had run his own first trade ad.)
[20] Ibid., June 19, 1915.
[21] FURNITURE WORLD, Sept. 10, 1903.

The History
and Development of
Arts and Crafts Furniture

1 The Arts and Crafts Sources of Stickley's Design

Philosophical Influences

Despite the long-established currency of the name "mission oak," the term "Arts and Crafts furniture" is more appropriate, since the furniture is essentially an American manifestation of an international Arts and Crafts movement which originated in England and later spread to Europe and the United States.

The Arts and Crafts movement began in England in the mid-nineteenth century with the writings of John Ruskin (1819–1900) and William Morris (1834–1896). Ruskin's concern with design was essentially humanistic; he judged decorative art and architecture more by the effect they had on the men who made them than by the objects themselves. To Ruskin, the worker of mid-nineteenth-century England had been dehumanized by the machine, and had consequently lost the possibility of joy and dignity in his daily labors. He advocated a return to handwork, to straightforward honest craftsmanship, and he was perfectly willing to accept the attendant crudities and imperfections. He saw the revival of handicrafts as necessary for the creation of a social order in which the workman was not enslaved by capital and the machine, but was free to take pleasure in his work.

Ruskin's theories about the nature of work form the basis of the Arts and Crafts doctrine. He was the first to espouse the importance of honesty of expression and truth to materials, and the virtue of a robust, crude simplicity in decorative objects. His writings preached individualism and antihistoricism in design, and his ideas influenced an entire generation of Arts and Crafts designers.

Yet it is not Ruskin but William Morris who is clearly the father of the Arts and Crafts movement, for it was Morris who expanded and gave practical expression to much of Ruskin's thought. Morris and his followers rebelled against the shoddiness, ugliness, and eclecticism that characterized the mass-produced decorative objects of the nineteenth century, objects designed for ease of manufacture and high profit rather than for beauty and utility. Morris, like Ruskin, abhorred the exploitation

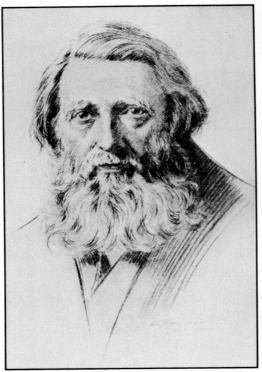

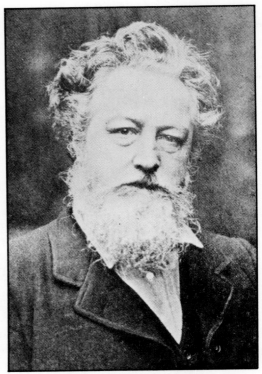

John Ruskin, from the illustration in El-
bert Hubbard's pamphlet "A Little
Journey to the Home of John Ruskin."

William Morris. This photograph was
used by Gustav Stickley to illustrate
the first issue of THE CRAFTSMAN in Oc-
tober 1901.

of the worker associated with mass production. Morris believed the
worker of his day had been reduced to little more than a cipher, totally
removed from the design and conception of the articles he helped
produce. Because of the mass-producers the worker found neither dig-
nity nor joy in his labors.

Morris's desire to reform contemporary design standards and to im-
prove the life of the worker led to the formulation of his Arts and Crafts
philosophy, the basic principles of which were stated some years later
in THE CRAFTSMEN by Ernest Batchelder:

> The term "Arts and Crafts" . . . stood boldly for three things: it was a
> protest against the narrow and commonly accepted definition of art; it was
> a protest against inutilities, the ugliness, the sham and pretense of a great
> portion of the English industrial product of that day; it was a protest against
> the deplorable industrial conditions which that product represented. To put
> the matter into a positive statement, it sought to demonstrate the value of
> art combined with honest workmanship when applied to useful service;

while it deplored the ugliness of the industrial product, it sought, not to withdraw art from it, but to bring art to it, under the belief that an enduring basis for the appreciation must be established in the home rather than in the picture gallery; it sought to make manifest the dignity of labor, and the individuality of the worker.[1]

In hopes of reforming the shocking working conditions of nineteenth-century England and the debased standard of design, Morris, like Ruskin, looked for a return to the values of medieval society. In particular, he felt that the craftsman should be responsible for his artifacts from design to completion, as he was before the division of labor made him merely a part of the process.

To put his theories into practice, Morris, along with the architect Philip Webb, the painters Dante Gabriel Rossetti, Edward Burne-Jones, and others, founded Morris and Company in 1861. The firm was the first of many associations formed in the spirit of the medieval craft guild. Its plan was to produce simple, handcrafted furniture, stained glass, fabrics, wallpapers, and even whole interiors following Morris's precepts of beauty, craftsmanship, and utility.

In the wake of Morris came more English Arts and Crafts practitioners who followed his principles and established similar enterprises: Arthur Heygate Mackmurdo, who established the Century Guild in 1882; Charles Robert Ashbee, who started his Guild of Handicraft in 1888; the Art Worker's Guild, founded in 1884; and the Arts and Crafts Exhibition Society, founded in 1888.

As the Arts and Crafts movement gained momentum in England, its influence began to be felt on the Continent, and in 1903 the Wiener Werkstaette (Vienna Workshop) was founded by the architect/designer Josef Hoffman and the designer Kolo Moser. Hoffman was directly influenced by his admiration for Morris and for Ashbee's Guild of Handicraft. The Wiener Werkstaette was a group of designers and craftsworkers who followed the principles of fine workmanship and good design espoused by the English. In his "Work Program of the Wiener Werkstaette," Hoffman stated a philosophy which bore the unmistakable stamp of William Morris:

> The immeasurable damage caused on the one hand by inferior methods of mass production, on the other, by the mindless imitation of bygone styles, has become a mighty current of world-wide proportions. . . . we want to establish an intimate connection between public, designer and craftsman, to create good simple articles of household use. Our point of departure is purpose, utility is our prime consideration, our strength must lie in good proportions and the use of materials. . . ."[2]

In America, both Elbert Hubbard and Gustav Stickley were firmly a part of the Arts and Crafts mainstream. Isabelle Anscombe and Charlotte Gere, in their book ARTS AND CRAFTS IN BRITAIN AND AMERICA, make a point about English Arts and Crafts designers that applies equally well to Hubbard and Stickley: "Their furniture reflected in concrete form the way of life of the craftsman, stressing the honesty of production with structural features becoming often the focal point of the decoration. 'Fitness for purpose' became an element of style . . ."[3]

Hubbard traveled to England in 1894, where he met William Morris at the Kelmscott Press, the private press Morris had founded in 1890 to apply the Arts and Crafts tenets of craftsmanship, beauty, and utility to the printing and binding of books. Within a year Hubbard established the Roycroft Press in East Aurora, New York, in direct emulation. The expanded Roycroft Shops, under his direction, produced over the next twenty years not only Arts and Crafts books but also furniture, leather goods, and functional copper household items.

Gustav Stickley found his way to England four years after Hubbard, making his first trip in 1898. Though Morris was dead by that time, Stickley's European travels gave him the opportunity to examine the work of the Arts and Crafts designers C.F.A. Voysey, C.R. Ashbee, and others at first hand, and there is no question that he felt their influence. He had certainly absorbed Ruskin's and Morris's influence through reading before he began his travels, and by that time was on his way, both as a writer and a designer, to becoming the leading American exponent of Morris's precepts.

Writing in HOUSE BEAUTIFUL, Stickley acknowledged his debt to Morris and his followers: "The handful of English medievalists who instituted the Arts and Crafts movement looked forward as well as backward. Their vision was equally clear and eager in both directions. They felt and knew that the beauty of the past could be translated into the simplicity of the present and the future without loss of force or substance."[4] Like William Morris, Stickley believed in the importance of high standards of craftsmanship and hated the slipshod machine-made article. Even earlier in "Chips from the Workshops of Gustave Stickley," in 1901, he exhorted readers with Morris-like fervor to avoid "eruptive carving, the applied ornament, the unrefined molding . . . threatening bric-a-brac."

Like Morris he believed in the uplifting of the worker, in the moral influence of everyday objects, in the integration of art and life. He believed that the applied arts were of equal importance with the fine arts. Even the Flemish motto Stickley chose for his shopmark, "Als ik kan,"[5] was borrowed directly from Morris.

In further emulation of Morris, Stickley established his workshops along the lines of a medieval craft guild, and he adopted the name "United Crafts." An article in a Syracuse, New York, newspaper entitled "A William Morris in Eastwood?" announced the appearance of a new magazine, THE CRAFTSMAN, as the "organ of the United Crafts." Not only was the first issue of THE CRAFTSMAN devoted solely to William Morris, it was "intended to mark the beginning of a new and unique labor association, a guild of cabinet makers, metal and leather workers, formed for the production of household furnishings."[6] The article reported Stickley's claim that the guild had only one parallel in modern time, the London firm of Morn's and Company.

The article identified the aims of the new guild as "the raising of the general intelligence of the worker, by the increase of his leisure and the multiplication of his means of pleasure and culture, the endeavor to substitute the luxury of taste for the luxury of costliness, and to do something along the Morris idea that all men shall have work to do which shall be worth doing, and be pleased to do it. . . ."

The writer of this article went on to say that following William Morris's ideals was praiseworthy, but that Mr. Hubbard of East Aurora made the same claim for his organization. He might also have mentioned Ashbee's Guild of Handicraft, the Century Guild, other English Arts and Crafts groups, the Wiener Werkstaette, and some of the American Arts and Crafts groups. In setting up his company along the lines of the medieval craft guild, Stickley showed himself to be very much a part of the Morris-influenced Arts and Crafts mainstream of his day.[7]

The organization of the United Crafts was not Stickley's only attempt at setting up an American equivalent of the medieval guild system. In 1904, in an interview with the SAN FRANCISCO CHRONICLE, he announced plans to establish a community of craftsmen in Southern California. A later account quoted him:

> As to the report that I am about to establish a cooperative community in California, my plans are not yet formulated, though it is true that I am thinking seriously of the matter. I have a number of tracts of land under consideration. I expect before long to purchase one of these, and then settle upon it craftsmen in all the various lines used in the building and furnishing of a home.
>
> As we plan it, it will be essentially a practical affair. There will be a sterling business basis to everything. We shall take pupils and educate them practically, as the old guilds of Europe used to do, in blacksmithing, carpentering, stonemasonry, bricklaying, silverworking, weaving of all kinds of textiles, gardening, and the like. . . .[8]

Several years later, when Stickley built Craftsman Farms, he envisaged it largely as a crafts and educational institution, albeit on a somewhat less ambitious scale than his abandoned California scheme. Craftsman Farms was built, but it never became the kind of crafts colony that Stickley had planned.

It is likely that the nineteenth-century English author and designer Charles Locke Eastlake also exerted a philosophical influence on Stickley. Eastlake's designs were drawn largely from the Gothic revival of the nineteenth-century and to a lesser degree from William Morris. His furniture looks little like Stickley's, yet the two men have a very strong philosophical link.

Eastlake, like Stickley, felt that oak was the proper wood for furniture —oak left in a "natural" state and not subjected to staining or varnishing, which obscured its beautiful grain. He believed in constructional truth and thought that the design of a piece of furniture should stress, not obscure, its use as well as its method of construction. "Every article of furniture should, at first glance, proclaim its real purpose," Eastlake wrote.[9] The overall forms of his designs were primarily rectilinear, and while he did decorate his work in a way Stickley could never have approved, he stressed that the only valid form of decoration is one which grows directly out of woodworking techniques. That is, he believed with Stickley in the idea of truth to materials, in the necessity of working with rather than against the strong points of the material and not trying to force it into designs inconsistent with its nature.

Eastlake also believed that good design should be available to the general public, and not just to the monied classes. Like Stickley's, his art was democratic. He too decried the fact that furniture styles change from year to year, and looked for more permanence: "Tables . . . might be solidly and steadily framed, so as to last for ages, and to become, as all furniture ought to become, an heirloom in the family."[10] Eastlake's philosophy is best summed up in these words, written in the 1860s, that would be echoed forty years later by Gustav Stickley: "In an age of debased design . . . the simplest style will be the best."[11]

Stylistic Influences

The sources of Stickley's designs can be found in medieval furniture, in American Shaker furniture, and in Japanese design, but the most direct

A dresser designed by Charles Locke Eastlake and illustrated in HINTS ON HOUSE-HOLD TASTE. Though unlike a Gustav Stickley design, the butterfly keys on the side are a decorative structural device found occasionally on his work, and the general form of this design is definitely reminiscent of the Craftsman serving table on page 193.

influences seem to be English. One English source of Stickley's work is Arthur Heygate Mackmurdo. His famous desk, made circa 1886, is apparently the first piece of Arts and Crafts furniture ever made, and shows many characteristics which appeared years later in both Stickley and Roycroft furniture. The desk is nearly totally devoid of ornament, basically rectilinear, and made of quartersawn oak. It is probable that Stickley and Hubbard (or one of Hubbard's early cabinetmakers) saw

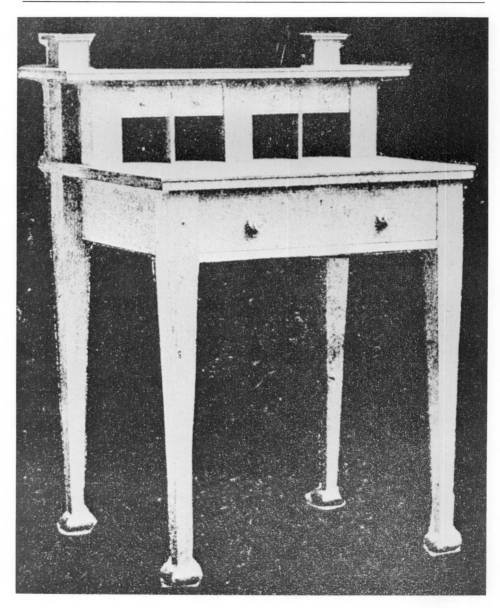

The desk designed by Arthur Heygate Mackmurdo which clearly had a strong influence on both Craftsman and Roycroft furniture.

this desk in an article on Mackmurdo which appeared in INTERNATIONAL STUDIO in 1897. Just a year after that article appeared, Stickley was deeply involved in his experiments with Craftsman furniture design and the Roycrofters were making their first furniture. The language the article uses to discuss the Mackmurdo desk could certainly apply equally to a Stickley piece as Stickley himself might have described it: "The table is of oak, and the artist has aimed accordingly at maintaining the sturdy character of the material in every part. The pronounced projections, intended to give distinct contrast with light and shade and to emphasize the construction, are features of this design of years ago which have been followed by many later designers."[12]

Further, the article on Mackmurdo points out his two main design tenets, both of which contain ideas essential to Gustav Stickley's work. It says that Mackmurdo considered proportion to be the fundamental element of beauty, and that he valued "architectural severity of line in all structural features."

Stickley's earliest work, such as the Celandine tea table on page 221, also shows the influence of French Art Nouveau. His visits to S. Bing's Salon de l'Art Nouveau and his contacts with Art Nouveau designers have already been documented. However, the unrestrained curvilinearity of Art Nouveau could not have been too congenial to Stickley's puritanical American soul, and it made only a fleeting impact on his designs. If Art Nouveau had any demonstrable influence on his work, it was more likely due to its antihistoricism and concern for craftsmanship, rather than its style and would not have been discussed here at all were it not for the fact that Stickley himself credited this source in the first newspaper ad for his furniture which appeared in 1900.[13]

Stickley certainly was influenced to some degree by his contemporary C.F.A. Voysey, the English Arts and Crafts architect and designer. Like Stickley, Voysey had been influenced by both Ruskin and Morris, and acknowledged the stylistic influence of Mackmurdo. Voysey shared Stickley's reverence for simplicity. As he wrote in THE STUDIO: "Simplicity in decoration is one of the most essential qualities, without which no true richness is possible. To know where to stop and what not to do is a long way on the road to becoming a great decorator."[14] His Arts and Crafts furniture, which predated Stickley's by several years, has many similarities to Stickley's. It is made of oak, is often quartersawn, and is basically rectilinear. Though Voysey employed such decorative touches as heart-shaped cutouts and highly elaborate strap hinges, the beauty of his furniture comes from the natural wood tones, structural details such as exposed dovetails, and careful proportioning.

Perhaps the strongest direct design influence on Stickley was the English architect M. H. Baillie Scott (1865–1945). Baillie Scott wrote an article for THE STUDIO in 1897 entitled "On the Choice of Simple Furniture," in which he laid out his Arts and Crafts philosophy and showed a variety of his furniture designs.[15]

Many points in the article echo the writings of Ruskin and Morris and show how closely aligned Baillie Scott was with Arts and Crafts theory. For example, he believed in the importance of the joy to be found in craftsmanship, claiming that "an incalculable amount of true pleasure both to the craftsman and purchaser might be gained in the making and keeping of rightly designed work." He was for hand craftsmanship and against the machine, as he shows by comparing the "true artist worker" to the "mechanical drudge of the modern workshop." Like Ruskin and Morris he laments "the loss of the traditional knowledge of generations of workmen [and] the substitution of a base commercialism for the old craftsman spirit."

Like Morris before him and Stickley after, Baillie Scott attacked the eclectic hodgepodge and overelaborate decorations of the typical Victorian home: "The vulgarity of most of the furniture of the shops has been painfully acquired at the expense of much misdirected labor, and if shorn of its so-called ornament it would often at least be inoffensive." His remedy for this excess seems to be a reliance on the middle-class family of modest means, the same kind of people to whom Stickley, a few years later, would try to sell Craftsman furniture and Craftsman houses. Baillie Scott wrote: "The necessary restrictions imposed by a limited purse often prove to be the best safeguard against over-extravagance; and so to those who can appreciate the beauty of simplicity and restraint, necessity in this case may become a virtue indeed, and instead of trying to emulate the splendors of the palace, so often vulgar, so seldom comfortable and homely, we may accept gladly the limitations which suggest a more cottage-like home."

Like Stickley, Baillie Scott preached right proportion and simplicity. As he wrote in the introduction to the 1901 catalog of his furniture designs, produced by John White, "the most important attribute is the careful study of proportion, before all things a greater simplicity of form than has hitherto been attempted, and a reliance on such proportions and simplicity for the effect of the piece."[16]

Finally, Baillie Scott, like most of the Arts and Crafts architects of his time, expressed a concern for the total home environment. Like Frank Lloyd Wright, Charles Rennie Mackintosh, and others, he designed the furniture for the houses he built in order to create unified interiors. And

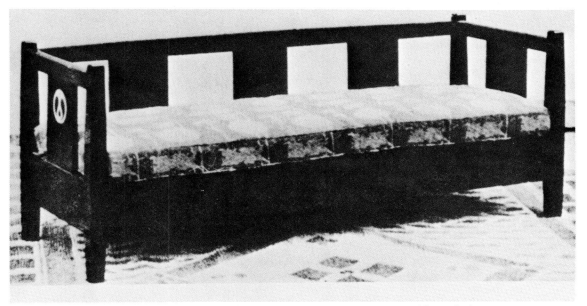

A settle designed by Baillie Scott. Its rectilinearity and use of broad slats were reflected in Stickley's work.

he used built-in settles and cupboards to integrate his furniture with the structure itself.

This last point leads to a consideration of Baillie Scott's furniture designs. The pieces of furniture illustrating THE STUDIO article are severely plain, boxy oak pieces with minimal repoussé copper decoration. Certainly the simplicity of these designs had its influence on Stickley, though none of them was directly copied by him. There are, however, elements in Baillie Scott's furniture which appear almost unchanged in some Stickley designs. For example, Stickley's typical side-chair stretcher arrangement, with one broad stretcher front and back and two narrow ones on each side, seems to have come directly from Baillie Scott. One of Stickley's rectangular dining-room-table designs, with a deep apron and splayed legs, is clearly an almost exact copy of a Baillie Scott design shown in Baillie Scott's 1901 catalog. Further, the basic design of the Stickley desk on page 172/73 derives from a "secretaire" shown in Baillie Scott's 1901 catalog. Stickley's desk is more structural, with its exposed tenons on both sides and sturdy pulls. He has done away with Baillie Scott's inlay of pewter, ebony, and ivory and relief carving on the fall front. It is also true that Baillie Scott created a number of awkward, overly heavy furniture designs which Stickley wisely ignored, and when he did borrow from Baillie Scott he improved upon him.

The two designers totally diverged on one aspect of furniture design: Baillie Scott, unlike Stickley, also designed elaborate formal furniture for clients who did not enjoy the benefits of "a limited purse." On the evidence of his work, Baillie Scott, like Morris, drew a distinction between formal pieces (such as those he created for the palace at Darmstadt in 1899) and the plainer, more homey designs seen in INTERNATIONAL STUDIO. Both types of his furniture appear in his 1901 catalog. Stickley, on the other hand, probably considered Baillie Scott's distinction of two kinds of furniture to be inconsistent, and a failure to follow the Arts and Crafts principles they both espoused.

While it is clear from the foregoing that Stickley was stylistically influenced by the Arts and Crafts designers who preceded him, it is equally evident that to those sources he added the element of his own genius. His designs also expressed his own ideas of beauty, proportion, and function. We consider this an extremely important point. As we have shown, Stickley's design philosophy was basically derived from those of Ruskin and Morris, and was consistent with the English and Continental Arts and Crafts designers. However, in practice he transcended them all, because his designs were a truer expression of that philosophy than theirs were.

While Voysey preached "simplicity," for example, even a cursory examination of much of his furniture reveals an elaboration of ornament unthinkable on a Stickley piece. Voysey's characteristic strap hinges, with their heart shapes or cutouts of birds and human figures, frequently detract from the beauty of his wood and are a form of applied ornament rather than a decorative expression of structure.

The same criticism may be leveled against some of Baillie Scott's furniture designs. Though he exerted a definite influence on Stickley, it is clear that his floreated inlays, applied ornament, and polychrome decoration are inconsistent with Arts and Crafts design theory. Many English Arts and Crafts designers exhibit the same inconsistency between theory and practice: "Lip service was paid to the original concepts of art for all and the deliberate use of nonpretentious materials—for instance, it is rare to find valuable precious stones or gold used for crafts jewelry, or exotic woods for the furniture—but within the limitations imposed by this discipline the craftsmen strove to produce the richest possible effect."[17]

The Austrian designer Josef Hoffman spoke of utility as the "prime consideration," but his use of rich materials, inlays, and elaborate form shows he was equally concerned with decoration. It is characteristic of much of the European Arts and Crafts work that its designers simply

couldn't resist the urge to apply some sort of decoration which their philosophies would not admit. Stickley himself, writing in THE CRAFTSMAN, was well aware of this gap between Arts and Crafts theory and the practice: "There is evidently an honest desire to produce something simple and strong and beautiful, but only in isolated instances is that desire fulfilled. For the most part, all that is achieved is a jumble of so-called decorative forms that are founded neither on need nor reason, and so are worse than the forms they seek to replace." [18]

We rarely find these contradictions between practice and theory in the work of Gustav Stickley. When he spoke of the need for simplicity and utility, he meant it; he was the only Arts and Crafts designer who consistently demonstrated the courage of his convictions and avoided unneeded ornament. Stickley depended upon fine craftsmanship, good proportions, and the color and grain patterns of wood to achieve his decorative effects.[19] Though he was unquestionably strongly influenced by the designers we have discussed in this chapter, he surpassed them all in his ability to strip design down to its essentials. One of his greatest contributions to modern design was his successful campaign to purge the eccentricity, preciousness, and extraneous detail so often seen in the Arts and Crafts furniture of the period.

Speaking of his designs, he wrote in THE CRAFTSMAN: "I wanted them to be beautiful . . . not with the superficial prettiness of applied ornament, but with that inherent decorative quality which comes from good proportions, mellow finish, and harmonious decorations."[20] When he began designing Arts and Crafts furniture in 1898, Stickley's work did not have the kind of beauty he sought; first, he had to try some experiments.

[1] THE CRAFTSMAN, p. 544, August 1909.
[2] Hoffman is quoted in Peter Vergo, ART IN VIENNA 1898–1918 (New York: Phaedon, 1975), pp. 132–133.
[3] Isabelle Anscombe and Charlotte Gere, ARTS AND CRAFTS IN BRITAIN AND AMERICA (New York: Rizzoli, 1978), p. 7.
[4] HOUSE BEAUTIFUL, December, 1903.
[5] "As I can," meaning that his work was always the best he could do.
[6] SYRACUSE POST-STANDARD, Sept. 15, 1901.
[7] Stickley's idea of running his business like a cooperative medieval guild was not financially successful and he dropped the idea in 1904. And even though he followed Morris's and Ruskin's notions about uplifting the worker, Stickley nonetheless had his share of labor-management problems. FURNITURE JOURNAL reported in September 1905 that he had held a dinner for his workmen where he praised them lavishly. Then he cut their wages. Apparently swayed neither by his fine words nor his fancy dinner, the workers promptly went out on strike.
[8] FURNITURE JOURNAL, June 1904.

[9] Charles Locke Eastlake, HINTS ON HOUSEHOLD TASTE (New York: Dover, 1969 [reprint of 1878 edition]), p. 85.

[10] Ibid., p. 76.

[11] Ibid., p. 287.

[12] INTERNATIONAL STUDIO, vol. XVI (1897), p. 187.

[13] CHICAGO TRIBUNE, Oct. 7, 1900.

[14] THE STUDIO, May 1896, p. 216.

[15] THE STUDIO, April 1897, pp. 152–57.

[16] White, J.P., "Furniture Made at the Pyghtle Works, Bedford, by John P. White. Designed by M.H. Baillie Scott" 1901.

[17] Anscombe and Gere, ARTS & CRAFTS IN BRITAIN AND AMERICA, p. 139.

[18] THE CRAFTSMAN, November 1906.

[19] Stickley's commitment to good workmanship was very real. According to Alfred Audi, current president of the L. & J.G. Stickley Furniture Company, Stickley once came upon one of his workers who was making a chair, and not doing it well enough to suit Stickley. He flew into a rage at the man, smashed the chair to pieces, and threw them out a window.

[20] THE CRAFTSMAN, October 1913.

2 Gustav Stickley's Stylistic Development

Gustav Stickley made his first Arts and Crafts furniture in 1898, and continued designing and producing until bankruptcy forced him out of business in 1916. During those years, his designs underwent enormous changes and development. It is these stylistic changes which, in our opinion, provide the best means for understanding, identifying, and dating specific examples of his work. His work can be divided into four distinct periods: the early Experimental Period, from 1898 to 1900; the First Mission Period, from 1900 to 1904; the Mature Period, from 1904 to 1910; and the Final Mission Period, from 1910 to 1916. It should be noted that there is inevitably some overlapping between these four periods; characteristics of one often appear in another. The dates assigned to these periods are somewhat arbitrary, but consistent enough to provide us with a useful means of understanding Stickley's development as a furniture designer, as well as assigning dates to some specific examples of his furniture.

Experimental Period, 1898-1900

"When the idea came to me that the thing for me to do was to make a better and simpler furniture, I naturally went about it in the most direct way. Having been for many years a furniture manufacturer, I was of course familiar with the traditional styles, and in trying to make the kind of furniture I thought was needed in our homes, I had no idea of attempting to create a new style, but merely tried to make furniture which would be simple, durable, comfortable, and fitted for the place it was to occupy and the work it had to do. It seemed to me that the only way to do this was to cut loose from all tradition and to do away with needless ornamentation, returning to the plain principles of construction and applying them to the making of simple, strong, comfortable furniture. . . ." [1]

Stickley's earliest efforts did not always measure up to his highest expectations. Even though he had articulated his Craftsman theory of

plain durable forms by as early as 1898, his first Arts and Crafts designs were not a fully realized expression of his high ideals. For this reason we refer to his work in the final years of the nineteenth century as the Experimental Period. Few of Stickley's early designs show the kind of structural detail associated with his later production: joints are not yet doweled into place, thin pieces of wood are used, and only rarely does tenon-and-key construction appear.

An excellent example of Stickley's Experimental Period is the side chair first illustrated in the December 1900 issue of HOUSE BEAUTIFUL in the Tobey Furniture Company ad (see facing page). Note its rounded top rail, swelling back slats, molded seat rails, and the modest whiplash curves of the aprons' lower edges.

As might be expected with such an early design, this rare and important chair is not as straightforward and boldly functional as Stickley's later designs would be. It seems almost fussy, with its molded seat rails, curved apron (certainly there is a modest echo of the Art Nouveau whiplash here), and expanding back slats. This chair also shows a Voysey-like English Arts and Crafts influence, particularly in the gently rounded crest rail. Stickley's experimental work seems largely concerned with an attempt to translate this and other influences into a uniquely American idiom.

The importance of his early furniture is that it shows Stickley's first tentative gropings toward a new style. It shows French Art Nouveau and English Arts and Crafts influences but it has not yet developed to the point where his work has become a true expression of his ideals. It was, by his own admission, experimental work: "The original pieces of Craftsman Furniture were made in 1898. For two years I experimented and worked over the main problems of design, construction and finishing." [2]

In 1900, Stickley was not only experimenting with his new style, he was also looking for ways to market it. This led him to the semiannual furniture trade show in Grand Rapids in July of that year, when what seems to be the first printed notice of Stickley's efforts appeared in AMERICAN CABINET MAKER AND UPHOLSTERER: "The Gustave Stickley Company will show a beautiful line of diners and rockers at Grand Rapids. They will be represented by Lee Stickley. . . . Mr. [Gustave] Stickley has devoted much of his time to the new finish in wax called Austrian Oak, and has succeeded in turning out some handsome designs that cannot fail to impress the buyers of fine goods favorably. The line will contain a variety of novelties, some finished in an exquisite shade of green, greatly resembling gun metal." [3] Stickley's first ad to the trade, showing

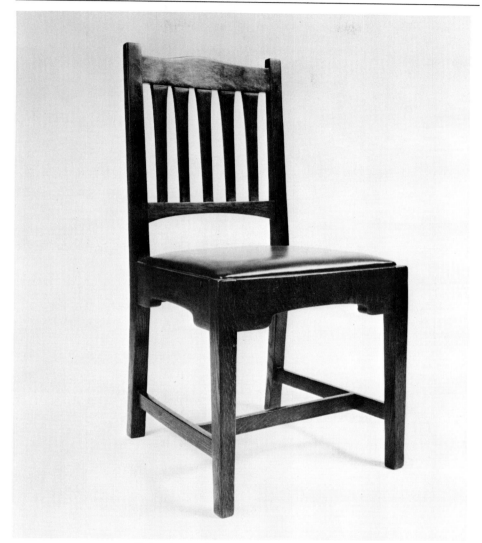

Side chair of the Experimental Period

a small armchair similar to the side chair illustrated above, as well as a tabouret holding a Greuby vase, appeared in the following issue.

Apparently, one outgrowth of the Grand Rapids show was a distribution agreement Stickley made with the Tobey Furniture Company of

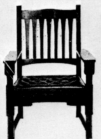
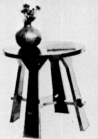
It is easy to forget how radical Stickley's designs were for his day. The golden-oak sideboard at the top of the page, a typical turn-of-the-century design, reminds us of the great distance between the accepted styles of that time and Stickley's work. The Stickley pieces shown here belong to his Experimental Period.

Furniture as an Educator.

The New Furniture belongs to a school of design almost unknown in this country, but it is understood and in great esteem in Europe at this time. Much of the furniture shown at the Arts and Crafts Exhibition in England, and known as the Glasgow School of Design, finds its motive from the same source, and the late William Morris worked largely along these lines. It is a departure from all established styles, a casting off of the shackles of the past — the only influence being the present.

It is *angular*, *plain* and *severe*. Such ornament as it bears is incut carving after what is known as the Nancy method. The Nancy school has something from nature, a flower or a leaf, as its motive, and all the carving is in bold lines, not unlike the impressionist style of painting.

NO. 3,600—BOOK STAND.
Weathered Oak.

While form and ornament have been considered first, color has been given prominent consideration. It is believed that the color scheme of furniture should accord with its surroundings, and to that end we have adopted a sort of gray-brown "*weathered-oak*" which gives a seasoned appearance to the wood, as though no stain had been used; a "*Tyrolean green*," and "*gun-metal gray*," unusual stains with silken luster, to which the wax finish gives a beautiful dull sheen.

NO. 39,000—ROCKER.
Spanish Leather, Weathered Oak.

The little table shown in Cut No. 326 has a top decorated with lines which carry out the shape of the poppy. The lower shelf of the table is similarly decorated, and the legs resemble another part of the plant. The table shown in Cut No. 3,401 is characteristic of the strength and simplicity which are the salient features of the "new furniture," achieving a result distinct and impressive. It is the Belgian construction of slot and pin — a table one feels would delight the soul of Ruskin, its genuineness is so apparent.

NO. 321—TEA TABLE.
Dark Mahogany, Wax Finish.

The plant stand shown in Cut No. 37 is a *Grueby tile* top. The celebrated Grueby tile plays a part in this "new furniture," making most excellent practical tops for plant stands and tabourettes. A rich green, a superb blue, and a vivid orange are the colors of this artistic ware. Besides the plant stands are small center pieces two or three inches high, with Grueby tile tops for the center of the tables, on which to place ferneries or palms.

NO. 326—POPPY TABLE.
Weathered Oak.

There are numerous chairs and benches on the same lines, perfect in proportion, restful and inviting, many of them with old-fashioned rush bottoms; others are covered with Spanish leather, fastened with big-headed oxidised nails. "*Spanish leather*," "*antique leather*," and "*roan skin*" are also an important feature. The entire collection at present comprises about seventy-five different shapes — tables, stools, chairs, rockers, settees, tabourettes, book stands and writing desks.

NO. 3,401—LIBRARY TABLE.
Weathered Oak.

NO. 37—PLANT STAND.
Weathered Oak, Grueby Tile Top.

It is but a beginning — the first slight harvest in this new field of furniture. Now that it has met with success, nothing will hinder its development. New pieces — pieces hitherto impossible to find — are being made, and it will be our constant endeavor to produce a variety of furniture that will be thoroughly practical, not too good for daily use, moderate in price, in demand by people of culture and taste, and that will help to make life better and truer by its perfect sincerity. Each piece of the "new furniture" bears our special trade-mark here shown. Descriptive catalogues will be ready for distribution about October 15th.

NO. 3,700—NORMAN SEAT.
Weathered Oak, Spanish Leather.

THE NEW FURNITURE
The Tobey Furniture Company, Chicago.

The Tobey Furniture Co.

The earliest-known advertisement for Gustav Stickley's Arts and Crafts furniture, from the October 7, 1900 CHICAGO TRIBUNE.

Chicago. The Tobey Company, which was both manufacturer and re-tailer, undertook an extensive advertising campaign in the fall of 1900 in the Chicago papers to introduce "The New Furniture." Stickley's name did not appear in any of the Tobey ads. This ad, which appeared on October 7, 1900 in the Chicago TRIBUNE, is the earliest known ad for Stickley furniture. The pieces here are Experimental Period designs, though the library table represents the beginnings of his later, more rectilinear work.

Stickley's agreement with the Tobey company was short-lived, prob-ably partly because of his reluctance to be relegated to the role of anonymous supplier. We know he was a cautious man, and the Tobey arrangement provided him with a low-risk means of getting his new designs to the marketplace. However, he was also strong-willed and assertive, and probably was not happy seeing his designs promoted and sold with no public recognition of his labors. Obviously, there was a demand for his furniture, and he was soon selling on his own through ads in THE CRAFTSMAN, his own catalogs and pamphlets, and the show-rooms of the first Craftsman Building.[4]

AMERICAN CABINET MAKER AND UPHOLSTERER informed its readers that Stickley had rented the famous Crouse Stables in Syracuse (later to be bought by Stickley and renamed the Craftsman Building), where they would show their new line, which consisted of complete furnishings for the library, smoking, sleeping, and club rooms and halls and hotel lob-bies. "The construction of these goods" said the magazine, "is on sim-ple lines and so solidly made as to be almost indestructible."[5] Thus by the end of 1900, Stickley had already begun to grow beyond his Exper-imental Period.

First Mission Period, 1900-1904

"Accepting as my basis the two principles of simplicity and adaptability to purpose, and intending from this basis to develop and mature a style . . ."[6]

Stickley's second period, which we refer to as his First Mission Period, started in 1900. This period was characterized by heavy structural de-signs which were a more accurate reflection of his Craftsman philoso-phy. For the first time, massive tenon-and-key[7] construction appeared, as did chamfered boards (Stickley referred to them as V-jointed) held together by internal spines, and exposed tenons. His furniture also grew increasingly rectilinear and severe, with the modest carved ornamenta-tion of his Experimental Period giving way to more geometrical designs.

This straightforward side chair, introduced in 1901, is a perfect example of Stickley's First Mission Period. It is plain and rectilinear, with the only decoration created by the exposed tenons and pins, and shows how far Stickley had progressed in the delineation of his structural style since the Experimental Period chair shown on page 35.

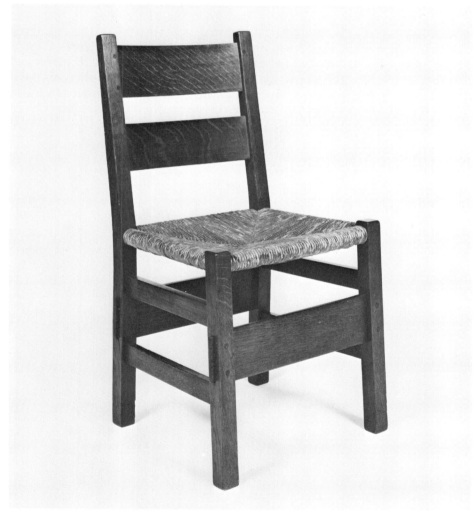

Side chair of the First Mission Period

For Gustav Stickley, decorative effects achieved through applied ornamentation were ugly and dishonest. The only valid form of decoration was that which developed naturally from the materials, the details of the construction, and the woodworking methods employed. The structural elements of his furniture during this period were always clearly expressed, showing how the piece was held together. There lay true decoration.

Another typical example of a design from this period is the CIRCA 1901/02 sideboard shown in a photograph taken at the Syracuse Craftsman Building. The back and sides are formed by vertical butt-jointed chamfered boards, fastened with internal splines. Squared-off tenons are mortised through the front and back legs. The whole impression given by this piece is one of solidity, sturdiness, and usefulness, exactly what Stickley wanted from his designs. The server, which clearly

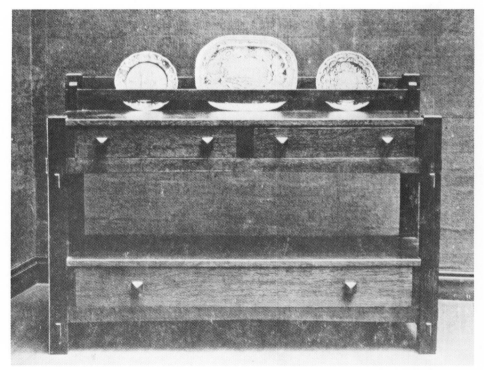

With its boldly expressed structure, this massive sideboard is characteristic of Stickley's First Mission Period.

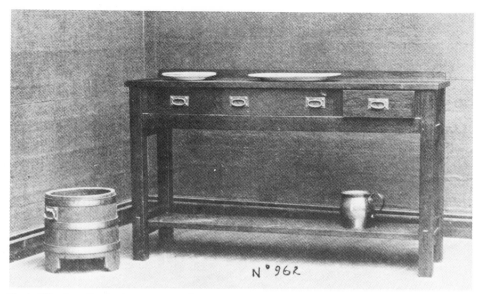

First Mission Period serving table, with double pinning on the apron and exposed tenons, which typifies Stickley's work of 1900/04.

prefigures the three-drawer server Stickley introduced in 1907, is also typical of this period.

It was this kind of massiveness that led some early detractors to call his work clumsy and heavy, but this is more an indication of their own inability to see that the massive proportions of this work made it simultaneously sturdy and elegant. His preachings on functionalism aside, Stickley always wanted to make beautiful furniture:

> We do not make our constructive features unduly prominent; for we never lose the opportunity to incorporate in our work lines of beauty, which will be recognized in the long, graceful curves; and the softening of wedge effects; in the forms of mullions entering into the doors of cases and cabinets; and the refinements of moldings and angles, so treated as to create an agreeable play of lights and shadows; in the restrained, though never tame decoration.[8]

The three rare design sketches shown on the following page must have been executed in late 1901 or early 1902. The flat top desk shows some of the characteristics typical of the First Mission Period: note the inverted V-shapes on the lower edges of the stretchers and the square pulls. The small cabinet (it is only 54 inches high) is apparently an early effort at designing children's furniture. Its tenon-and-key joints, vertical-board back, and cast hardware relate it to the 1901–1902 period. Of greater interest, however, are the painted doors, a form of decoration almost unheard of on Stickley furniture. It is not known if any of these three designs was actually produced.

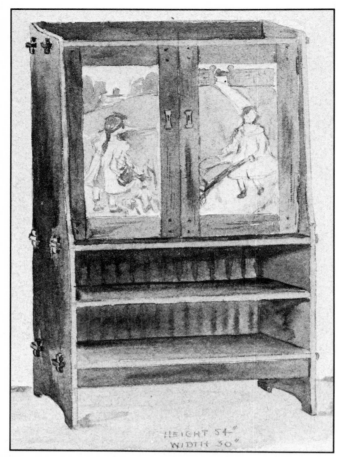

HEIGHT 54"
WIDTH 30"

Three early
design sketches,
CA. 1901/02.

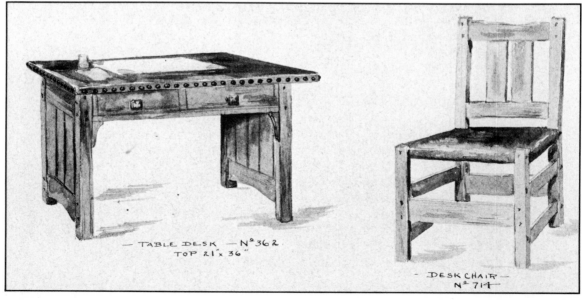

— TABLE DESK — N° 362
TOP 21" x 36"

— DESK CHAIR —
N° 714

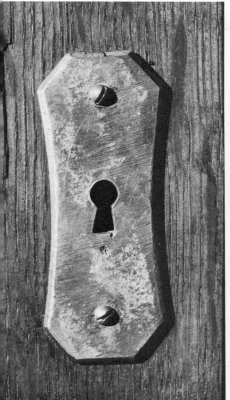
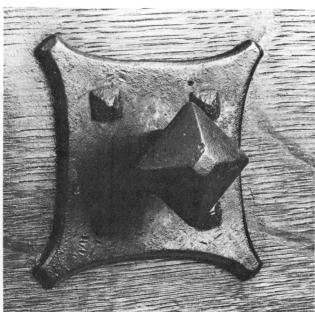
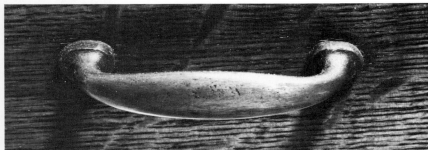

Characteristic hardware from the earliest years of the First Mission Period.

Stickley's first hardware appeared during this period, even before the opening of his metal workshop in May 1902. He soon realized that the shiny, flimsy hardware used by most other furniture manufacturers simply would not work on structural Craftsman pieces and that he had to develop a new style of furniture hardware that would relate visually to his Craftsman designs.

His earliest plates and pulls for drawers and cabinet doors were cast brass or iron and were filed smooth before they went on furniture. The bevel-edge plate at top left comes from the bookcase on page 103. The hardware at the top right, from the server on page 193, has a square faceted pull and a butterfly-shaped plate attached to the drawer front with lag screws. The smooth brass pull at the lower right comes from the fall-front desk on page 172/73.

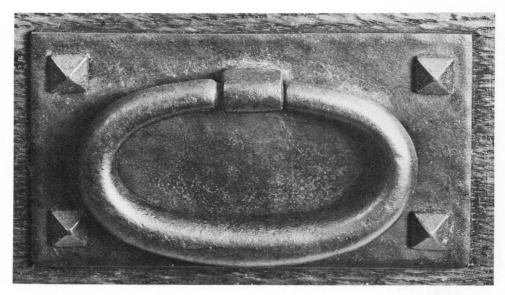

By 1902, the cast hardware had given way to the heavier hand-wrought escutcheons, plates, and pulls. The first hammered copper or iron hardware generally consisted of beveled rectangular plates with oval pulls (above) or round pulls on the facing page, fastened to the wood by square-faceted lag screws. The hammer marks are clearly visible.

Wooden knobs were also introduced during this phase. Stickley preferred wooden knobs to metal hardware, a fact which may surprise modern-day collectors who tend to favor the hand-wrought hardware.[9] The first wooden knobs, shown on the facing page, are square and faceted and are chamfered to a slight point.

Even though the designs produced during the First Mission Period were increasingly consistent with Craftsman philosophy, Stickley still had not made a clean break from his earlier, more derivative style. During the beginnings of this period, elements of the earlier period were sometimes brought into play. The settle on page 137 and the serving table on page 193, both of which actually date from circa 1901–1902, exhibit the moldings and curves of the Experimental Period, even though they are truly First Mission Period pieces. Though we consider these pieces to be part of the First Mission Period, they are perhaps best described as transitional designs, incorporating aspects of both periods. Though both are massive and structural in a manner consistent with his work during the First Mission Period, they retain design elements which are more characteristic of his experimental designs.

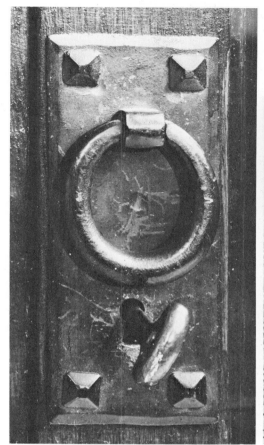

Hardware and the square, faceted wooden pull which came into use in the middle of the First Mission Period.

The importance of the stylistic changes which took place during the First Mission Period is that they moved Stickley away from the uncertainties of his Experimental Period. He began to develop the design vocabulary only hinted at in the earlier years, and his work became increasingly robust and strong, fairly bristling with visually exciting structural details. The furniture he designed and made during this period was the first successful expression of the structural style and was truly functional in a way that much of the experimental work was not. Although designs of his subsequent periods became increasingly simplified, often shedding the expressed structural characteristics of the First Mission Period, the vigorous, functional approach to design that he developed in these years characterized his furniture output from then on.

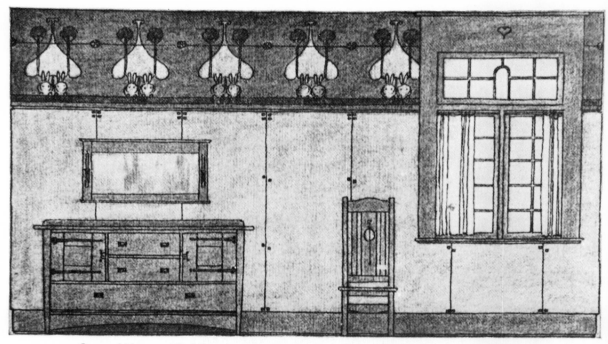

One of Harvey Ellis' first renderings of a Craftsman interior, which appeared in the magazine in July 1903.

It was during the First Mission Period that an important and unique offshoot of Stickley's designs first appeared. In early 1903, Stickley hired a man whose genius as a furniture designer equaled his own: Harvey Ellis. A Rochester, New York, newspaper carried a small notice that "Harvey Ellis, a well known artist and architect" had been employed by Gustav Stickley, who "will hereafter control Mr. Ellis's designs and work." [10]

During the 1870s, Ellis had worked briefly for the architect H.H. Richardson in Albany, and then had returned home to Rochester to establish an architectural practice with his brother. In the 1880s and 1890s he had worked for LeRoy Buffington, a Minneapolis architect, as well as for other Midwestern architects, for whom he produced countless beautiful renderings and elevation drawings. By the end of the nineteenth century he had returned to architectural practice in Rochester and become aware of the current trends in Europe, probably through exposure to INTERNATIONAL STUDIO and similar art publications, and his work began to reflect these trends.

The furniture designs and architectural work he produced for Stickley were strongly influenced by the English Arts and Crafts designers, primarily C.F.A. Voysey, Baillie Scott, and the Glasgow architect Charles Rennie Mackintosh. His work was more purely decorative than Stick-

ley's, and he brought a new sense of lightness and color to the Craftsman Workshops. Ellis's beautiful color renderings of Craftsman interiors first appeared in The Craftsman in July 1903, and differed markedly from the heavy, often medieval-looking designs then being produced by Stickley.

In the Ellis rendering, shown on the facing page, the side chair against the wall is the first appearance of the inlaid chair pictured below, though with a different inlay motif in its broad central splat. Note also the typical

Inlaid side chair, designed by Harvey Ellis in 1903.

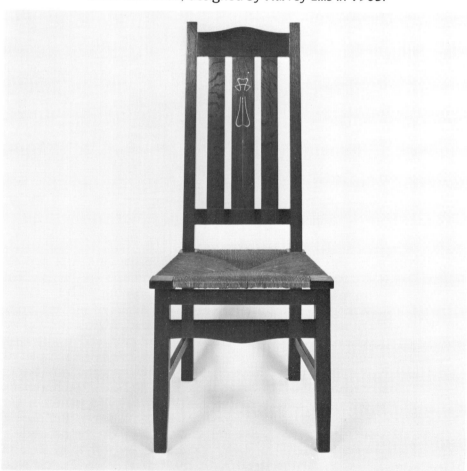

Stickley's first ad for his inlaid furniture, from the July 1903 issue of THE CRAFTS-MAN.

Ellis treatment of the low chest of drawers: overhanging top, bowed sides, arching apron. This piece certainly prefigures the woman's chest of drawers on page 159 and the small sideboard on page 200.

Ellis created a line of furniture decorated with inlays of pewter, copper, and light-colored woods in the manner of English Arts and Crafts. The forms of his inlaid pieces were, for the most part, unlike anything Stickley had produced before. Many of the Ellis-designed case pieces have wide overhanging tops, bowed sides, arching aprons, and backs made of laminated wood, and some have veneered sides. The highback side chair first drawn by Ellis in the July and August 1903 issues of THE CRAFTSMAN epitomizes the delicate nonstructural work he created during his brief stay with Stickley. The graceful chair, shown on the preceding page, represents a major break from earlier Stickley furniture, though the swelling crest rail relates strongly to the Experimental Period side

chair seen early in this chapter. Interestingly, the crest rails of these two chairs probably derive from different sources, with the earlier one drawing on the American ladderback and the Ellis design taking its inspiration from Baillie Scott and Voysey. Note how Ellis repeats the crest rail's swelling form, inverted, in the front stretcher.

These inlaid pieces are very rare today, since according to Stickley's daughter, Barbara Wiles, the inlaid oak furniture was never produced commercially. A limited number of pieces were made for exhibit to the furniture trade and to display in some retail stores, but the line never caught on and very few pieces were sold. According to Mrs. Wiles, these few samples were the only pieces of inlaid furniture made.

Because it was not successful in the stores, the inlaid furniture was produced for less than a year. It was first advertised in THE CRAFTSMAN for July 1903, two months after Ellis came to work for Stickley. The last mention of it is found in the June 1904 issue of the magazine. It is also mentioned briefly in "What Is Wrought in the Craftsman Workshops," a pamphlet Stickley published in the spring of 1904: "In certain cases, an inlay of woods and metals, showing obscured plant forms, or purely linear designs, is used with discretion upon the oak or the maple pieces."

In January 1904, just nine months after joining Stickley, Ellis died tragically at the age of fifty-two. But his designs exerted a strong influence on Gustav Stickley for years to come.[11]

Mature Period, 1904-1910

"I had hit upon an idea which was to have a far greater success than even I had hoped for."[12]

Stickley's third period, which we call his Mature Period, began in 1904 and continued into 1910. It was during this time that he produced most of his work, and not surprisingly, most Stickley pieces found today fall into this period.

During this time his furniture designs were perfectly consistent with his Craftsman doctrine of usefulness, durability, and comfort. And, because Stickley's workshops were turning out more furniture than ever before, it was also, of necessity, a time of simplification and standardization of construction details and hardware. However, standards of construction and finish remained at high levels. The V-back side chair, one of Stickley's favorite designs, typifies his mature style. No chair equals

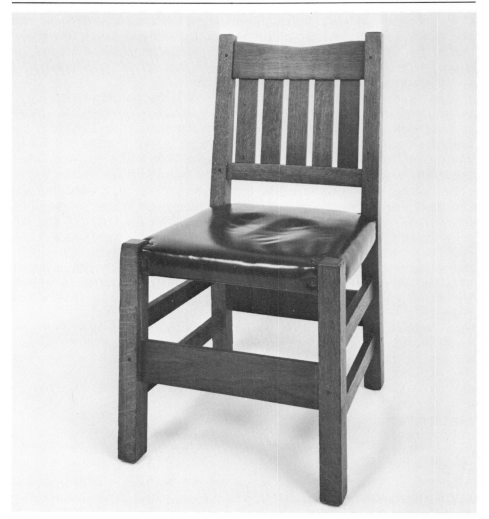

The V-back side chair, characteristic of the Mature Period.

the V-back as an expression of Stickley's Mature Style. Its stretcher arrangement, minus the exposed tenons, is like the First Mission Period chair on page 39, but the gentle V-shape of its crest rail and the refined proportions create a much more elegant design.

By 1909, at the height of his Mature Period, Stickley had put a great deal of distance between himself and the philosophies underlying the

English Arts and Crafts furniture which had so greatly influenced his earlier efforts. In that year he wrote:

> Like the Arts and Crafts furniture in England, it [Craftsman furniture] represented a revolt from the machine-made thing. But there is this difference: the Arts and Crafts furniture was primarily intended to be an expression of individuality, and the Craftsman furniture was founded on a return to sturdy and primitive forms that were meant for usefulness alone.[13]

In these years, Stickley's commitment to the decorative value of articulated structure continued to be strong, even though the structural elements of these pieces were not as forcefully expressed as they had been during his earlier periods. The heavy chanfered boards which formed the backs of early bookcases and desks disappeared and were replaced by laminated oak panels. The pieced muntins from bookcase doors were replaced by muntins which simply butted together. Tenon-and-key construction appeared less frequently, and tenons were more likely to end within the mortise rather than piercing through. Stickley's first commercial use of veneer appeared during this period, enabling him to enhance his furniture with the decorative effects of matching grain patterns. The furniture of this third period rarely exhibits the visual excitement associated with his early styles, but it does have a simplicity, a correctness of proportion, and a purity of form that gives it great beauty. Certainly Stickley's most dramatic designs of the Mature Period are his spindle and Ellis-derived curved pieces. Perhaps of the pieces shown, the three-drawer library table on page 218, the two-door bookcase on page 105, and the nine-drawer chest on page 158 are the most representative of this period.

It is apparent that Ellis, even though he died at the beginning of 1904, greatly influenced Stickley's Mature Period. Ellis's inlaid furniture exhibited construction details totally unlike those found on Stickley's First Mission Period designs. As we have pointed out, the inlaid pieces were lighter in feel and had paneled backs, overhanging tops, curved aprons, bowed sides, and, occasionally, veneer. Since these elements are found in many Stickley pieces made between 1904 and 1910, it may be said that Ellis's designs, produced during Stickley's First Mission Period, foreshadowed Stickley's Mature Period.

During Stickley's Mature Period, the different types of hardware found in his First Mission Period (except for the oval pulls) were replaced by hand-wrought copper and iron hardware which was decorated with deep planishing marks and a rich brown patina. The new hardware assumed three basic shapes: the V-shape first used in 1904,

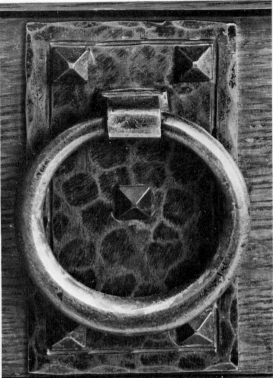

Hand-hammered hardware and the round wooden pull of the Mature Period.

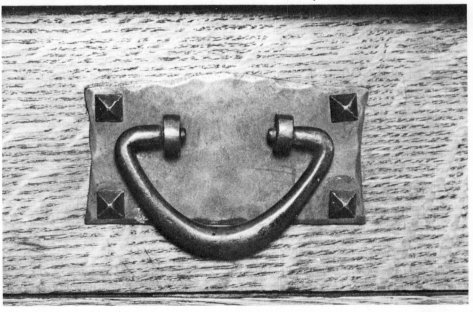

the flattened V-shape first used in 1904, and huge round pulls which appeared on built-ins in THE CRAFTSMAN in 1908, but were not used on furniture until 1910. Stickley continued to use wooden knobs throughout his mature production years, but in this period the square-faceted pulls gave way to round ones similar to pulls found on Shaker furniture.

Final Mission Period, 1910-1916

"Most of my furniture was so carefully designed and well-proportioned in the first place, that even I with my advanced experience cannot improve upon it."[14]

By his own admission, Stickley introduced few new Craftsman designs during these final years. Indeed, this period is best characterized by those designs he no longer produced: by 1910 all his spindle furniture and most of his Ellis-inspired curved furniture was gone. There is less use of tenon-and-key construction in his final period. For example, Stickley's hexagonal library table (page 209) lost its forcefully expressed tenon-and-key joints in 1910. After 1910, most of his more dramatic designs were no longer carried, and most of the pieces of the Final Mission Period are continuations of his more conservative Mature Period designs. Many of these became even more rectilinear during the final years. For example, the two-door china closet on page 111 was made with a curved apron from its introduction in 1906 through 1910. By 1912 the apron had become straight.

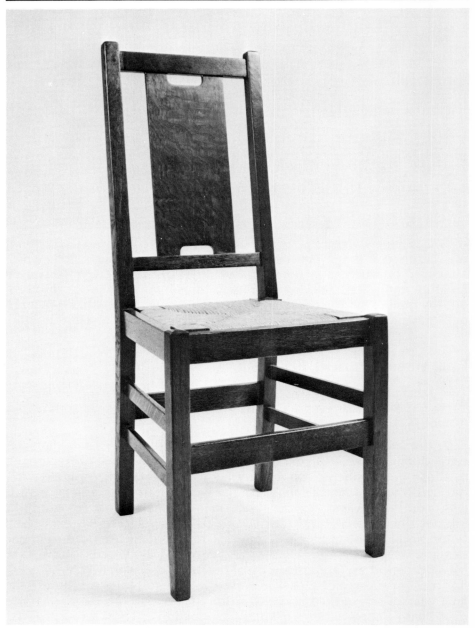

H-back side chair of the Final Mission Period.

The new designs Stickley did develop during this period are severely rectilinear and only moderately structural, and in their general outline they are reminiscent of much of what he produced during the First Mission Period. However, they are also very "modern." More than any other of his stylistic periods, Stickley's Final Mission Period exhibits what Anscombe and Gere refer to as the "stripping down process which marked the prelude to the Modern Movement."[15] The H-back side chair, shown on the facing page, with its severe simplicity is characteristic of the final period.

His furniture during these final years had shed its need for the expressive structural details of the earlier period, while gaining a new purity which frankly bespoke the machine processes used to produce it.

Even before his final period, Stickley had been one of the first to recognize the true value of the machine and put it into its proper perspective. He came to see it as no more than a craftsman's tool, which could relieve the worker of onerous, repetitive chores:

> To say in this day of well-nigh perfect machinery that anything to be good must be done entirely by hand is going rather far. There are certain purely mechanical processes that can be accomplished much better and more economically by machinery, giving the craftsman better prepared materials to work with instead of taking his time for their preparation.[16]

But most important, Stickley also saw that machine production demanded its own style. Rather than using it to simulate hand carving in imitation of period furniture, he harnessed it. He took advantage of its strengths instead of attacking its shortcomings, and created a rectilinear style which grew naturally from those strengths. In effect, Stickley was one of the first "machine age" designers, as the productions of his Final Mission Period show. Each of his four successive stylistic periods demonstrate his progression toward increasingly pure forms. The armchair on page 127 and the single-door china closet on page 110 typify his work of this final period.

Because he incorporated the philosophy of the Arts and Crafts movement with the practicality of new machines, Stickley was a pivotal figure in the development of modern design. On one hand, he loved the warm qualities of wood, fine craftsmanship, and honest construction; these traits tie him directly to the design reforms of the nineteenth-century Arts and Crafts movement. On the other hand, his belief in functionalism and pure form prefiguring the International style of the 1920s makes him a pioneer perhaps more than any other Arts and

Crafts designer of what this century has come to consider modern design.

[1] "Craftsman Furniture," Stickley's 1909 catalog, p. 3.

[2] "Craftsman Furniture," 1912.

[3] AMERICAN CABINET MAKER AND UPHOLSTERER, June 30, 1900.

[4] Although Stickley always functioned as both manufacturer and retailer, he apparently did it exclusively only from 1901 to 1904. FURNITURE JOURNAL told its readers in October 1904 that Stickley was looking to sell to the retail trade. Up to that time he had been able to sell nearly all his products direct to the consumer and had not sought the retailer's patronage. A similar notice appeared in the same magazine the following July.

[5] AMERICAN CABINET MAKER AND UPHOLSTERER, Dec. 22, 1900.

[6] Gustav Stickley, "Cabinet Work from the Craftsman Workshops," 1906 catalog.

[7] These and other furniture-making terms are defined in Appendix B.

[8] "Chips from the Workshops of Gustave Stickley," 1901.

[9] "I prefer to use drawer and door pulls of wood, as I regard the plain wooden knob as being more in keeping with the furniture than metal." "Catalogue of Craftsman Furniture," 1909.

[10] ROCHESTER HERALD, May 30, 1903.

[11] Harvey Ellis never stated publicly that he designed Stickley's inlay furniture. However, there is compelling evidence that it is his work:

• Ellis joined Stickley in May, 1903, and the first inlay furniture appeared in THE CRAFTSMAN just two months later, in July of that year. This furniture was almost totally unlike any of Stickley's previous Craftsman designs, but it was similar to some of Ellis's work from the turn of the century. For instance, a side chair he designed for the Cunningham house in Rochester during 1900 shows strong similarity to the Stickley inlaid chair on page 47.

• Most of the articles in THE CRAFTSMAN that show inlay furniture were both written and illustrated by Harvey Ellis.

• Although financial considerations were apparently the primary factor that led to the termination of inlay work at the Craftsman Workshops, the fact remains that no new designs in this mode appeared after Ellis died in January, 1904.

• Barbara Wiles, Gustav Stickley's daughter, confirmed in an interview with the author that Ellis was responsible for the inlay designs.

• Finally, Ellis worked in relative anonymity all his life, and the pattern of producing inspired designs for others was established early. It is now well documented that he created some magnificent architecture in the 1880's for the Minneapolis architect Leroy Buffington, yet he was given no credit for this work. He did design work for several midwestern architects during the 1880's and 1890's, none of whom acknowledged his contributions. Thus, even though he signed his name to the articles and illustrations he produced for the THE CRAFTSMAN in 1903, it is easy to see that the assertive, strong-willed Stickley would not be likely to give Ellis credit for his designs, and that Ellis was willing once again to submerge his personality in another's, and forego the public acknowledgment of his work.

[12] Gustav Stickley, "Craftsman Furniture," 1912.

[13] CRAFTSMAN HOMES [New York: Craftsman Publishing Co., 1909), p. 156.

[14] Gustav Stickley, "Craftsman Furniture," 1912 catalog.

[15] Anscombe and Gere, ARTS AND CRAFTS IN BRITAIN AND AMERICA, p. 168.

[16] "Chips from the Craftsman Workshops," 1906.

3 "Stamped in an Unobtrusive Place": How Gustav Stickley Marked His Furniture

It is generally an easy matter to identify Gustav Stickley's Craftsman furniture, because he was so scrupulous about marking it with his name and shopmark. However, anyone who has seen a quantity of Stickley furniture quickly learns that he used a puzzling array of differing marks. This leads to the all-important question of dating: do the marks on Stickley furniture provide an accurate way to determine when a particular piece was made? This is not an easily answered question since it is apparent that Stickley used more than one version of his shopmark at a given time. While acknowledging this difficulty, it is possible to date a piece quite accurately by the manner in which it is marked.

While a thorough knowledge of Stickley's various marks is important to anyone with an interest in the furniture, an ability to identify it in the absence of marks is even more important. Stickley used both decals and paper labels to mark his furniture, and these can easily be effaced by refinishing or reupholstering. Pieces without marks can often be accurately attributed to the Craftsman Workshops by reference to Stickley's catalogs and books, but even when this sort of documentation is not available, a person with a practiced eye can differentiate his work from that of his competitors. In other words, get to know the furniture first by examining it carefully—then look for marks as confirmation. Our emphasis throughout this chapter will be to DATE the furniture by means of Stickley's marks, rather than to IDENTIFY it.

Before we look at specific marks, it is important to point out that they provide only one of the means to dating this furniture. Many of Stickley's designs went through evolutionary changes during the years of his production. Consequently, by studying his catalogs and pamphlets it is possible to accurately place the dates of some pieces within a year or two of their manufacture. For example, the smoker's cabinet on page 237 was certainly made CIRCA 1912, because it was shown for the first time in this form in that year's catalog. It has the paper label used from 1907 to 1912. So 1912 is a very likely date for this piece. To cite another example,

Stickley began using square nailheads in late 1907 on small chairs with leather wrapped around the seat rails. We know this because he announced the change that year: ". . . chairs are shown with seats of soft leather, slightly padded and finished all around the bottom of the seat-rails with ornamental nails of dull brass or iron. We now use only hard leather . . . and, instead of the rows of round-headed nails . . . square-headed nails are used only at the corners." [1] Thus round-head nails on a small arm, side, or rocking chair indicate a pre-1907 date; square-head nails show that the chair was made late 1907 or after. [2]

Stickley originally upholstered his large armchairs and Morris chairs with loose cushions supported by wood frames fitted into each chair and laced with hand caning. [3] In late 1906 he began to employ the "swing" seat, a loose cushion supported on a strong piece of canvas slung between the front and rear seat rails. [4] Stickley introduced the use of the spring cushion to his large chairs in 1909. [5] So, it is possible to date a large armchair or Morris chair simply by seeing how the seat is constructed: a loose seat supported by caning dates CIRCA 1901–1906, [6] a swing seat CIRCA 1906–1909, a spring seat CIRCA 1909–1916. This kind of information along with a clear understanding of when certain marks were used, makes exact dating possible.

Further, some of Stickley's designs were made only briefly. By checking which catalogs first include them, and then noting when they are no longer listed in the catalogs, it is possible to get an accurate fix on date of manufacture. For example, the Grueby-tile plant stand on page 233 may be found only in Stickley's 1901 and 1902 catalogs. This is not absolute proof that it was made in one of those two years, since he didn't necessarily show his complete line in every catalog, but it is nevertheless strong evidence in support of a 1901/02 dating.

Finally, as we have discussed in detail, one can date Stickley's furniture by studying construction characteristics and at least assign a specific example to one of the four major stylistic periods.

We have taken all of these elements into consideration in our study of Stickley's marks. We have also studied the marks as they appear in his many publications, most notably THE CRAFTSMAN from 1901 through 1916 and his furniture catalogs for 1901, 1902, 1905, 1906, 1907, 1909, 1910, 1912, and 1913.

The collector is quite fortunate that so much of Stickley's furniture carries his mark, for in the closing years of the nineteenth century and the early years of the twentieth few manufacturers used any marks at all. It was believed that the retail customer cared only about where the furniture was bought, not where it was made or by whom. Stickley, who

started marking his products in 1901, was very much in the vanguard, since "he is the only furniture manufacturer in the world who stamps every piece of furniture made in his shops with his own name and trademark."[7]

Stickley, of course, had many reasons to mark his furniture, probably the strongest being his desire to distinguish his work from that of his imitators. In addition, he meant his mark to stand as a guarantee of quality and workmanship. Finally, starting in 1901 he was selling a good deal of his furniture direct to the retail customer, via his catalogs and ads in THE CRAFTSMAN, and through his showrooms at the Craftsman Building in Syracuse. It was also important for him to develop a recognized name in the retail market place. AMERICAN CABINET MAKER AND UP-HOLSTERER commented: "The trademark upon these goods will always distinguish them from all comers. The device is the joiner's compass with the Flemish legend 'Als ik kan,' together with the signature of Mr. Stickley. The 'As I Can' is said to be an incentive to the craftsman who seeks to advance the cause of art allied to labor."[8]

From 1901 to 1916, Stickley marked his furniture with red decals, paper labels, and a burned-in (or branded) mark. However, the earliest furniture that he produced during his Experimental Period wasn't marked at all—at least not by Stickley. Since he was such a strong believer in the importance of marking furniture, it is somewhat ironic that his first furniture was sold to the public with the paper label of the Tobey Furniture Company. In the fall of 1900, the Tobey Furniture Company had adopted a new label to be specifically used in connection with their line of Stickley-produced "New Art Furniture."[9] This circular label, surrounded by little twigs, then, is the earliest mark to be found on Stickley furniture. Note its overall similarity to the round device Stickley adopted for his own first paper label in the fall of 1905.

The round paper label created by the Tobey Furniture Company in 1900 for Stickley's "New Art Furniture."

Shopmarks

Stickley's famous shopmark, the joiner's compass and the motto "Als ik Kan," first appeared in 1901 and was announced in the first issue of THE CRAFTSMAN. He also reproduced it in the furniture catalog, CHIPS FROM THE WORKSHOPS OF GUSTAVE STICKLEY, which he had issued earlier that year. In describing his new shopmark, Stickley said it was "branded upon" the furniture, along with his signature and the date of manufacture. The first version of the joiner's compass mark is quite different from the ones that followed; note the GS monogram enclosed within the compass and the 'Als ik kan" placed in the rectangle below it.

1901

Although we have examined Stickley pieces which are shown in the three issues of THE CRAFTSMAN published in 1901, or in that year's catalog, we have never found this particular mark on any piece of furniture. If he did use it, he dropped it after a very brief period and either the furniture never carried this mark, or he used a decal which could easily be destroyed. We can only wonder about his use of the word "branded," since a brand is almost impossible to efface. Finally, if Stickley did date the furniture being made at this time, it is doubly unfortunate for the collector that he ceased the practice so quickly, since it would be much easier to date his pieces exactly and trace the steps of his development more accurately.

In January 1902, Stickley altered his shopmark to one of its more familiar forms.

1902–1903

This second version of the joiner's compass mark first appeared in THE CRAFTSMAN for January 1902, supporting the conclusion stated above that Stickley used the first version for only a few months. He again stated that this mark, plus the date of manufacture, would be found on all his products. By February 1902, in his catalog "Things Wrought by the United Crafts," he had eliminated the date of manufacture from this mark. A dated Stickley piece, if such a thing were to be found, would have to have been made in October, November, or December 1901 or January 1902.

The second version of the joiner's compass mark, a red decal with a rectangle around the Stickley name, was used throughout 1902 and 1903. Stickley described it in THE CRAFTSMAN for October 1902, saying that it has been adopted by the United Crafts as their crest and registered trademark, and that it would thereafter be placed on all the pieces made in his shop. This version of the joiner's compass mark can be found on the inside of the rear leg on side chairs, under the arms of armchairs, and centered on the back of the toprails of case pieces, such as servers, sideboards, and desks. Its size varies from 1 inch to 2½ inches high.

In THE CRAFTSMAN for November 1902, nine months after the appearance of the second version of the joiner's compass mark, Stickley introduced yet another variation, enclosing the entire mark within a rectangle.

1902–1904

This third version was shown in THE CRAFTSMAN throughout 1903. Some of Stickley's inlaid pieces have this mark, showing conclusively that it was used during 1903 and probably into 1904. In our experience, the third version of the joiner's compass appears on chairs and smaller pieces such as plant stands, small library tables, and the like. The second version of the mark, when it appears on pieces traceable to 1903, is always seen on larger pieces, including library tables, fall-front desks, and other case pieces.

We were fortunate to come across additional proof that the second and third versions of the mark were both used in 1903. When we examined several pieces of Stickley furniture, including several examples of inlay pieces, we found that all the chairs in the lot were marked with the third version of the joiner's compass. A library table, an Ellis design which first appeared in THE CRAFTSMAN for October 1903, was marked with the second version. All the pieces had been originally purchased in 1903.

The third version of the joiner's compass mark is a red decal, always 1 inch high, and is applied to the furniture on the inside rear legs of side chairs, under the arms of armchairs, and under the tops of tables.

The fourth version of the joiner's compass mark first appeared in "What Is Wrought in the Craftsman Workshops," which Stickley published in the spring of 1904. This version also showed up within the pages of THE CRAFTSMAN that year.

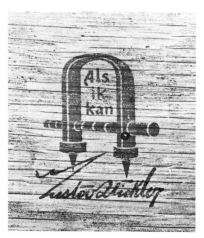

1904–1912

Here, the rectangles which had earlier enclosed his name and the mark have been removed. Further, Stickley has added his first name, a clear indication of his concern over growing competition from the other Stickleys. While we know that Leopold and J. George Stickley had set up their competing business in 1902, they didn't form a corporation until 1904. During this year they began selling Arts and Crafts furniture carrying their Onondaga Shops label, and this development must have motivated Stickley to further distinguish his work from theirs by using his first name on the furniture.

The introduction of this fourth version of the joiner's compass mark clearly corresponds to what we have defined as the beginning of his Mature Period. It is therefore the mark most likely to be found today, since Stickley's Mature Period was the time of his greatest furniture output. He used this mark, in varying sizes, until 1912. For the most part, the 2½-inch version appears on the backs of case pieces made in 1904. The tiny ¾-inch size is seen on the outside rear stretchers of chairs and settles made in 1904, 1905, and 1906. The 1½-inch size is generally seen on pieces made between 1906 and 1912. This size is found in the drawers of case pieces, on the inside rear stretchers of chairs, and on the inside of bookcases and china closets. This mark is nearly always a red decal. We know this from observation, as well as from four of Stickley's catalogs of this period: in his 1905 and 1906 catalogs, he says the mark is "Stamped in red in an unobtrusive place."

In the 1907 "Descriptive Price List" and the 1909 catalog he says it is "printed in red."

However, Stickley's catalogs to the contrary, on very rare occasions the fourth version of the joiner's compass mark is found in black, not red. And the black mark is not a decal; it appears to be a kind of stamp. Apparently, he began using the black stamp in 1910: his discussion of the joiner's compass in that year's catalog makes no reference to the color of the mark. We assume that he used the black stamp throughout 1910 and 1911 and into late 1912, although he also used the red decal during these years.

The fifth version of the joiner's compass mark first appeared in late 1912.

1912–1916

This mark is branded into the furniture. It is always 1¼ inches high, and is found on the sides of drawers and on the outside rear stretchers of chairs. As with the fourth version of the joiner's compass mark, the development of this fifth version is apparently related to developments at L. & J.G. Stickley. In 1910, L. & J.G. Stickley had been using the red "Handcraft" decal with its wood clamp device, a clear imitation of Gustav Stickley's joiner's compass. In 1912, the L. & J.G. Stickley catalog supplement announced that the name "Handcraft" would no longer be used and that it would be replaced by a rectangular red-and-yellow mark identifying "The Work of L. & J.G. Stickley." With his two brothers now using a mark totally unlike his, it is probable that Gustav Stickley felt confident enough to return to his earlier practice of using just his last name. We have found no evidence to suggest that Gustav Stickley resorted to litigation to force his two brothers to stop using a mark so

easily confused with his, but it would not be a surprise to learn that he used some strong measures.

Paper Labels

In THE CRAFTSMAN for December 1905, Stickley made use of a new circular mark, which was incorporated into his first paper label (or "paster" as he generally called it). The paper label did not replace the joiner's compass mark but was used in conjunction with it.

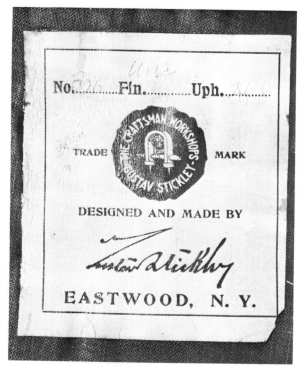

1905–1907

In this issue of THE CRAFTSMAN he also announced the opening of his "Branch Exposition Office" at 29 West 34th Street in New York City. Apparently, the introduction of the first paper label coincided with Stick-

ley's move to New York, even though there is no mention of the New York address on this label. He used this label until 1907; its circular device appears prominently in his catalogs and in THE CRAFTSMAN throughout 1905, 1906, and 1907. It is usually found on the underside of chairs and tabletops, and is always used in conjunction with the fourth version of the joiner's compass mark.

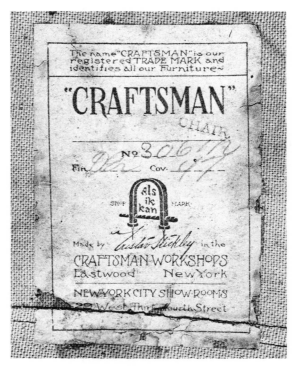

1907–1912

Stickley's second paper label first appeared late in 1907, and included the address of his New York offices. He described his joiner's compass and this version of the paper label in the January 1908 issue of THE CRAFTSMAN: "This shopmark is stamped in red. . . . A brown paper label showing both trademark and shopmark with the number of the piece is pasted on the underside of the lighter pieces, such as chairs and the like, within one of the drawers of each desk, large table or chest of drawers, and on the back of the heavier pieces of furniture."

This is the most commonly found paper label, since it is the one most

likely to be used on an example of his Mature Period. As with the first paper label, it is found in conjunction with the fourth version of the joiner's compass mark. He continued to use it until the fall of 1912.

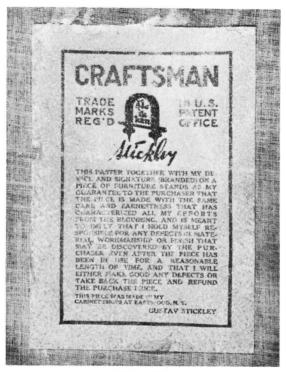

1912–1916

The third, and final, version of Stickley's paper label was shown for the first time in THE CRAFTSMAN for October, 1912. It also appeared in his 1913 furniture catalog, where he wrote that his "paster" was used "together with my device and signature [branded]". This version of the paper label is applied to the furniture in the same places as the second, and is always seen in conjunction with the burned-in joiner's compass mark.

The fact that there is no mention of Stickley's New York address (he was in the process of establishing the New York City Craftsman Building by this time) has misled some collectors into thinking that this is an early label; this is clearly not the case, since it does not appear at all until

1912. Further, the pieces found with this label are always easily identifiable as late productions.

It is interesting that each successive paper label increases in size. The first is 2¾ by 3 inches. The second is 3 by 4¾ inches. The third is 4 by 6 inches. This would seem to indicate Stickley's mounting concern about his increasingly successful competitors and his overwhelming desire to distinguish his work from theirs.

The Difficulties of Exact Dating

Because of our careful study of the changing forms of Stickley's marks, we feel confident that our conclusions about their dates are correct. By combining the evidence found in his various publications with observations of literally hundreds of marked examples of his furniture, we are certain that we have discovered an accurate method for dating his work. However, some problems remain.

When Stickley introduced his joiner's compass shopmark in the first issue of THE CRAFTSMAN, he said it was "branded upon" the furniture. However, the earliest marks seen to date are all red decals; the "branded" or burned-in mark didn't appear until 1912. Yet there is little doubt that Stickley made some use of the branded mark well before 1912—in 1904, 1905, and 1906. This conclusion cannot be adequately documented in any of Stickley's publications. However, the conclusion does seem to be valid.

For example, one chest of drawers we have examined clearly falls into Stickley's First Mission Period. It has square wooden pulls, chamfered boards forming the back and sides, exposed tenons, and a generally uncompromising massiveness to its overall form. It appears in both the 1901 and 1904 catalogs, though the design is probably earlier. No catalog after 1904 shows it, so there is no question that it was made in 1904 or earlier. It has the branded joiner's compass mark on the side of the top right-hand drawer. There is no paper label.

A final problem lies in the second form of the decal, in which the Stickley name is enclosed within a rectangle. This decal, as we have shown, was used in 1902 and 1903. It does not appear on pieces made in 1904 or after. However, in Stickley's catalogs for 1905 and 1906 he shows this form of the mark, although there is no evidence that he was still using it on his furniture. Further, ads in THE CRAFTSMAN for his spindle furniture, which first appeared in 1905, also show this form

of the mark. Yet the spindle furniture is marked with the fourth version of the joiner's compass mark, without the rectangle and with Stickley's full name. The question arises: why did he continue to show the second form of his mark long after he had ceased to use it on his furniture?

Perhaps further study will answer these questions. Or it might raise new ones. It is important to remember that no marking system is 100 percent reliable. The decals and paper labels were applied by workmen who were certainly not giving any thought to those of us, working seventy years later, who are trying to pinpoint dates of manufacture. Nor is it realistic to expect that as soon as one form of the joiner's compass mark was discontinued, the next went into exclusive use; it is more likely that there was some overlap between the end of one and the start of another.

[1] "Descriptive Price List," 1907, p. 15.
[2] Stickley's large three-slat side chair, shown on page 122, is an exception. It always had round nailheads.
[3] "Craftsman Furnishings," 1906.
[4] Descriptive Price List, 1907, p. 16.
[5] "Catalog of Craftsman Furniture," 1909.
[6] The Eastwood chair is an exception. As late as 1912 it was still made with a loose cushion supported by caning.
[7] FURNITURE WORLD, June 30, 1904.
[8] AMERICAN CABINEt MAKER AND UPHOLSTERER, May 3, 1902.
[9] Ibid., Oct. 20, 1900.

4 The L. & J.G. Stickley Furniture Company

Regrettably little information is available concerning the L. & J.G. Stickley Furniture Company of Fayetteville, New York. Neither Leopold nor J. George Stickley ever became prominent national figures like their older brother Gustav, nor did they produce the great outpouring of books, magazines, catalogs, and pamphlets that emanated from him. Consequently we cannot turn to their writings, as we can with Gustav Stickley, to learn about the men, their philosophies, or their work in any great depth. However, there are two sources of information available to us. First, the brief introductions to the L. & J.G. Stickley catalogs supply us with some of the information and provide some insights into their work. Second, the furniture trade publications of the period occasionally reported on all of the Stickleys, and this sketchy information has made it possible for us to trace the course of the L. & J.G. Stickley Company.

Leopold Stickley (he was always referred to as Lee) was born in 1869 and died in 1957. Men who worked for him remember him to this day with fondness and respect. John George was born in 1871, the youngest of the five Stickley brothers. He died in 1921. Lee was the business manager who ran the factory and designed some of the furniture,[1] while J. George concentrated on sales. Apparently J. George had an unusual talent for sales because he was known as "the best fancy rocker salesman in America."[2]

According to Robert Judson Clark, Leopold and J. George worked for Gustav Stickley for several years and then broke away from him in 1900 to establish their competing business.[3] Actually, this is not the case. The L. & J.G. Stickley Furniture Company was not formed until early 1902, when their modest beginnings were reported by AMERICAN CABINET MAKER AND UPHOLSTERER:

> There is a new edition of the Stickley chair interest. Lee Stickley, late of the Gustav Stickley chair interest, and J. George Stickley, of the Grand Rapids branch of the family, have purchased a factory in Fayetteville, New York,

70

formerly occupied by the Fayetteville Furniture Company, and will attempt to add new lustre to the chair reputation of the Stickley family.[4]

This brief notice shows first of all that L. & J.G. Stickley went into business in 1902, not 1900, and it also shows that J. George did not work for Gustav Stickley. He was in Grand Rapids during the closing years of the nineteenth century, working with his brother Albert Stickley of the Stickley Brothers Company.

The two brothers named their business the Onondaga Shops, a reference to Onondaga County, where their factory was located.

Although L. & J.G. Stickley set up their business in 1902, they seem to have maintained a fairly modest operation for the first two years, since none of their activities was reported by the trade press. The incorporation of their business was announced in 1904.[5]

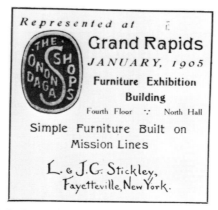

Represented at
Grand Rapids
JANUARY, 1905
Furniture Exhibition
Building
Fourth Floor ∵ North Hall
Simple Furniture Built on
Mission Lines
L. & J. G. Stickley,
Fayetteville, New York.

L. & J.G. Stickley's earliest-known advertisement.

Later that year, L. & J.G. Stickley placed what is apparently its first trade ad in FURNITURE WORLD. The tiny ad reproduced the oval Onondaga Shops paper label, and announced the firm's "simple furniture built on mission lines" which was to be exhibited at Grand Rapids in January 1905. This trade show marked L. & J.G. Stickley's first introduction to the trade. It came exactly five years after Gustav Stickley had launched his Craftsman line at the same show. A short article praising L. & J.G. Stickley appeared in the following issue of FURNITURE WORLD:

> I visited the Onondaga Shops a short while after L. & J.G. Stickley (Inc.) got under way. I told the trade at the time what the Stickley boys had in the way of a factory and what they were doing. . . . I can say of Lee and J.

George that they have made an unqualified success of their business. The only trouble they are experiencing is an inability to fill orders. The capacity of the factory is tested, but to relieve the pressure they are enlarging the dry kiln and putting in an up-to-date heating plant. New machinery has been installed. A two story addition to the finishing shop has just been completed and occupied. This is but the beginning of the enlargement of the factory. Before long the main building will be run up a story.

I said to Lee Stickley: "What do you call your furniture, Arts and Crafts?" "No, it isn't Arts and Crafts nor mission, just simple furniture on mission lines." This furniture is made in carefully selected oak, with a dull wax finish. Quite an extensive assortment for the bedroom, dining room and library when you contemplate it. The catalogue shows settees, chairs, tables, chiffoniers, bookcases, beds, bureaus, dressers, sideboards, rockers, etc. . . . L. & J.G. Stickley dye and finish their own leather, and such hammered copper trimmings as is used in ornamenting caseworks are manufactured in the factory.[6]

Represented at

GRAND RAPIDS

JANUARY, 1905

Furniture Exhibition Building

Fourth Floor North Hall

Arts and crafts and Simple Furniture Built on Mission Lines.

L. & J. G. STICKLEY,

FAYETTEVILLE, NEW YORK.

A second L. & J.G. Stickley ad, where the term "Arts and Crafts" is used for the first time.

L. & J.G. Stickley ran a second trade ad to announce its participation in the Grand Rapids trade show. Although the ad refers to their work as "simple furniture built on the mission lines" it also refers to it as "Arts and Crafts." Apparently they were undecided on the right term at that time, and covered themselves by using both.

After L. & J.G. Stickley's debut at the January 1905 furniture trade show at Grand Rapids, FURNITURE WORLD reported that their work had been successfully received by the dealers.[7] Reflecting the quickly broadening scope of their output, L. & J.G. Stickley's trade ads for the balance

of 1905 referred to them as "cabinet makers, upholsterers, and leather workers."

Their activities continued to expand throughout 1905. They purchased a cottage near the factory, and set it up as a crafts house and studio, with furnishings from the factory. In this cottage, they began to manufacture draperies and portieres, ornamentation, appliqué work, stenciling, and hand embroidering.[8]

As might be expected, there are many parallels between L. & J.G. Stickley furniture and Gustav Stickley furniture. First, many L. & J.G. Stickley designs are obviously inspired by Craftsman designs. Second, they shared nearly identical philosophies of design and construction, so that even original L. & J.G. Stickley designs often remind us of Craftsman work. Third, L. & J.G. Stickley furniture evolved over the years in a manner that in many ways parallels the stylistic development of Gustav Stickley's work.

Anyone who has even superficially examined examples of L. & J.G. Stickley furniture can see how their designs are derived from Gustav's work. For example, the two CIRCA 1904/05 L. & J.G. Stickley chairs (see following page) are rather crude but vigorous variations on the early work of Gustav Stickley. The stretcher arrangement on both chairs is borrowed from Gustav Stickley, and the jaunty crest rail is reminiscent of the Experimental Period side chair on page 35. The early L. & J.G. Stickley serving table, shown on the following page, is not shown in the 1905 Onondaga Shops catalog and probably predates it. The paneled sides and faceted rectangular wooden pulls relate to work typical of Gustav Stickley's First Mission Period and probably derive from it. The beveled underside of the overhanging top is a typical stylistic trait of English Arts and Crafts movement furniture and was used frequently by both Gustav Stickley and L. & J.G. Stickley. The manner in which the sides step forward at the level of the lower shelf expressed the shelf and creates a kind of "leg." But while the design concept may be sound the execution of this detail is somewhat awkward, and the arched apron and rounded ends of the back rail are visually at odds with the basic rectilinear massiveness of the overall design. However, the philosophical parallels and stylistic evolution may be less apparent. These last two points are made clear when four catalogs issued by the L. & J.G. Stickley Furniture Company over a period of seventeen years are examined.

L. & J.G. Stickley issued their first catalog of early mission designs in March 1905. This undated catalog, the only known example of which is in the possession of Alfred Audi, current president of the company, is entitled "Some Sketches of Furniture at the Onondaga Shops."

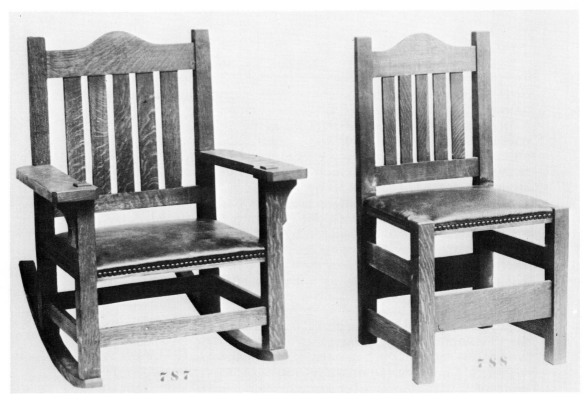

787 788

Early L. & J.G. Stickley furniture designs.

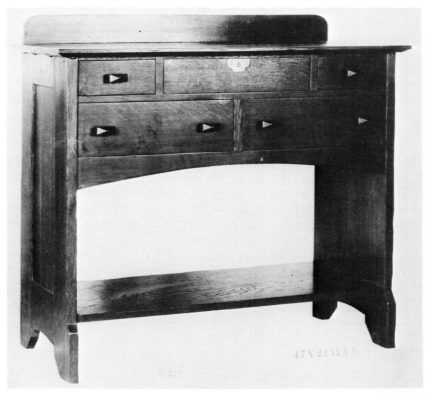

The furniture in this catalog, for the most part, is largely derivative of the work Gustav Stickley was producing during his First Mission Period. The backs of bookcases, china closets, and magazine stands are made of vertical chamfered boards, butt-jointed in characteristic Craftsman fashion. The inverted flattened V, a design motif which is found on the aprons and rails of many early Craftsman pieces, appears in L. & J.G. Stickley's work on the top rails of chairs and desks. L. & J.G. Stickley's version of the "basic" bookcase appears here, similar to Gustav Stickley's in terms of its vertical proportions and in the use of the slab side topped with a curve, although the curve is much more fluid than Gustav's. We also see that the massive hammered copper hardware, held in place by faceted-head lag screws, is similar to the hardware Gustav Stickley produced during his First Mission Period, but with a warmer patina. L. & J.G. Stickley's furniture also used wooden knobs at this time, similar to Gustav's but rectangular rather than square. There are also some designs in the Onondaga Shops catalog which parallel designs from Gustav Stickley's Mature Period, showing that, like him, L. & J.G. Stickley developed designs which continued nearly unchanged through its years of Arts and Crafts furniture production.

For the most part, the furniture in this catalog is of very high quality, comparable in many instances to Gustav's work. It is also quite scarce.

L. & J.G. Stickley hardware in its earliest form.

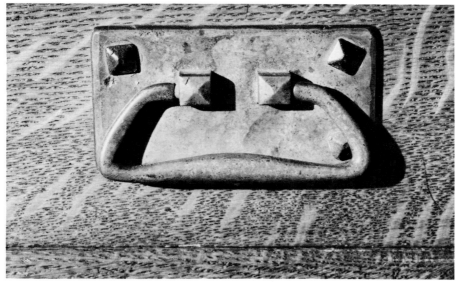

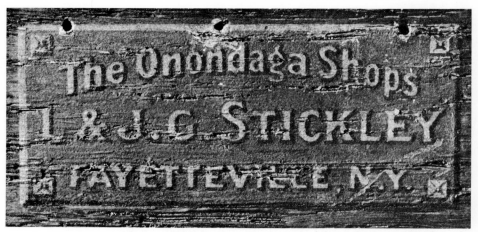

The decal L. & J.G. Stickley used to mark furniture, CA. 1905.

L. & J.G. Stickley furniture of this period is marked with either a rectangular decal (above) or the brown oval paper label shown in their trade ads, and bears the name of the Onondaga Shops and a large capital S for Stickley.

The introduction to the Onondaga Shops catalog is brief and expresses none of the philosophical zeal so typical of Gustav Stickley's catalog introductions. However, it shows that L. & J.G. Stickley shared his belief in the importance of honestly expressed structure and simplicity.

> The workers devote their abilities to the making of furniture which is good, serious, and above all, interesting. They hope to win favor by virtue of practical common sense; the obvious study of proportion and scale; the proper value of plain surfaces contrasted with surfaces slightly carved. . . . some of this Furniture has quaint cuttings in places; some has metal work to accent certain points; some has an outline simple and so devoid of ornament as to be almost severe in its plainness; but all is frankly constructive.

Apparently the next catalog issued by L. & J.G. Stickley was "Handcraft Furniture," which was issued in 1910. It is a huge catalog with 145 oversized pages illustrating hundreds of pieces of furniture. For the most part, the designs in this catalog relate to Gustav Stickley's Mature Period, although L. & J.G. Stickley was still constructing the backs of case pieces with chamfered boards, a costly practice which Gustav Stickley had ceased six years earlier. L. & J.G. Stickley's "standard" hard-

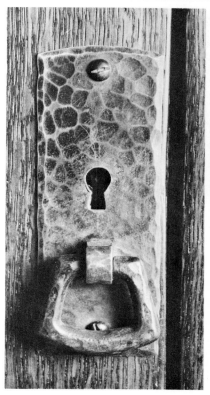

Hand-hammered copper hardware which
came into use in the years preceding
1910 and became standard
L. & J.G. Stickley hardware
from then on.

ware appears in this catalog: it is hammered copper plates, pulls, and
strap hinges, patinated a rich brown but of a much lighter gauge than
their earlier hardware. The wooden knobs of this period are round rather
than rectangular. In general, the pieces shown in this catalog exhibit
less structural decoration than those produced earlier, and follow the
standardization, sobriety, and purity of form found in Gustav Stickley's
work during these years.

By the time the 1910 catalog was published, L. & J.G. Stickley had
adopted a new shopmark. The Onondaga Shops paper label had been
retired and replaced by a red decal of a handscrew bearing the legend
"L. & J.G. Stickley Handcraft." The new shopmark is discussed in the
introduction to the catalog: "Our Shopmark, the device of the Hand-
screw, will be found on every piece of Handcraft Furniture, and is a
pledge of its excellence, as well as a safeguard against imitators."

L. & J.G. Stickley's Handcraft decal, adopted between 1906 and 1910, and dropped in 1912.

The last sentence is especially revealing. It shows that L. & J.G. Stickley too was troubled by low-priced imitators, but also that the firm might have been trying to create some confusion as to which Stickley was the original. The use of the family name obviously infuriated Gustav.

The catalog refers to the "simple friendliness" of L. & J.G. Stickley furniture, a thought directly borrowed from Gustav. Also, like Gustav, the catalog talks about their favorite wood, quartersawn American white oak, "chosen because of its strength and its close grained surface." Here, too, is the concern for durability, comfort, and sound construction. In the construction of its furniture, L. & J.G. Stickley strove for honesty and durability. Its designs showed a careful study of line and proportion, and a constant concern with comfort. Straight lines were sometimes relieved by graceful curves, but the only ornament lay in the expression of structural features that were both useful and decorative, such as pins and tenons.

Finally, the introduction credits L. & J.G. Stickley with being the first to use the spring seat, an advance in comfort borrowed from the automobile. Here is one area where, apparently, the firm preceded Gustav Stickley.

Business was clearly booming for L. & J.G. Stickley at the time the 1910 catalog was issued. It was a record business year for the company and it continued to expand, erecting a four-story building in Grand Rapids to be used as a showroom.[9] An ad placed in 1910 in the AMERICAN CABINET MAKER AND UPHOLSTERER illustrates this new showroom.

In 1912, L. & J.G. Stickley issued a supplement to the 1910 catalog entitled "The Work of L. & J.G. Stickley." The importance of this supple-

A 1910 L. & J.G. Stickley trade ad announcing the new Grand Rapids showroom.

ment is not so much the furniture it pictures as in these key words: "The word Handcraft will no longer be used, and that our furniture may be distinctive, each piece will bear the Shopmark THE WORK OF L. & J.G. STICKLEY."

This is important for two reasons. First, the red Handcraft decal was very similar to Gustav Stickley's red Craftsman decal, and of course Handcraft could be confused with Craftsman. It is likely that L. & J.G. Stickley stopped using this mark because of pressure (perhaps legal) from Gustav Stickley. More important, from the collector's point of view, it establishes a means to approximate the date of manufacture of L. & J.G. Stickley furniture: a piece with a Handcraft decal is made before 1912, while a piece marked with a red-and-yellow rectangular decal reading "THE WORK OF L. & J.G. STICKLEY" is 1912 or after. The same mark branded into the wood seems to be of the same time period.

The L. & J.G. Stickley decal which came into use in 1912, replacing the earlier Handcraft decal.

The next L. & J.G. Stickley catalog, also undated, is called "The Work of L. & J.G. Stickley," and therefore can be dated after 1912. Since the firm did not produce catalogs every year, we believe this one was issued CIRCA 1914. The furniture designs here are the same, basically, as those seen in the 1910 catalog and its 1912 supplement. Again, however, our interest is drawn to the introduction. Here we find a few words dealing with L. & J.G. Stickley's thoughts on the decorative value of their own brand of "structural style": "Graceful curves and variations of surface, perhaps bits of inlay in the same wood." This part about inlay is especially provocative: we have seen it used by Gustav Stickley, by Stickley Brothers Quaint Furniture, and by Limbert, but we have never seen inlaid L. & J.G. Stickley furniture, nor is it illustrated in any of the catalogs we have studied. If it was made at all, it was probably done to special order only.

The introduction to the CIRCA 1914 catalog also shows that L. & J.G. Stickley believed in the timelessness of its designs, that the company embraced the machine as a necessary tool of the crafts worker, and that it believed furniture should be adapted to current needs and not based on the meaningless imitation of period designs. Finally, in a paragraph revealing the professional enmity between the Stickleys, we find this apparent slap at Gustav: "The Work of L. & J.G. Stickley is a product that claims and fills the entire time of its producers, who indulge in no other occupations. . . . Furniture building, it is believed, is in itself an important work demanding the entire time of the modern craftsmen who attempt it." Gustav Stickley was a furniture designer and manufacturer who branched out into writing, magazine and book publishing, architecture and home building, retailing, landscape gardening, and so forth. L. & J.G. Stickley stuck with furniture manufacturing, and while they were apparently somewhat jealous of Gustav's success (note especially the phrase "INDULGE in no other occupations"), their more conservative business posture was more successful in the long run.

The mark "THE WORK OF L. & J.G. STICKLEY" was still in use in 1917,[10] but events of a few months later caused it to be phased out. Later that same year, after his own business had gone under, Gustav Stickley joined with Leopold, J. George, and Albert Stickley to form Stickley Associated Cabinetmakers. The first ad for this new combination appeared in FURNITURE WORLD in 1918, showing Gustav Stickley's Chromewald designs as well as a new line, "Berkshire," based on Shaker furniture design.[11]

An ad from the November 28, 1918 issue of the same magazine shows that while Arts and Crafts furniture was still in production, the

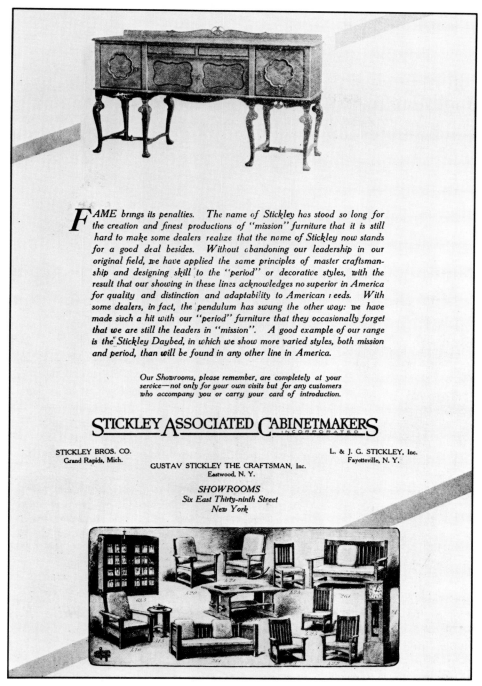

*F*AME *brings its penalties. The name of Stickley has stood so long for the creation and finest productions of "mission" furniture that it is still hard to make some dealers realize that the name of Stickley now stands for a good deal besides. Without abandoning our leadership in our original field, we have applied the same principles of master craftsmanship and designing skill to the "period" or decorative styles, with the result that our showing in these lines acknowledges no superior in America for quality and distinction and adaptability to American needs. With some dealers, in fact, the pendulum has swung the other way: we have made such a hit with our "period" furniture that they occasionally forget that we are still the leaders in "mission". A good example of our range is the Stickley Daybed, in which we show more varied styles, both mission and period, than will be found in any other line in America.*

Our Showrooms, please remember, are completely at your service—not only for your own visits but for any customers who accompany you or carry your card of introduction.

STICKLEY ASSOCIATED CABINETMAKERS
INCORPORATED

STICKLEY BROS. CO.
Grand Rapids, Mich.

GUSTAV STICKLEY THE CRAFTSMAN, Inc.
Eastwood, N. Y.

L. & J. G. STICKLEY, Inc.
Fayetteville, N. Y.

SHOWROOMS
Six East Thirty-ninth Street
New York

The Stickley Associated Cabinetmakers ad from the November 28, 1918 issue of the trade magazine, FURNITURE WORLD.

brothers were reorienting their output to include "period" designs.[12] The address of their New York showroom was 6 East 39th Street; the firm now rented the third floor of what had previously been the Craftsman Building.

The conjoined Handcraft and Craftsman decal adopted by L. & J.G. Stickley in 1918.

L. & J.G. Stickley had adopted a new mark by early 1918. This was a circular red-and-yellow decal, showing the word "Handcraft" and the handscrew and the word "Craftsman" and the joiner's compass. The story behind the use of this conjoined Gustav Stickley and L. & J.G. Stickley mark may be found in this brief notice from FURNITURE WORLD:

> The business of Gustav Stickley, The Craftsman, at Eastwood Heights, has recently been reorganized and the name of the corporation will be The Stickley Company, Inc. L. & J.G. Stickley, of Fayetteville, purchased a large block of the stock, giving them virtual control. At the election last month, Lee Stickley was chosen President, Gustav Stickley Vice-President, J. George Stickley Treasurer. . . . the factory is being overhauled, electric power installed. The new company will make bedroom furniture its principal production. "We have lots of work," said Lee Stickley. . . . For the trade, the Stickleys are still building mission furniture, bedroom furniture, Shaker rockers.[13]

By the end of that year, Gustav Stickley's name had been dropped from these ads and was replaced by the more impersonal "Stickley Manufacturing Company." His daughter, Barbara Wiles, told us that Gustav, a strong-willed, domineering man, only worked for about six months before he and Leopold came to a parting of the ways, and this is probably why his name was dropped from the ads.

The firm's final Arts and Crafts furniture catalog was published in 1922 and entitled "L. & J.G. Stickley Inc. Furniture in Craftsman and Handcraft designs." The introduction continued the earlier practice of praising the furniture as being free from ornamentation. It still emphasized the furniture's timeless qualities, stressing that it was a permanent investment and a continual source of enjoyment which could be passed down from generation to generation.

While most of the designs in this catalog have been carried over unchanged from the previous catalogs, and the standard hammered copper hardware is still in use, the furniture as a whole lacks vitality. Much of it has acquired the dull institutional look so common in cheaply produced mission oak furniture. The most apparent structural change from the earlier production is that the chamfered board back is gone and has been replaced by laminated panels.

This is the catalog in which L. & J.G. Stickley announced its "line of period designs in popular finishes." The previous catalog, CIRCA 1914, had stated that Arts and Crafts furniture, and not period reproductions, was the only appropriate furniture for modern homes. However, by 1922, Arts and Crafts design was clearly out of favor with the American consumer. The rage for Colonial was beginning to dominate furniture production, and L. & J.G. Stickley responded to this shift. The firm did so by inaugurating its Cherry Valley reproductions of American Colonial designs. This furniture was of very high quality, and has even begun to attract a limited number of collectors over the past few years, though it has none of the design significance of the Arts and Crafts production.

After Leopold died in 1957, his widow ran the business for several years and then sold it to Alfred Audi, who, along with his wife, has been revitalizing it for the past few years. The current factory output continues to be the kind of Colonial reproductions produced since the early 1920s.

Both the words "Craftsman" and "Handcraft," along with the joiner's compass and handscrew, were used in the 1922 catalog, though there is no evidence of the conjoined mark of 1918. L. & J.G. Stickley ceased production of Arts and Crafts furniture in 1923. Though there are no factory records to document this date, it has been corroborated by Mrs. Leopold Stickley, in an interview with the author. This date was also cited by Mr. Ken Cooper, a retired employee who joined L. & J.G. Stickley in 1918, and by Mr. Tony DeMichele, who worked for the firm starting in 1923.

In 1926, L. & J.G. Stickley published a catalog of Colonial daybeds and davenports. There was no Arts and Crafts furniture in the catalog,

but the firm was still using the joiner's compass with the name Stickley in a circle. To this day, the joiner's compass, the mark of Gustav Stickley, may be seen on the showroom wall at the L. & J.G. Stickley factory in Fayetteville, New York.

[1] Louise Stickley, Leopold's second wife, said in an interview with the author that he "roughed out" the basic designs of much of the Arts and Crafts furniture. The actual designs were then refined and worked out in detail by the firm's designer, Donald Hansen.

[2] FURNITURE JOURNAL, July 11, 1904.

[3] Clark, ARTS AND CRAFTS MOVEMENT IN AMERICA 1876–1916. Perhaps Leopold Stickley himself helped cause this confusion: he celebrated the company's fiftieth anniversary in 1950, though he was obviously two years premature.

[4] AMERICAN CABINET MAKER AND UPHOLSTERER, February 1, 1902.

[5] FURNITURE JOURNAL, Feb. 10, 1904.

[6] FURNITURE WORLD, Nov. 17, 1904. There are few articles about either L. & J.G. Stickley or Gustav Stickley in the early furniture trade magazines. The editorial content of these publications clearly favored the products of regular advertisers, and neither L. & J.G. Stickley nor Gustav Stickley were heavy advertisers to the trade. At this time, the L. & J.G. Stickley company was a fledgling operation and probably couldn't afford regular advertising expenditures. Gustav Stickley, on the other hand, had little need for trade advertising, since he was concentrating on selling direct to the consumer and hence did not have to advertise to retailers to get them to carry his products.

[7] FURNITURE WORLD, February 2, 1905.

[8] FURNITURE WORLD, May 11, 1905.

[9] Reported in AMERICAN CABINET MAKER AND UPHOLSTERER, June 4, 1910.

[10] GOOD FURNITURE, June 17, 1917.

[11] FURNITURE WORLD, March 7, 1918.

[12] The ad itself reveals the decreasing importance of Arts and Crafts furniture, since it used an illustration that was at least six years old at the time rather than a new one. The age of this drawing is apparent because of the handscrew mark which had been phased out in 1912, and because of the tall case clock which was not made after 1912.

[13] FURNITURE WORLD, May 16, 1918.

5 The Roycroft Shops

Elbert Hubbard, the founder and guiding light of the Roycroft Shops from its birth in 1895 to his death aboard the LUSITANIA in 1915, was not a furniture man like the Stickleys. He was a consummate businessman and promoter, who first achieved wealth and success as a junior partner in J.D. Larkin and Co., his brother-in-law's soap business in Buffalo, New York. He left the business in 1892 at the age of thirty-six, spent a brief, frustrating period as a student at Harvard, traveled abroad, and tried his hand at writing. He originally established the Roycroft Shops as a small printshop to publish his own work, and with the hopes of establishing an American equivalent to William Morris's Kelmscott Press, which he had visited in 1894. His primary concern in the early years of the Roycroft Shops was to revive the printing arts in America as Morris had done in England—to produce handmade books in which paper, ink, typography, and page layout all worked together to create a unified work of art. The name Roycroft was chosen to honor the seventeenth-century printers Samuel and Thomas Roycroft. His Roycroft insignia, the orb and cross, was taken from the monk Cassidorius, a thirteenth-century bookbinder and illuminator.

By the turn of the century he had become a nationally known figure, publishing his monthly magazine, THE PHILISTINE, and his LITTLE JOURNEYS, a series of biographical sketches of famous people written in pamphlet form. He was a tireless speaker on lecture circuits across the country (even touring one season with a vaudeville company), constantly doing and saying things that made "good copy" and were reported by the press. It was Hubbard's forceful and flamboyant personality that dominated the Roycroft Shops, and the adoring biographies and magazine articles written about him and the shops perpetuated this bigger-than-life personality. All this, however, has effectively obscured the day-to-day workings of the Roycroft Shops, and makes it difficult to study the furniture operation as well as to trace the time of manufacture of Roycroft pieces.

Elbert Hubbard. COURTESY OF JORDAN-VOLPE GALLERY

Furniture making was a secondary interest of the Roycroft Shops. Printing was always the primary concern, and all other crafts activities grew out of it. Hubbard initially did not bind the books he printed; he sent the work out to a Buffalo bookbinding company. But he was dissatisfied with the quality of the work and set up his own bindery. The bindery paved the way for a leather-working shop, and as he expanded he needed more buildings to house his growing enterprise and furniture to be used in the buildings. Consequently, although the Roycroft Shops were supposed to run along the lines of a craft guild, all the other crafts the Roycrofters pursued, like metalworking, leather tooling, rug weaving, and furniture making, were subordinated to printing. Although Roycroft furniture sprang from William Morris-inspired Arts and Crafts roots, it did not undergo any clearly discernible pattern of stylistic development during the years it was made. Since the furniture was only a secondary concern the Roycroft Shops never used a succession of labels and identifying marks as the Stickleys did which would now enable us to pinpoint the year a specific piece was made. Nor, apparently, did the Roycroft Shops produce nearly as much furniture as the Stickleys did.

Nevertheless, Roycroft furniture demands our attention because it made an important contribution to the growth of American Arts and Crafts design in this country. Nearly all Roycroft furniture is superbly made. And, although the Roycrofters created their share of inept designs, much of their work shows the beautiful plainness so characteristic of the best American Arts and Crafts furniture. For the most part, Roycroft furniture exhibits the same straightforward rectilinearity and expressed structure which typifies Arts and Crafts furniture. Perhaps its most common visual trait is the straight, tapered leg terminating in a bulbous foot, a Mackmurdo-derived feature never seen on Stickley furniture. Some of the best Roycroft furniture is totally devoid of visual refinement, like the chair on page 120, but it succeeds because of its exciting proportions. Finally, the Roycrofters were among the first to manufacture Arts and Crafts furniture in America, and as a result were a strong influence on this type of design. Although Hubbard never seems to have claimed to be the first "mission" furniture maker, he certainly was one of the earliest. The first Roycroft pieces were made in 1896, two years before Gustav Stickley produced his first experimental designs.[1] By 1897, he was not only making Roycroft furniture, he was selling it to visitors. Writing of the expansion of his print shop, Hubbard reveals the almost willy-nilly way in which the Roycroft Shops began making furniture: "The place got too small when we began to bind

books so we built the wing on one side; then a wing on the other. To keep three carpenters busy who had built the wings, I set them to work making furniture for the place. They made it as good as they could—folks came along and bought it."[2]

The first wing Hubbard refers to was erected in 1896, the second in 1897, thus definitely fixing the dates of the beginnings of Roycroft cabinetmaking. By 1899, Hubbard was advertising the furniture in his magazines. A write-up in the NEW YORK SUN that same year described the beginnings of Roycroft furniture in a prose style suspiciously like Hubbard's:

> The East Aurora carpenter and cabinet maker spent his life, until lately, tinkering. The Roycrofters went to him and ordered a table made after the William Morris fashion, circular and some eight feet in diameter, with six or eight great plain legs, and all polished oak. The carpenter doubted, but took the order and filled it. When he heard that a visitor to the shop paid $75 for the table after it was made, he grumbled no more. Now, when he can be spared from the buildings, he makes tables, chairs, and a plain oak pedestal for statuary. These things are all taken away by visitors who did not come with any idea of buying them.[3]

Shortly thereafter, FURNITURE JOURNAL carried a short notice about Roycroft furniture. (This paragraph is the only mention of Roycroft furniture we found in furniture trade publications published between 1895 and the early 1920s. That the furniture trade journals paid so little attention to Roycroft is not surprising, since their editorial content always favored the big advertisers, and Hubbard was never a big furniture manufacturer. His operation always remained relatively small and, like Gustav Stickley in the early years, he achieved most of his sales through his catalog, ads in the magazines, and direct sales to visitors to the Roycroft Shops. Thus most furniture was advertised in an almost roundabout fashion as Hubbard printed news of the Roycroft shops.)

> . . . the cabinet maker has his hands full. . . . the Roycroft Shops, as they are called, not only print beautiful books but produce artistic furniture, delightful things in iron, and a pottery of no mean quality. About 100 workers are employed. . . . Mr. Hubbard writes us that he cannot begin to meet the demands for his quaint furniture, and has not yet been able to sell anything to the trade, so many private parties having a prior claim to his production, but he hopes before long to make a few pieces that he can place with leading decorators around the country, even if he can only give out one or two pieces at a time. . . .[4]

Roycroft furniture was primarily the work of individual cabinetmakers working in a Hubbard-approved Arts and Crafts mode. They were not

"Uncle Albert" Danner, a Roycroft cabinet maker, with a chair he has apparently just finished.

Herbert Buffum, superintendent of the Roycroft furniture shop. Elbert Hubbard, who favored full, flowing ties as a badge of individuality, must have required his key employees to dress in a similar fashion, at least for promotion photographs.

designers, but cabinetmakers who naturally made modifications to basic designs over the years. One of the first Roycroft cabinetmakers, who also designed furniture, was Santiago Cadzow, who taught woodworking to other Roycrofters. In the early 1900s, other cabinetmakers came to the Roycroft Shops, including a German artisan named Albert Danner.

Hubbard's promotional literature made frequent reference to him, referring to him as "Uncle Albert" or "Uncle Albert Roycroft." Herbert Buffum also joined the Roycroft Shops around the same time, and eventually became superintendent of the furniture shop.

No one is quite sure who created the major designs of the Roycroft Shops. It is known, however, that Victor Toothaker, an illustrator who did renderings of room settings for Hubbard, created some of the Roycroft designs. While Charles Hamilton has referred to him as the "key designer," the enormous variety in designs found in Roycroft furniture indicates that no one designer ever dominated its appearance. Some periodicals of the time credited Hubbard with the design of Roycroft furniture, and while he probably did take a stab at it, it seems inconceivable that he could have done much designing, since he had neither the time nor the talent for this line of work.

The Roycroft furniture shop remained small throughout the first decade of this century, with ten full-time employees on the payroll from 1903 through 1909. Many part-timers were also involved in furniture making during these years, but how many is not known. That manufacture responded to demand is indicated by the increase in the number of pieces produced, despite the relatively constant size of the work force: the 1906 catalog carried a line at least double that shown in the 1904 catalog.

Philosophically, Roycroft furniture was as much an expression of Arts and Crafts precepts as their leather-bound books and hand-hammered copper items. Concern was with fine handwork, simplicity, and producing works that would endure. The introduction to the 1904 Roycroft furniture catalog assured customers that the furniture was made entirely by hand, and that the workers' aim in making the furniture was to embody three elements in each piece: simplicity of design, the highest quality of workmanship, and durability.

The introduction to the 1906 catalog reiterated these Arts and Crafts principles and attempted to establish a clear distinction between Roycroft furniture and "mission": "We would ask you not to classify our products as 'mission,' or so-called 'mission furniture.' Ours is purely Roycroft." At some point, however, they did adopt the term "mission," and the 1912 Roycroft catalog stated that Roycroft furniture resembled that made by the old mission monks. In accordance with Arts and Crafts principles, Roycroft furniture, according to the catalog introduction, eliminated all unnecessary elaboration, but kept in view the principles of artistic quality, sound mechanical construction, and good workmanship.

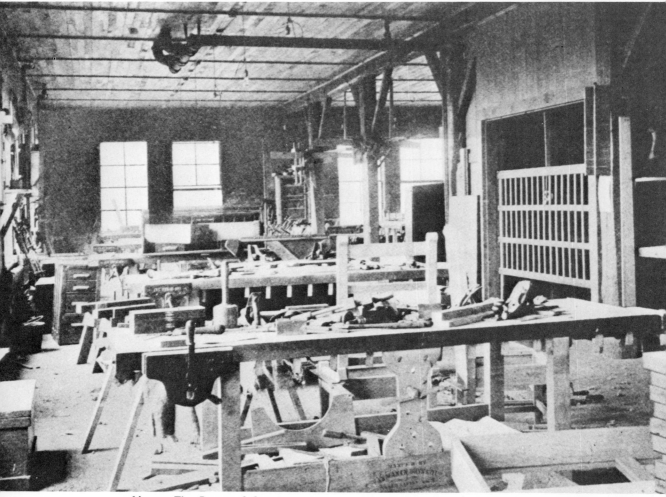

Above: The Roycroft furniture shop in 1906. Although the shop used big power saws to cut the large rails, each piece of furniture was individually made and required an enormous amount of handwork.

Right: Examples of Roycroft hand-wrought furniture hardware, displayed in the furniture shop in 1906.

The two pages from the 1906 Roycroft furniture catalog, shown on the following page, clearly reveal the simplicity and solidity of its design. They also reveal its unevenness of Roycroft design. The fall-front desk and its chair are beautifully realized examples of Arts and Crafts furniture. The corner chair and the high-back armchair are ill-proportioned

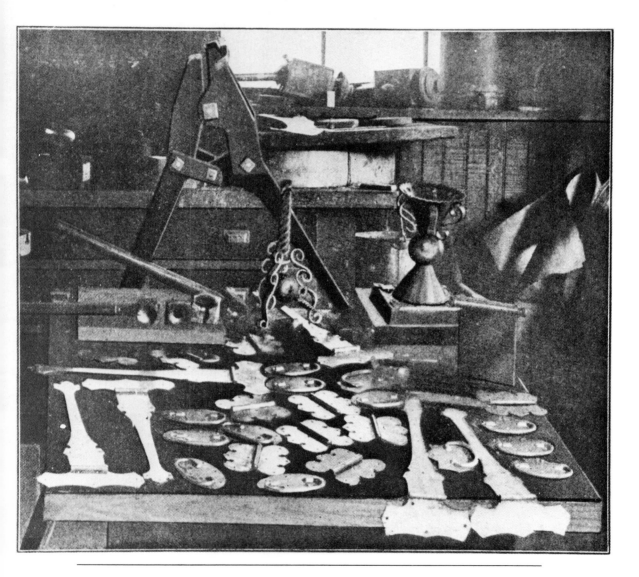

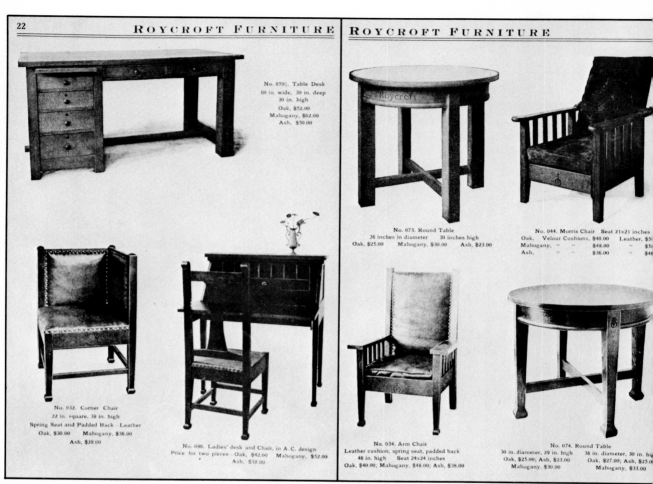

No. 059J. Table Desk
60 in. wide, 30 in. deep
30 in. high
Oak, $52.00
Mahogany, $62.00
Ash, $50.00

No. 073. Round Table
36 inches in diameter 30 inches high
Oak, $25.00 Mahogany, $30.00 Ash, $23.00

No. 044. Morris Chair Seat 21x21 inches
Oak, Velour Cushions, $40.00 Leather, $5
Mahogany, " " $48.00 " $5
Ash, " " $36.00 " $4

No. 032. Corner Chair
22 in. square, 38 in. high
Spring Seat and Padded Back—Leather
Oak, $30.00 Mahogany, $36.00
Ash, $28.00

No. 090. Ladies' desk and Chair, in A. C. design
Price for two pieces—Oak, $42.00 Mahogany, $52.00
Ash, $38.00

No. 034. Arm Chair
Leather cushion, spring seat, padded back
46 in. high Seat 24x24 inches
Oak, $40.00; Mahogany, $48.00; Ash, $38.00

No. 074. Round Table
30 in. diameter, 29 in. high
Oak, $25.00; Ash, $23.00
Mahogany, $30.00

36 in. diameter, 30 in. hig
Oak, $27.00; Ash, $25.00
Mahogany, $33.00

COURTESY OF CHESTER DUBOVSKY

oddities. The Morris chair, with its oddly shaped arms, is not the equal of its Craftsman counterpart. The round table shows the characteristic bulbous Roycroft foot derived from Mackmurdo.

Like Stickley, Hubbard felt that his furniture was based on enduring principles that would protect it from going out of style, and that its sound construction would enable it to stand up to years of use. However, unlike Stickley, he expressed this thought in pecuniary terms, as in an extraordinary Roycroft furniture ad for his "Aurora Colonial Designs," in, of all places, THE CRAFTSMAN in 1905.

The ad reproduced a newspaper article headed "Colonial Furniture in Demand," which detailed the high prices then being paid for American antiques. Hubbard's ad then continued: "All the furniture here men-

tioned was made a hundred years ago by men who had the time, talent and inclination to make it well. We think that we are making by far the best furniture in America today. We make furniture that is an endowment investment for you—you use it and can pass it on to your heirs. It does not wear out, and like true friendship, grows better with the passing years."[5]

The Roycrofters boast that their furniture exemplified good craftmanship was at least a sound one. Most Roycroft pieces are carefully joined with mortise and tenon, usually locked in place with dowels. It is generally made of first-quality quartersawn oak which was bought in the Carolinas; the Roycrofters were not, however, as singleminded about this wood as the Stickleys tended to be. They also worked in ash, walnut, Honduras mahogany, and bird's-eye maple.

Roycroft ads referred to their furniture's oak finish as a "weathered" finish, a combination of stain, filler, and wax polish. The actual formula of the finish was kept a secret and apparently remains so to this day. However, Mr. Gerald Youngers, who joined the furniture shop as an apprentice in 1913 and still lives in East Aurora, shed some light on the nature of this formula in an interview with the author in 1979. Mr. Youngers said that the essence of the secret formula was a barrel of soupy water left standing, apparently for years on end, full of rusting nails and other pieces of scrap metal, and wood stain. This bizarre mixture was applied to the furniture by brush and left to stand. After it had completely dried and achieved a uniform overall color, the furniture was sanded to smooth the grain which had been raised by the watery stain. Wood filler was applied next, to fill in the open-pored oak, and then the furniture was waxed. The Roycroft finish gave a beautiful color to the wood, but it was not as durable as Stickley's shellac finish, and many Roycroft pieces found today need to be carefully brought back by refinishing.

Roycroft furniture was always proudly marked in a prominent place. It was not signed, as Stickley furniture was, "in an unobtrusive place," but right on the front for all to see. Certainly Hubbard, the perpetual publicist, must have insisted on this. He first adopted the orb and cross as the Roycroft symbol to identify the books he printed, but it was later used on all his products, including tooled leather, hand-wrought copper pieces, and the furniture. Some of the furniture is marked with the orb and cross, and some with the word "Roycroft" incised in Gothic script, and there is no apparent reason why one mark is sometimes favored over the other. Gerald Youngers states that the orb and cross was used on small pieces and the spelled-out name on larger ones, but this is

Roycroft furniture was marked with either the orb and cross, or with the name "Roycroft" incised in Gothic script.

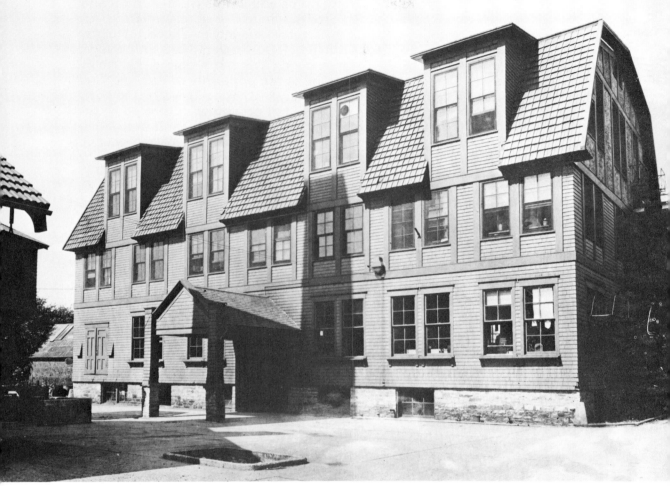

The building that housed the Roycroft furniture shop as it appeared CA. 1919.
COURTESY OF CHESTER DUBOVSKY

clearly not consistent with the Roycroft pieces we have examined. Nor are the marks any indication of the date of manufacture, since both were used simultaneously throughout the years of furniture production. Charles Hamilton feels there is no rationale behind the choice of the different marks, but it may be that the spelled-out "Roycroft" tended to be used on special pieces, while the orb and cross indicated more

routine work, although on some forms both marks were used together.

Peak employment in the Roycroft furniture shop came in the years from 1912 through 1919, with as many as eighty to a hundred full- and part-time employees. Approximately 500 workers were employed by the Roycroft Shops as a whole during this same period. By the late teens and early 1920s the decline in the popularity of Arts and Crafts that was affecting the furniture industry was taking its toll on the output of Roycroft furniture. The 1916 Roycroft catalog was devoted to all of the shops' products, including pecan patties and Roycroft ties, and just one small section illustrated the furniture. Furniture making was curtailed sharply in the early 1920s, though pieces were produced into the mid-1930s. Roycroft went bankrupt in 1938, a belated victim of the economic depression that had hit the country in 1929, and of the final eclipse of the American Arts and Crafts movement which had begun many years before.

[1] I am indebted to Charles F. Hamilton, the longtime Roycroft scholar and Hubbard biographer, for pointing out to me that by 1896 Hubbard was employing local cabinet-makers and carpenters to erect the Roycroft Shops and to make the furniture for them.
[2] LITTLE JOURNEYS TO THE HOMES OF THE GREAT, p. XXII, 1915.
[3] Quoted in: "Some Books for Sale at Our Shop" Roycroft book catalog, 1900, p. 25.
[4] FURNITURE JOURNAL, April 1900.
[5] THE CRAFTSMAN, April 1905.

"A Fine Plainness":
Examples of
Arts and Crafts Furniture

Bookcases and China Closets • Chairs and Settles • Chests of Drawers • Desks • Servers and Sideboards • Tables • Individual Pieces

In many ways, this is the most important section of the book. The preceding chapters have dealt with a history of the furniture and its stylistic development, with information on marks and dating. The photographs and explanations in this section will help you develop your eye for American Arts and Crafts furniture.

Because of its simplicity, this furniture must be very well designed and constructed to have any enduring value. It has no "art" to hide behind, no decorative tricks to conceal flaws. That is why, of course, ineptly made mission oak is such worthless furniture.

To comprehend American Arts and Crafts furniture you must first learn how to see it. You must develop enough of an eye to see the often subtle distinctions which separate a great piece from an ordinary one.

When you look at an example of this furniture you must ask yourself:

Is it well designed? Are the proportions right, or does the piece look clumsy?

Is it constructed of prime-quality oak? Is the oak quartersawn? Does the finish truly enhance the color and the feel of the wood?

Is the piece well made? Are the joints carefully fitted? Are the structural details well executed? Do they make the piece stronger as well as more pleasing to look at?

Are the less accessible parts, such as the back of the piece or the bottom of the drawers, well made, or are they flimsily constructed of inferior wood?

Is the hardware well designed and well executed? How well does it relate to the piece as a whole? Is it hand-wrought of heavy-gauge copper or iron, or is it simply stamped from sheet metal? Is it well patinated?

In addition to discussing the structural details of the furniture, this section will give dates when specific pieces were first made, show how they evolved over a period of years, and indicate when they were phased out. We will show how different examples relate to the stylistic periods discussed earlier, and use our knowledge of marks and construction details to assign dates to every piece shown.

We will also, where possible, comment on the rarity of the illustrated piece. When we say a particular piece is rare, it is because we know of perhaps one or two examples. For example, we know of only one other desk like the inlaid fall front on page 174. On the other hand, we would not consider the V-back armchair on page 125 to be rare; we know of about twenty existing pieces of this type.

Most of the pieces in this section are the work of Gustav Stickley, but we have also included a wide selection of examples from L. & J.G. Stickley and the Roycroft Shops. The section is broken down into seven chapters: Bookcases and China Closets; Chairs and Settles; Chests of Drawers; Desks; Servers and Sideboards; Tables; and Individual Pieces. Where possible, we have put the examples within each chapter in chronological sequence, to assist in the understanding of chronological development. At the end of each chapter there are extensive captions relating to each photograph.

After studying the examples of Arts and Crafts furniture illustrated in this section, you should be able to judge a piece by careful examination. A knowledgeable, reputable dealer can also help you increase your understanding of this furniture, but the serious collector will study the following examples and apply what he has learned when he examines actual examples of the furniture himself.

6 Bookcases and China Closets

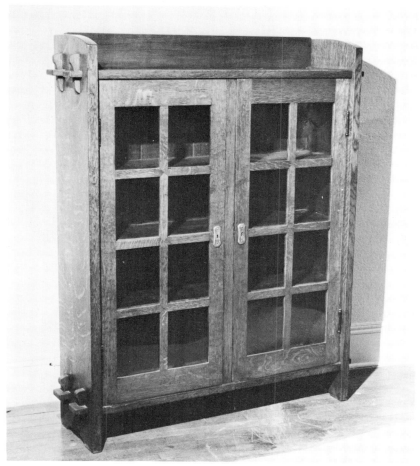

Bookcase
Gustav Stickley H 56" W 42" D 12" Marking: Decal with Stickley
in rectangle CA. 1901/02 Oak

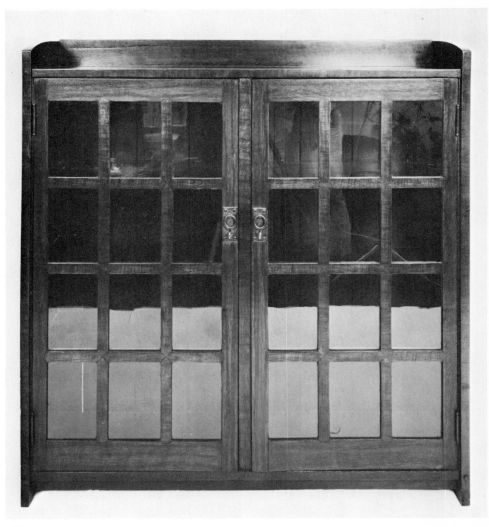

Bookcase
Gustav Stickley H 55¾″ W 52½″ D 12″ Marking: 2½″ decal with
Stickley in rectangle CA. 1902 Oak

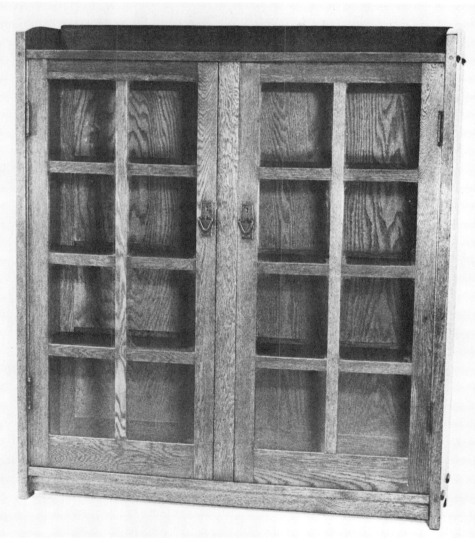

Bookcase
Gustav Stickley H 56" W 48" D 13" Marking: Gustav Stickley decal
CA. 1905/12 Oak

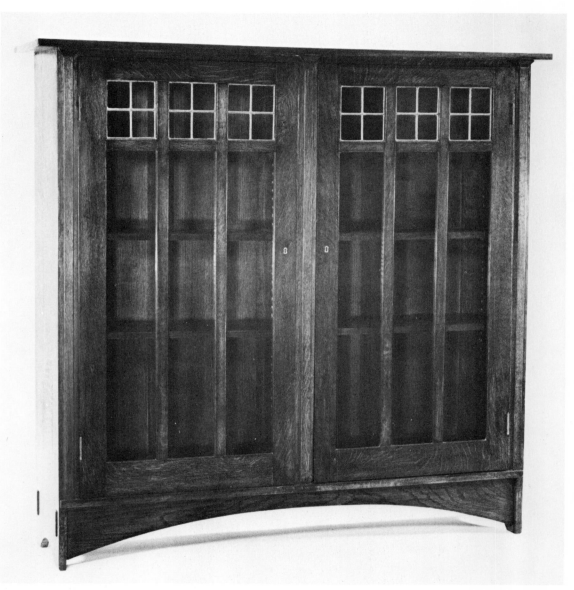

Bookcase
Gustav Stickley H 54″ W 60″ D 14″ Marking: Decal with Stickley
in rectangle CA. 1903/04 Oak

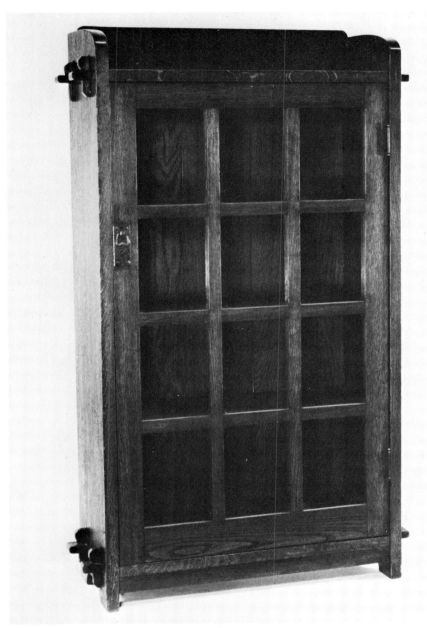

Bookcase
L. & J.G. Stickley H 56¾″ W 30″ D 12″ Unmarked Cᴀ. 1904/05

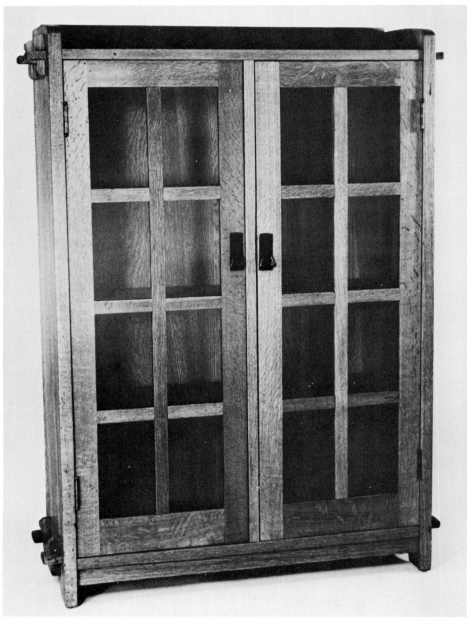

Bookcase
L. & J.G. Stickley/Gustav Stickley H 55″ W 40″ D 12″ Marking:
Conjoined L. & J.G. Stickley and Gustav Stickley shopmark CA. 1918 Oak

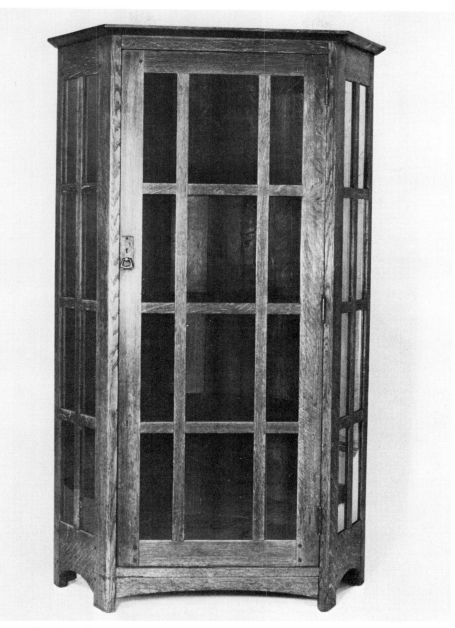

Corner Cupboard
L. & J.G. Stickley H 65" W 48" D 26" Marking: Rectangular decal,
"The Work of L. & J.G. Stickley" CA. 1912 Oak

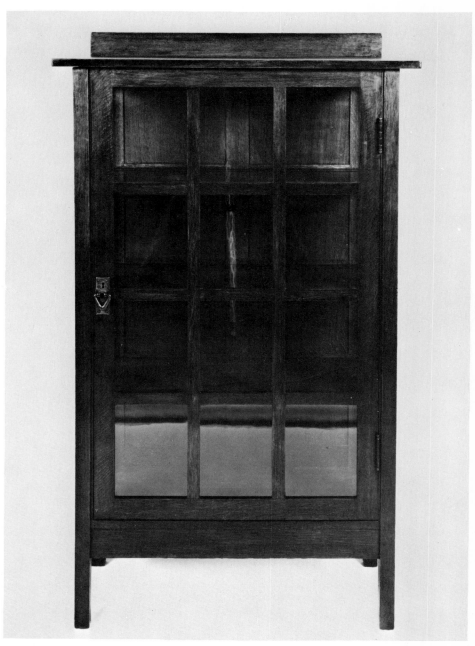

China Closet
Gustav Stickley H 62½″ W 36″ D 15″ Marking: Burned-in joiner's
compass and Eastwood paper label CA. 1912/15 Oak

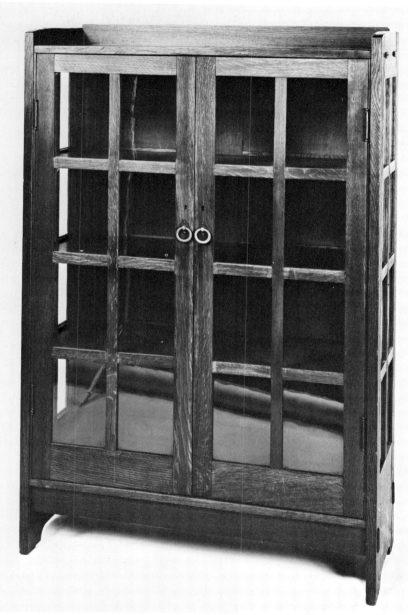

China Closet
Gustav Stickley H 64″ W 39″ D 15″ Marking: Burned-in joiner's
compass CA. 1912/13 Oak

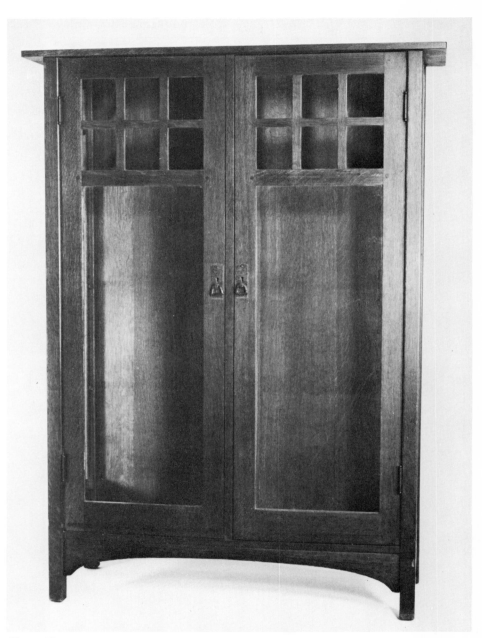

China Closet
L. & J.G. Stickley H 62″ W 44″ D 16″ Marking: "The Work of L. & J.G. Stickley" Decal CA. 1912/15 Oak

BOOKCASE: page 103

Gustav Stickley made many bookcases following this design, but over the years he produced numerous variations on the theme. The most apparent design element, common with all bookcases of this basic design, is the slab side topped with a curve sloping down toward the front of the bookcase. A bookcase of this design, though slightly smaller, first appeared in THE CRAFTSMAN for June 1902.

The construction details of this bookcase place it firmly in Stickley's First Mission Period. The back is made of vertical chamfered boards, a mode of construction requiring both more labor and material than the paneled backs found on later bookcases. The muntins in the doors are composed of ten separate strips of wood, joined together at 45° angles. On later bookcases with the same number of panes of glass on their doors, the muntins are fashioned from seven strips of wood, with one vertical strip running the length of the door and six horizontal pieces butting against it. The later method is just as strong as the earlier, but requires less labor and less wood to produce. The hardware also reveals the early date of this bookcase: the bevel-edged brass plates are cast, and retain file marks where they were hand-smoothed. Stickley bookcases of this vintage are seen only rarely.

Another distinguishing feature which places this piece in Stickley's First Mission Period is that the back rail and curved sides rise nearly 5 inches above the top of the carcass. On later bookcases this was reduced to 4 inches, by making the carcass taller. While this bookcase has the same overall height as the later bookcases shown on the following pages, it is much narrower. These two elements combine to give it slightly eccentric proportions which emphasize the vertical and make this bookcase much more dramatic in appearance than the next two examples.

Note, too, that there is no apron at the bottom of this bookcase; the lack of an apron contributes to the vertical feeling created by the proportions. Aprons appeared first on slightly later bookcases, and not only contributed to their finished appearance, but greatly enhanced structural strength.

COLLECTION OF BETH AND DAVID CATHERS

BOOKCASE: page 104

Even though the overall form and proportions of this bookcase are characteristic of Stickley's mature production phase, nearly all the structural details are of the first mission period. Thus, this bookcase may be considered a transitional piece, leading from the First Mission Period into the Mature Period.

With its square, solid proportions, this bookcase has none of the vertical exuberance of the earlier bookcase on the preceding page. It is a much more sober design, and prefigures the shape of Stickley's bookcases for the remaining years of his furniture production. The recessed apron appears here, giving the bookcase strength as well as rooting it visually to the floor. Otherwise, it is

like the earlier bookcase in construction details: note the pieced muntins joined at 45° angles and piercing the door frames, and the back composed of vertical chamfered boards.

The hardware, with its rectangular plates of hammered copper held to the doors by faceted-head lag screws and with round pulls above the keyholes, first appeared in THE CRAFTSMAN in May 1902. It is a development beyond the earlier cast hardware, but has not yet attained the characteristic shape of Stickley's final period.

COLLECTION OF BETH AND DAVID CATHERS

BOOKCASE: page 105

Here, then, is the "basic" bookcase in its final form. It has evolved from the slightly eccentric proportions of the first example to a sober and beautifully plain design. The construction details of the first two bookcases have disappeared, replaced by the simpler features of Stickley's mature style. This bookcase appears for the first time in this final form in the September 1904 issue of THE CRAFTSMAN.

This bookcase has a back made of laminated oak panels. The muntins simply butt together, and the hardware is the standard V-form found on Stickley's furniture from 1904 on. It is a true expression of Stickley's belief in solid construction, functionalism, and purity of design.

COLLECTION OF DR. AND MRS. THOMAS BLUMENFELD

BOOKCASE: page 106

First appearing in the October 1903 issue of THE CRAFTSMAN, this bookcase was either designed by Harvey Ellis or derived from his work. The wide overhanging top, the curved apron, the lack of hardware, and the paneled back relate this piece to the Ellis-designed desk on page 174. The applied moldings on the front of the bookcase have a classical look to them, seemingly out of place on Stickley furniture. However, the flaring capitals are somewhat reminiscent of similar forms used by both Mackintosh and Baillie Scott in their architectural work, and therefore strengthen the likelihood that Ellis designed this bookcase.[1]

In his 1906 catalog, "Craftsman Furnishings," Stickley offered this bookcase in oak, maple, and mahogany. It was available in three sizes. He also produced a smaller single-door version and an open version. By 1907, it was made in oak only. It is very rare.

Although Stickley made bookcases of this design until 1909,[2] the leaded

glass at the top of the doors was discontinued in either 1908 or 1909, and replaced by the wooden muntins found on his other bookcases.

COLLECTION OF SYDNEY AND FRANCES LEWIS

[1] A bookcase design in the August, 1903 issue of THE CRAFTSMAN, apparently Ellis's work, uses an identical molding on its front. There it is described as deriving from a "Tuscan column."

[2] This bookcase, with wood muntins, appeared in the 1909 catalog, but not in the 1910, indicating that it was phased out that year.

BOOKCASE: page 107

This bookcase illustrates L. & J.G. Stickley's version of what we have identified as the "basic" bookcase. Although it is certainly derived from Gustav Stickley's 1901 design, and shares many features with that design, it also has many distinctively L. & J.G. Stickley characteristics.

First of all, notice how the curve at the top of the slab side differs from Gustav's: it is more fluid, flowing to the front of the case and not crisply cut off as on a Gustav bookcase. The curves at either end of the top rail are more rounded than on a Gustav bookcase, and the top rail is only ¾ inch thick, whereas the same piece on a Gustav bookcase is 1 inch thick.

The muntins are not pieced together as on early Gustav bookcases, but the doors are nonetheless very well made; note the pinning at the top and bottom of the door frame. The keys holding the exposed tenons are faceted in the typical L. & J.G. Stickley manner, rather than rounded as on a Gustav piece. Note, too, the back formed of vertical chamfered boards. We have shown that Gustav, when he used chamfered boards, joined them with internal splines. L. & J.G., on the other hand, accomplished this internal joining by means of tongue-and-groove joints.

The hardware is similar in design and comparable in quality to the hardware on the Gustav bookcase on page 104. It has a beautiful mellow patina, and it is a shame that L. & J.G. Stickley did not continue to use this hardware, since it is clearly superior to the hammered copper hardware found on their later pieces.

Finally, the overall vertical proportions of this bookcase relate it to the earliest Gustav bookcases, like the one shown on page 103. Of course, the heavy hardware and the chamfered board back show that it is an early piece. We cannot pinpoint the exact date of manufacture, but it is illustrated in the Onondaga Shops catalog and hence dates from L. & J.G. Stickley's earliest years. The firm was still producing this model as late as 1922, but the later bookcases are 2 inches shorter and therefore more horizontal in proportion, and they have paneled backs and lighter-weight copper hardware.

As is all L. & J.G. Stickley furniture produced during the Onondaga Shops period, this bookcase is very rare.

COLLECTION OF LEWIS GRANT

BOOKCASE: page 108

Produced very late in the Arts and Crafts era, this L. & J.G. Stickley bookcase exhibits all the characteristics we expect from this firm: faceted keys, ¾-inch-thick toprail, hammered copper pulls on thin-gauge copper plates. It is, in other words, a typical L. & J.G. Stickley bookcase, and what makes it most interesting historically is its marking: the circular red-and-yellow decal bearing L. & J.G. Stickley's handscrew shopmark and Gustav Stickley's joiner's compass, plus the words "Handcraft" and "Craftsman." As discussed in the chapter on L. & J.G. Stickley, Gustav Stickley worked with his two brothers briefly after his bankruptcy. Both Gustav and Leopold are remembered as strong-willed men, and it is impossible to imagine that they could have worked together for long. Very few pieces with this round conjoined decal have been found, further indication of the brevity of their partnership.

COLLECTION OF MR. AND MRS. CLARK STILL

CORNER CUPBOARD: page 109

This corner cupboard demonstrates convincingly that L. & J.G. Stickley furniture can equal the work of Gustav Stickley. The wood, the finish, and the construction are of the highest order. If it has one fault, it is the hammered copper hardware, which is not as robust as the hardware produced by Gustav.

The corner cupboard is not shown in the 1905 Onondaga Shops catalog, but we believe it to be one of their first designs. An early factory photograph shows it with hardware not unlike the hardware Gustav Stickley was using in 1901 and 1902: a key escutcheon with no pull. The back of the early version is formed of vertical chamfered boards. The corner cupboard appears in its final form in L. & J.G. Stickley's 1910 catalog, with a paneled back and "standard" hammered copper hardware. It was dropped from production by the time the post-1912 catalog was issued.

The overhanging top of the corner cupboard is beveled underneath, a characteristic found only rarely on L. & J.G. Stickley furniture, apparently derived from Voysey and Mackintosh. Here, however, the overhang is abbreviated and kept close to the sides of the cupboard, keeping it in harmony with the massive form of the piece. Further, although not visible in this photograph, the top is attached to the carcass by large vertical dowels, cut off flush with the top and left exposed. This is a characteristic found frequently on Roycroft cases, but rarely seen on Stickley furniture. The boards forming the top are butt-joined and splined.

Note the extensive use of pins throughout this cupboard, to enhance the sound construction and for their decorative effect. Note, too, the curved aprons, which help to lighten the effect of this otherwise massive piece.

JORDAN-VOLPE GALLERY

CHINA CLOSET: page 110

Stickley introduced this china closet in 1907. This piece is a prime example of the Final Mission Period—even though it was first made three years before that period began.

It is uncompromisingly straight, totally without curves or expressed structural details. It is simple and functional: a glass-and-wood box designed to hold tableware. Yet, though the design may be stark, its good proportions, careful joinery, and warm wood tones relieve it from severity.

COLLECTION OF RON NASSAR

CHINA CLOSET: page 111

This two door china closet is a derivation of Stickley's "basic" bookcase, which we have discussed earlier. Exposed tenons top and bottom, and double-pinned lap-jointed side rails form the modest structural accentuation characteristic of Stickley's mature style.

The design was introduced in Stickley's 1905 catalog. It was available in either oak or mahogany, had adjustable shelves and a curved apron. By 1909 it was made in oak only and had stationary shelves. Finally, the curved apron was replaced in 1912 by a straight one, and the piece had achieved its ultimate form.

PRIVATE COLLECTION

CHINA CLOSET: page 112

This L. & J.G. Stickley china closet was probably derived from the Ellis-inspired Gustav Stickley bookcase seen on page 106. Like that bookcase, it has a broad overhanging top, muntined glass doors, and an arching apron.

L. & J.G. Stickley introduced its first version of this china closet in the 1905 Onondaga Shops catalog. Initially, the squares of glass at the top of the doors were leaded, and instead of an apron there were curved corbels uniting the front legs with the lower edge of the carcass. It was 70 inches tall, 8 inches higher than our later example. The hardware was of the early type: heavy rectangular copper plates and round pulls. In L. & J.G. Stickley's 1910 catalog, the piece appeared virtually unchanged except that the hardware had been replaced by "standard" light-gauge hardware characteristic of the company's middle and final years of Arts and Crafts furniture production.

The final form of this piece, which is seen in our example, did not emerge until 1912, when it was shown in that year's catalog supplement. It had been shortened to 62 inches, wooden muntins replaced the leading, and the curved apron replaced the earlier corbels. It was made virtually unchanged until L. & J.G. Stickley ceased mission production.

COLLECTION OF DAVID WEXLER

7 Chairs and Settles

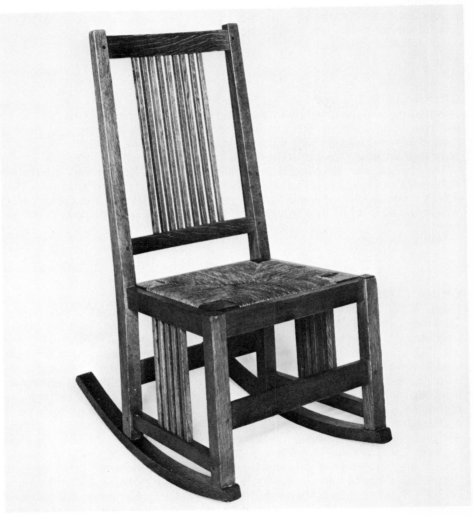

Spindle Sewing Rocker
Gustav Stickley H 36″ W 16″ D 14″ Marking: Gustav Stickley decal
CA. 1906/07 Oak

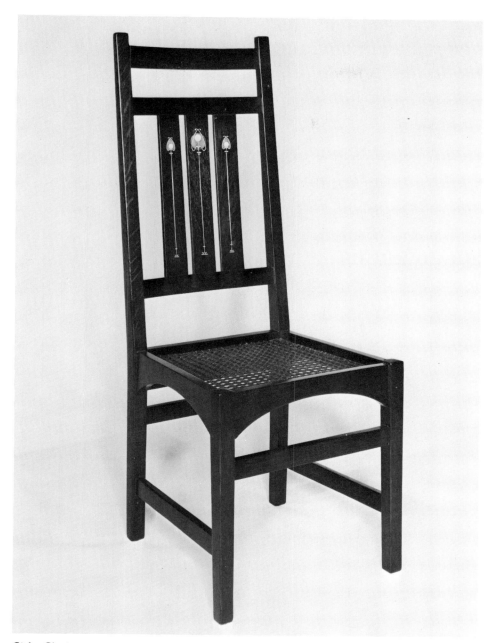

Side Chair
Gustav Stickley H 42¾" W 17" D 15½" Marking: Decal within
rectangle Cᴀ. 1903/04 Oak, with inlay of copper, pewter, and light woods

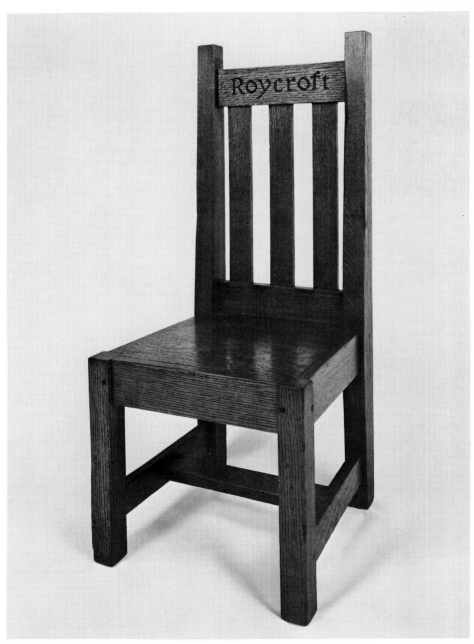

Side Chair
Roycroft H 46½″ W 18¾″ D 19″ Marking: Roycroft carved into top
rail Ca. 1901/16 Oak

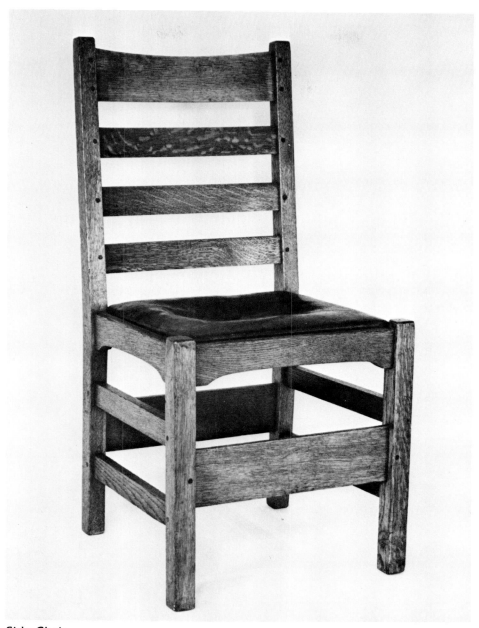

Side Chair
Gustav Stickley H 38″ W 18″ D 16″ Unmarked CA. 1901 Oak

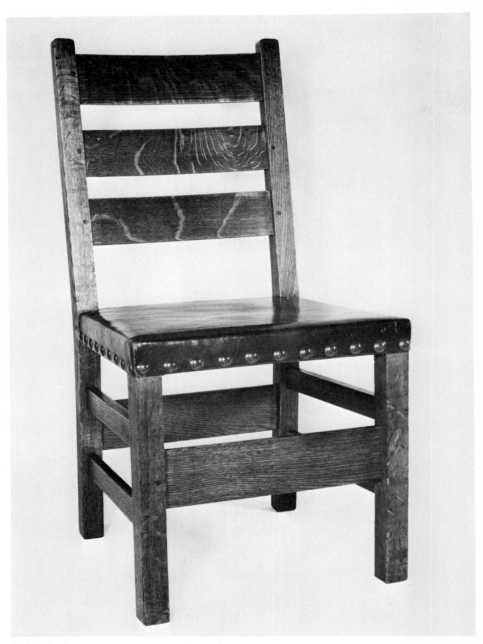

Side Chair
Gustav Stickley H 38″ W 16″ D 16″ Marking: Gustav Stickley decal
CA. 1905/06 Oak

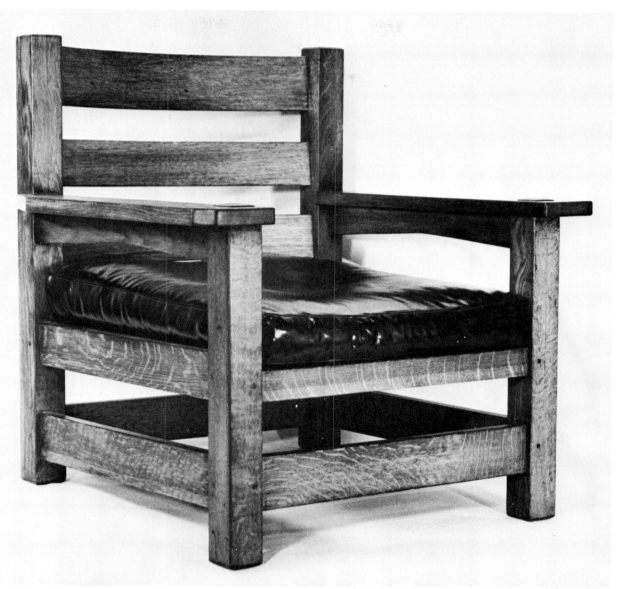

Eastwood Chair
Gustav Stickley H 36¾″ W 36¼″ D 31½″ Unmarked
CA. 1905/13 Oak

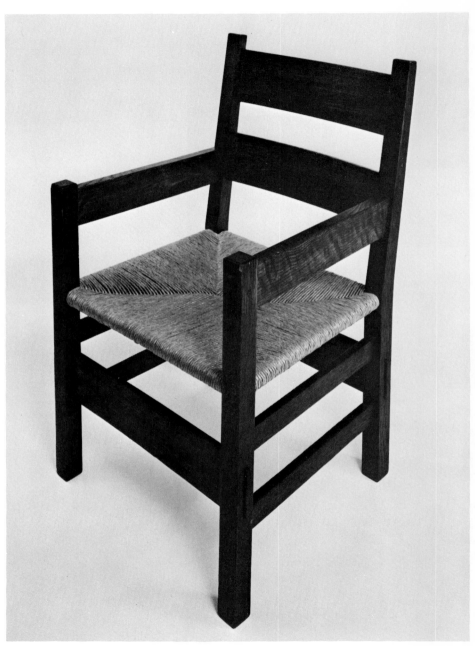

Armchair
Gustav Stickley H 37½″ W 21¼″ D 20½″ Marking: Joiner's compass
in rectangle CA. 1902

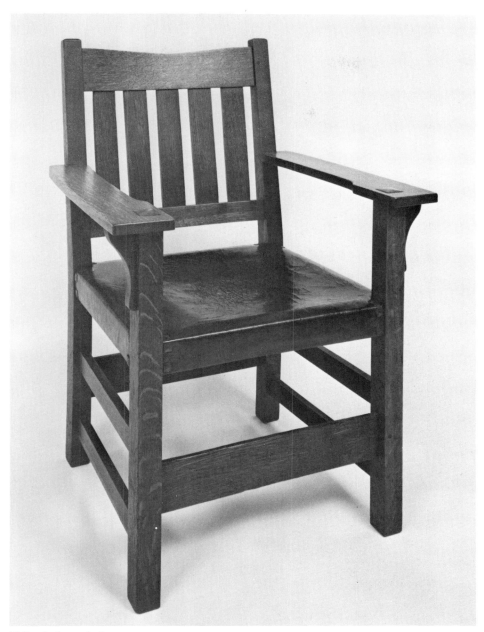

V-Back Armchair
Gustav Stickley H 37″ W 25¾″ D 20½″ Marking: 1″ decal and
New York paper label Ca. 1907/12 Oak

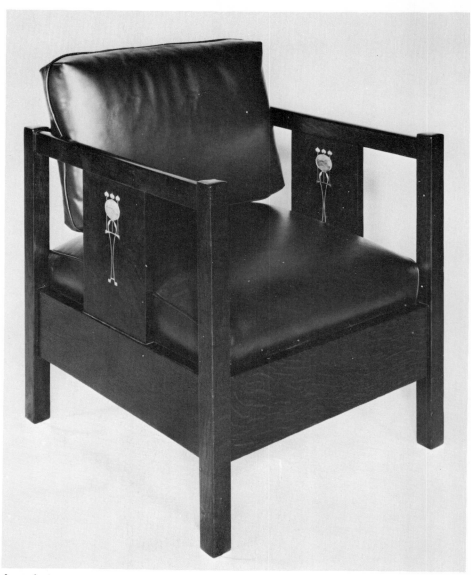

Armchair
Gustav Stickley H 28½" W 26" D 27¾" Marking: 1" decal
in rectangle CA. 1903/04 Oak with inlay of pewter, copper and light woods

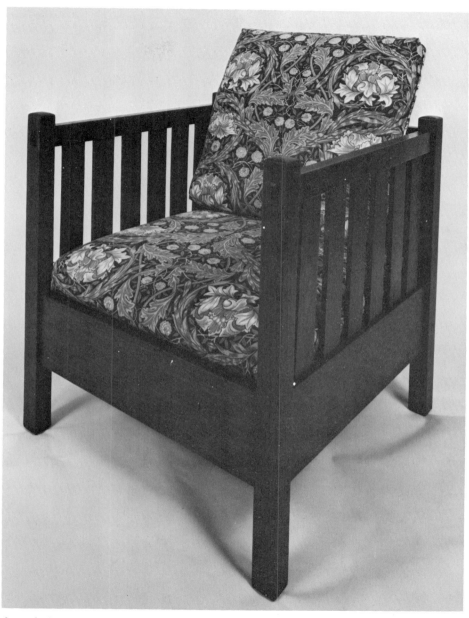

Armchair
Gustav Stickley H 29" W 25½" D 27½" Marking: Burned-in joiner's
compass CA. 1912 Oak

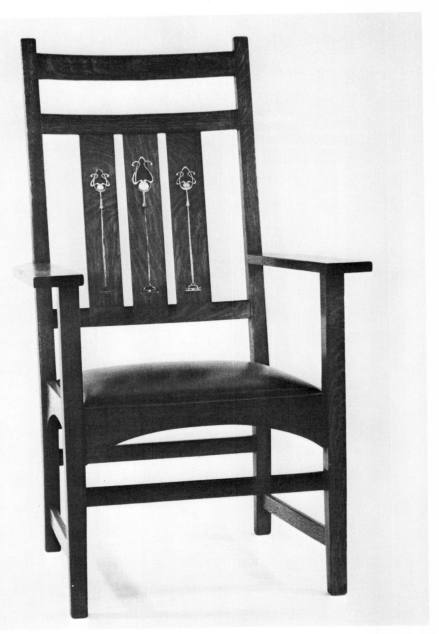

Inlaid Armchair
Gustav Stickley H 43½″ W 24½″ D 19″ Marking: Decal in
rectangle Ca. 1903/04 Oak, with copper, pewter, and light wood inlay

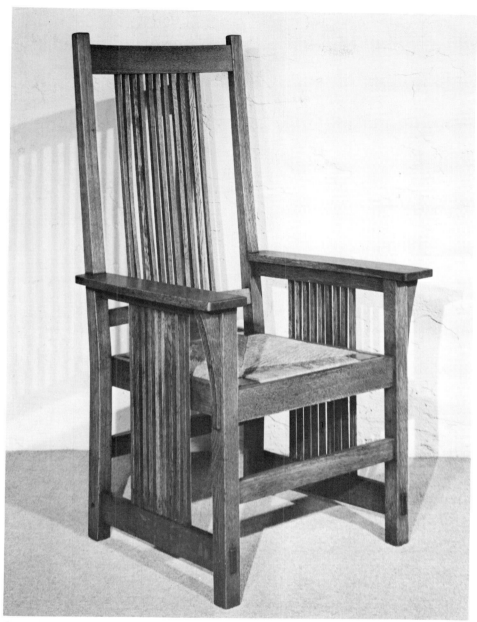

Spindle Armchair
Gustav Stickley H 48½" W 27½" D 20½" Unmarked
CA. 1905/08 Oak

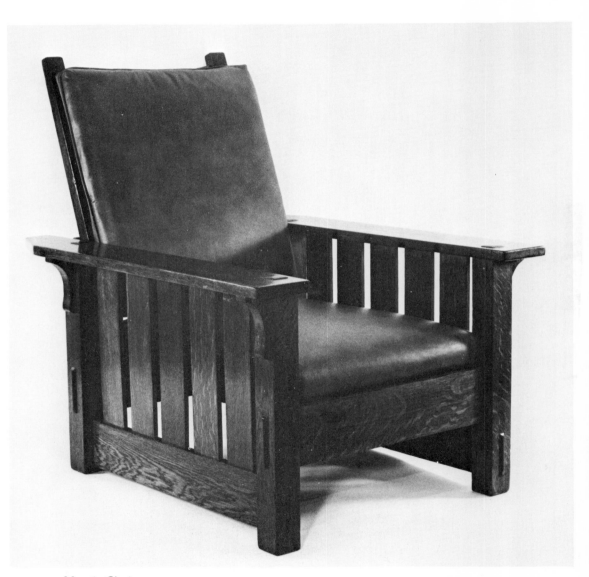

Morris Chair
Gustav Stickley H 40″ W 23″ D 27″ Marking: Gustav Stickley decal
CA. 1909/12 Oak

A sketch from THE CRAFTSMAN showing the Morris chair on the facing page in the context of a Craftsman interior.

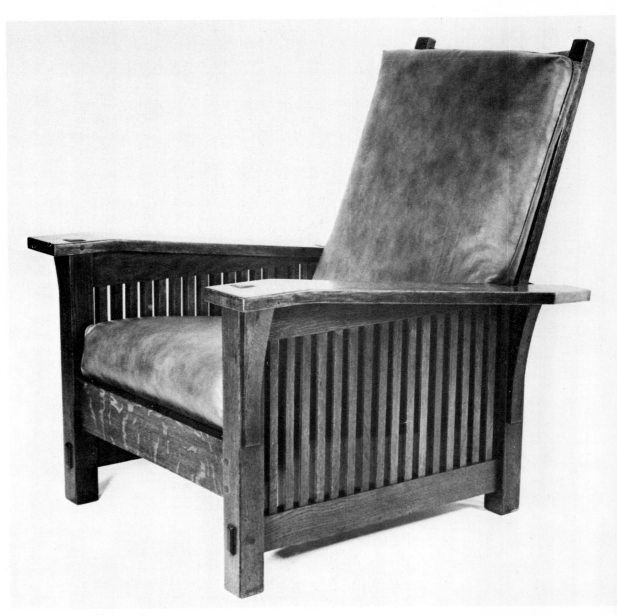

Morris Chair
Gustav Stickley H 40″ W 33″ D 37″ Marking: Gustav Stickley decal
CA. 1906/07 Oak

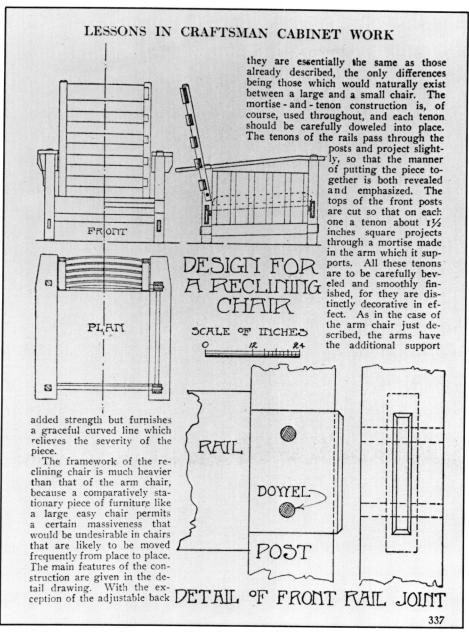

FRONT

PLAN

DESIGN FOR
A RECLINING
CHAIR

SCALE OF INCHES

0 12 24

they are essentially the same as those already described, the only differences being those which would naturally exist between a large and a small chair. The mortise - and - tenon construction is, of course, used throughout, and each tenon should be carefully doweled into place. The tenons of the rails pass through the posts and project slightly, so that the manner of putting the piece together is both revealed and emphasized. The tops of the front posts are cut so that on each one a tenon about 1½ inches square projects through a mortise made in the arm which it supports. All these tenons are to be carefully beveled and smoothly finished, for they are distinctly decorative in effect. As in the case of the arm chair just described, the arms have the additional support

added strength but furnishes a graceful curved line which relieves the severity of the piece.

The framework of the reclining chair is much heavier than that of the arm chair, because a comparatively stationary piece of furniture like a large easy chair permits a certain massiveness that would be undesirable in chairs that are likely to be moved frequently from place to place. The main features of the construction are given in the detail drawing. With the exception of the adjustable back

RAIL

DOWEL

POST

DETAIL OF FRONT RAIL JOINT

337

Plans from THE CRAFTSMAN magazine for a slat-sided version of the Morris chair on the facing page, revealing the techniques used in its construction.

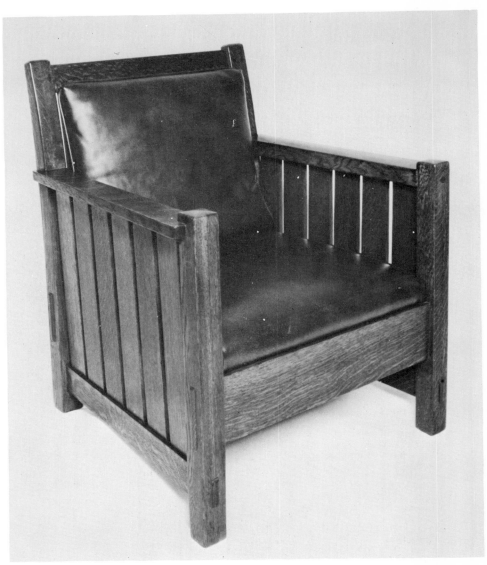

Armchair
L. & J.G. Stickley H 32″ W 25″ D 26″ Marking: "The Work of L. & J.G. Stickley" decal Ca. 1912 Oak

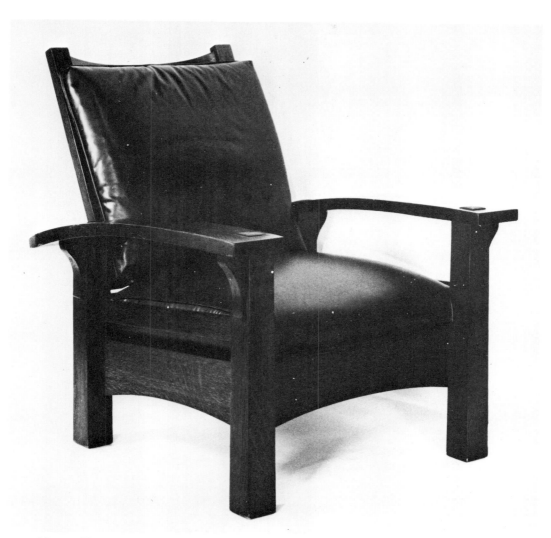

Morris Chair
Gustav Stickley H 40″ W 22″ D 23″ Marking: Decal in rectangle
CA. 1902/03 Oak

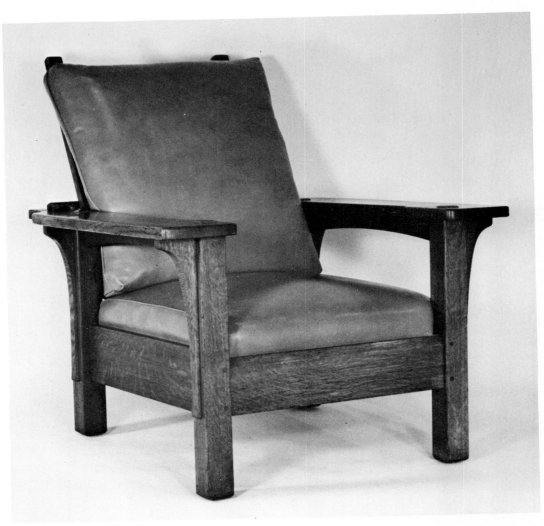

Morris Chair
L. & J.G. Stickley H 40″ W 27″ D 30″ Marking: Handcraft decal
Ca. 1910 Oak

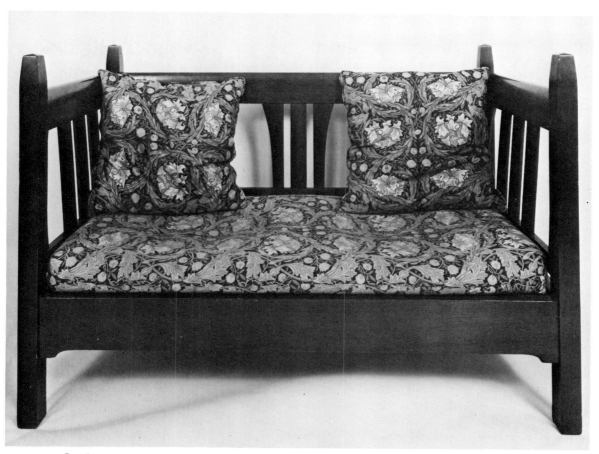

Settle
Gustav Stickley H 40¼″ W 60″ D 27½″ Marking: Decal with Stickley in rectangle Ca. 1901/02 Oak

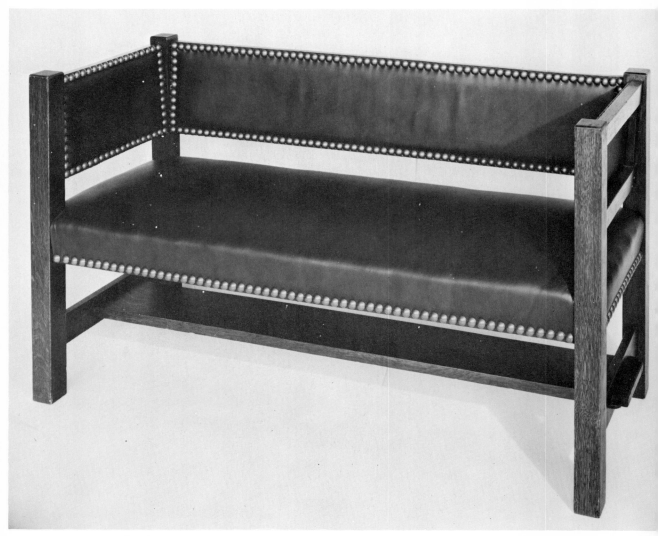

Settle
Gustav Stickley H 32″ W 54½″ D 20½″ Unmarked CA. 1901 Oak

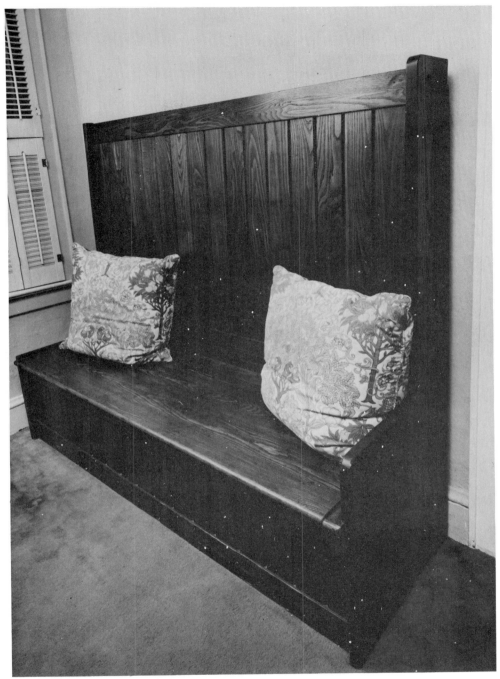

Settle
Gustav Stickley H 60½" W 69½" D 23" Marking: Paper Label
Ca. 1908 Chestnut

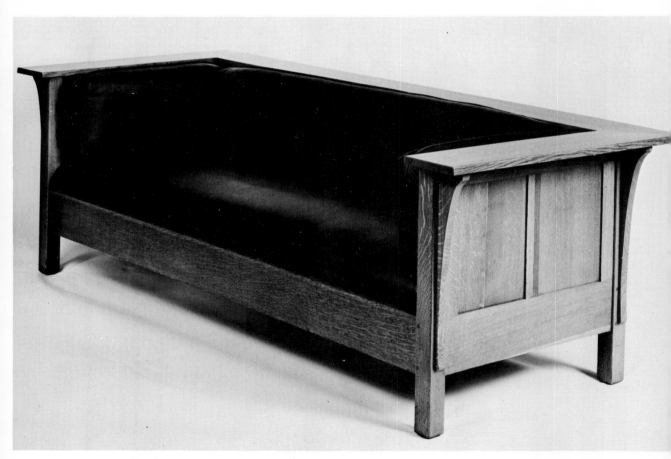

Settle
L. & J.G. Stickley H 28½″ W 84½″ D 36½″ Marking: Decal, "The Work
of L. & J.G. Stickley" Ca. 1912 Oak

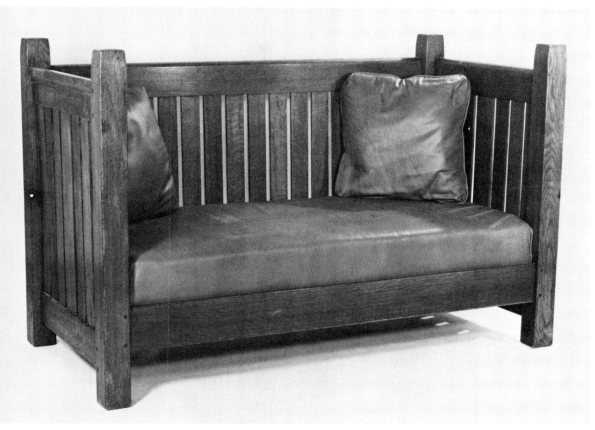

Settle
L. & J.G. Stickley H 39″ W 60″ D 30″ Marking: "Handcraft" decal
CA. 1910 Oak

SPINDLE SEWING ROCKER: page 118

This spindle sewing rocker appeared (along with a spindle library table) in Stickley's first ad for his line of spindle furniture, in THE CRAFTSMAN for November 1905. The ad copy read: "The illustrations herewith are from pieces selected from the later models which are built on rather lighter lines, still retaining, however, the structural and simple features which have always characterized the Craftsman furniture. . . ." It is interesting that Stickley, when introducing designs which were fairly radical departures from his previous work, always took pains to assure his readers that the new work was consistent with his Arts and Crafts principles. The ad for spindle furniture certainly contains echoes of his 1904 article introducing his inlaid designs, which he also carefully stated were in line with his structural philosophy. Though in both cases Stickley was probably trying to convince his constituency, one wonders if he was not trying to convince himself as well.

This rocker was designed for use by a woman, and its delicacy is enhanced by the dramatic use of spindles on the back and at the sides. It was shown in Stickley's 1906 catalog in both oak and mahogany, and in his 1909 catalog, the last year it was made, in oak only.

JORDAN-VOLPE GALLERY

SIDE CHAIR: page 119

This Harvey Ellis-designed side chair[1] first appeared in the January 1904 issue of THE CRAFTSMAN as part of the article introducing Stickley's line of inlaid furniture. As we have said before, the inlay line was made only briefly, though this particular design does appear in THE CRAFTSMAN again, in May 1904. In its second (and final) appearance it was made of maple rather than oak.

The side chair exhibits all the characteristics we have come to associate with the work of Harvey Ellis. It is very graceful and delicate, with curved aprons, tapering legs, and a high back. The chair has a strong vertical look to it, nicely restrained by the two horizontal rails at the top.

The symmetrical, attenuated inlay design of copper, pewter, and colored woods is a typical Ellis pattern and clearly shows its Glasgow heritage. The pattern may be seen as a conventionalized floral motif, but it has a somewhat human form as well. The base of the inlay is in the shape of a Tori, reminding us of Ellis's love for Japanese art.[2]

By September 1904 this chair appeared in THE CRAFTSMAN in a drastically altered state. The inlay was gone, the height of the chair had been reduced by 4 inches by removing the top rail, and the stretcher arrangement had been changed. This new version, lacking the drama of the inlay chair but still light

and graceful, was a standard Stickley design for the remaining years of his furniture production.

PRIVATE COLLECTION

¹ Shown here without seat cushion.
² In the Ellis obituary note which appeared in THE CRAFTSMAN, Stickley referred to him as a connoisseur of Japanese art.

SIDE CHAIR: page 120

This high-backed Roycroft desk chair was made for at least fifteen years, yet we are aware of only four examples. This design was first seen, with a single broad slat rather than three vertical slats, in the June, 1901, issue of HOUSE BEAUTIFUL. It was still being made when Elbert Hubbard II issued a Roycroft catalog circa 1916.

Though totally lacking in visual refinement, it is a very satisfying design, full of strength. Like much of the Roycroft furniture, it is solid quartersawn oak and extremely well made, with its mortise-and-tenon joints held fast by pins.

COLLECTION OF BETH AND DAVID CATHERS

SIDE CHAIR: page 121

Here is another Gustav Stickley design with all the earmarks of a Mature Period design, especially in the stretcher arrangement, yet it was made much earlier: it first appeared in his 1901 catalog. On closer inspection its early origins become more apparent: note the curve of the aprons on the seat rails, which are nearly identical to those on the Greuby-tile plant stand on page 233. Note, too, the broad curved top rail, a shape seen on many Stickley-designed chairs from the early years of his First Mission Period.

JORDAN-VOLPE GALLERY

SIDE CHAIR: page 122

The three-slat, or ladderback, chair is the most frequently found Gustav Stickley side chair. It first appeared in 1904. However, he also made a larger version of that ladderback chair which is less common. Our example is one of the larger size.

The chair first appeared in Stickley's 1907 "Descriptive Price List" and was included unchanged in later catalogs. One interesting point about this chair is the use of round nail heads. As we have pointed out, Stickley stopped using round nail heads in 1907 and changed to square ones. However, on this particular design, he continued to use the round nail heads.

COLLECTION OF MR. AND MRS. ANDREW FEUERSTEIN

EASTWOOD CHAIR: page 123

Apparently the biggest chair Stickley ever made, the Eastwood[1] must have been one of his favorite designs, since he had one in his Syracuse home and another in the main room at Craftsman Farms. The Eastwood is the ultimate in mission styling, with its uncompromisingly plain and straight lines and its massive arms, legs, and stretchers. Though no taller than a standard Stickley Morris chair, it is so wide and deep that it can easily dwarf all but the largest case pieces.

Because of its capacious seat and broad, flat arms, Stickley must have been thinking of the Eastwood when he wrote: ". . . certain [chairs] are sometimes employed, which, by their roominess or peculiar construction, partake of the nature of a bed, table, and chair; providing an excellent resting place, and, at the same time, offering conveniences for holding books, or the works of the occupant."[2]

Note the supports under the arms, which form an inverted, flattened V, a characteristic shape found on a variety of early Stickley designs, as we have pointed out elsewhere in this book. The broad back slats are interesting because the top slat is wider than the one below it. This, too, is an early Stickley trait, seen, for example, on the chair on the following page.

The Eastwood first appeared in the November, 1901 issue of THE CRAFTSMAN and was still in production twelve years later when it was pictured in Stickley's 1913 catalog. Its design was practically unchanged during those years, except for the manner in which the seat was supported. Initially, it had a loose cushion supported by rushing wrapped around round seat rails. Later versions, like our example, have square seat rails with caning supporting the cushion.

Even though it was made for at least twelve years, the Eastwood is rarely found today. Whatever the reason for its rarity,[3] it remains a prime example of Stickley's genius for creating durable, massive furniture of the highest order.

COLLECTION OF BETH AND DAVID CATHERS

[1] The name "Eastwood," of course, comes from the location of Stickley's cabinet shops in Eastwood, New York.
[2] "Chips from the Workshops of Gustave Stickley," 1901.
[3] Perhaps its rarity may be attributed to its bulk; few homes can accommodate such a large chair.

ARMCHAIR: page 124

This chair is pictured in the first issue of THE CRAFTSMAN in October, 1901, in Stickley's April, 1902 furniture catalog, and again in THE CRAFTSMAN for July, 1902. Apparently it was made for only this brief period.[1]

The chair is perfectly straightforward and functional, though not without exciting details. The back is formed by two broad slats, not unlike the slats made for the chairs in the Swedenborgian Church in San Francisco—the origi-

nal "mission" chairs. These broad slats are also similar to those used on the tall ladderback chairs Mackintosh designed for the smoking room of the Argyle Street Tearoom in Glasgow in 1897.

It is worth noting that the top slat is broader than the one below it; on later slatback chairs Stickley always used slats of equal depth. L. & J.G. Stickley, which apparently picked up this trait from him, continued to make the top slat broadest throughout its mission productions.

The arms of this chair are little more than stretchers joining the front and back legs, with tenons mortised through and pinned. They offer strong evidence of Stickley's commitment to the structural elements of his furniture, even, in the case of this chair, to the detriment of comfort. While Stickley used this kind of stretcher arrangement on other chairs, he topped the stretchers with a horizontal arm to make them more comfortable.

The stretcher arrangement is characteristic: broad horizontal slats front and rear, and two thinner slats on either side. As we would expect on a chair of Stickley's First Mission Period, the tenons of the front and rear stretchers are mortised through the legs.

COLLECTION OF BETH AND DAVID CATHERS

[1] However, Stickley Brothers of Grand Rapids copied this design and were still producing their watered-down version in 1907, when they illustrated it in their catalog for that year.

V-BACK ARMCHAIR: page 125

In his book CRAFTSMAN HOMES (1909), Gustav Stickley showed a V-back armchair and arm rocker, and wrote: "No better examples of the Craftsman style can be found than are shown in this chair and rocker." Seventy years later it is impossible to disagree with his sentiment: the V-back chair, so named because of the flattened "V" of its toprail, while modest at first glance, is perhaps Stickley's most nearly perfect chair design. Everything about it is right. Over the years of its production, the chair changed very little. Stickley liked to say, somewhat smugly, that many of his designs couldn't be improved upon; the V-back makes an excellent case in point.

The V-back was exhibited in Stickley's booth at the Pan-American Exposition in 1901 and included in the catalog he published that year. It was introduced to the readers of THE CRAFTSMAN in July 1902 and was still being made in 1913. Most likely, it was kept in Stickley's line until he went out of business. Since it was made for many years, it is not rare.

The first version of the V-back had round seat rails with seats "woven in colored raffia." There was no pinning where the toprail joins the rear legs. In 1903, it was advertised by the Chicago department store Marshall Field in HOUSE BEAUTIFUL. The rocker in this ad is identical to the chairs pictured in the

July 1902 issue of THE CRAFTSMAN, except the "brown roan leather" has replaced the raffia seat. The ad describes the chair as "a large, comfortable rocker, finished in Baronial Oak." [1] Its price was $9.

In 1905, as may be seen by that year's catalog, the round seat rails began to be replaced by square rails. The seat was leather-covered and had a row of round nail heads bordering the lower edge. However, it could still be bought with round seat rails and a woven raffia seat, and either version was available in oak or mahogany. In early 1907, Stickley stopped using the round nail heads and switched over to an arrangement of square nail heads at the four corners of the seat. It was made without further changes from then on.

COLLECTION OF BETH AND DAVID CATHERS

[1] The HOUSE BEAUTIFUL ad goes on to say: "This is only one of many artistic pieces of the celebrated United Crafts Furniture, now shown on our 6th floor." The bottom half of the ad is devoted, properly enough, to Grueby Pottery: "Celebrated for its individuality, imposing strength and simple beauty. A most appropriate accompaniment for Stickney [sic] Furniture."

ARMCHAIR: pages 126/27

The armchair on page 127, a perfect example of the simplicity and purity of Stickley's Final Mission Period, is a design which he refined over a period of nine years. It first appeared in THE CRAFTSMAN for October 1903. The first manifestation had one broad vertical slat below each arm, rather than the six narrow slats seen on our later example, and both slats were decorated with a characteristic Harvey Ellis inlay pattern, a clear indication that Ellis was responsible for design of the chair itself.

When the chair appeared again, in the July 1904 issue of THE CRAFTSMAN, it was being made without the inlay. The 1906 catalog shows it unchanged. At that time it was available in oak, mahogany, and maple. In 1907, Stickley first offered the chair with spindles rather than the broad slats. It was shown in this configuration in the 1909 catalog, the last year Stickley produced spindle designs.

By 1912 the chair reached its final form, with rows of vertical slats under the arms and at the back, as seen on our example on page 127. Except for the exposed tenons piercing the front legs, the chair avoids stressing structural features as a means of decoration. It is actually quite a stark design, basically a cube shape, saved from coldness by the warm tones of its brown oak finish. (Note: This chair has been recovered in "Jungle Marigold," a Liberty of London fabric designed by William Morris. It was originally covered with sheepskin.)

Chairs of this overall form were not unusual to the forward-looking designers of the early 1900s. For example, Frank Lloyd Wright designed a similar chair for the Bradley house in Kankakee in 1900.[1] Further, Josef Hoffman used this

form for some chairs he designed for the Purkersdorf Sanitarium. It seems likely that Stickley's design was influenced by these earlier efforts.

However, if the chair looks backward to these earlier influences, it also looks forward into the twentieth century. If the chair were executed in metal rather than oak, it could arguably be considered an example of the International Style; compare its form with Corbusier's 1928 "Gran Confort" armchair.

Both these chairs are quite rare.

SLATTED CHAIR: COLLECTION OF BETH AND DAVID CATHERS
INLAY CHAIR: PRIVATE COLLECTION

[1] See FRANK LLOYD WRIGHT: THE EARLY WORK (New York: Bramhall House, 1968), p. 25.

INLAID ARMCHAIR: page 128

This armchair is one of the designs introduced in the article "Structure and Ornament in the Craftsman Workshops" in January 1904. Its most notable aspect is the symmetrical Mackintosh-like inlay patterns on the three back slats.

The inlay pattern, as well as the chair body, is the work of Harvey Ellis. The chair has all the characteristics which identify it with the work Ellis did for Stickley: a high back, gracefully arched seat rails, an overall sense of lightness, and a lack of expressed structural detail. Note, for example, that the tops of the front legs are not mortised through the arms, a detail found on most Stickley chairs.

Like all of Stickley's inlaid furniture, this chair was made only for a brief time. As we have mentioned, he apparently made inlaid pieces as samples to create interest in the line, and the line did not catch on.

By August 1904, when it again appeared in THE CRAFTSMAN, Stickley had modified this design and put it into production. He removed the inlay design, took away the toprail, and reduced the chair height by 2½ inches. He also put the stretchers all on the same level. It was produced in that form till he closed his shops.

SPINDLE ARMCHAIR: page 129

It is often impossible to say with complete certainty when a particular Stickley design was first introduced. This, however, is not the case with his line of spindle[1] furniture, which was patented on August 8, 1905.[2]

This high-backed armchair first appeared in THE CRAFTSMAN for September 1905, and was shown there frequently over the next year and a half. It made

its first appearance in a Stickley catalog in 1906. In Stickley's 1907 "Descriptive Price List" it was cataloged as a "hall chair."

The chair echoes the forms of normal-size dining-room armchairs, but in actuality is much larger. The design is clearly more delicate than Stickley's characteristic "mission" look. The vertical spindles emphasize the strong upward thrust of these pieces, and therefore may be said to show a definite relationship to Mackintosh's high-back chair designs. There is, of course, the strong influence of Frank Lloyd Wright on Stickley's spindle chairs.

By 1909 Stickley was phasing out his spindle designs. He did include a spindle armchair in that year's catalog, but it was 10 inches shorter than the earlier version and the spindle below the arms had been replaced by Stickley's characteristic stretcher arrangement. Since Stickley's spindle pieces were made for such a brief period, it is likely they did not achieve great commercial success. Pieces are found today only rarely.

It is interesting that L. & J.G. Stickley made its own version of this spindle chair in 1910. However, instead of spindles it had thin lightweight slats.

COLLECTION OF KEN HARPER

[1] Since spindles are usually thought of as round, rather than square, "spindle" may seem to be the wrong name to apply to this furniture. However, it is the name Stickley used to describe it.

[2] FURNITURE WORLD for August 17, 1905, reported that Stickley had been granted patent #37507 and #37508 for his spindle chair frames

MORRIS CHAIR: page 130

This is probably the first Craftsman Morris chair which Gustav Stickley designed. He was granted a patent on this chair body in July, 1901. It is illustrated in the first issue of THE CRAFTSMAN, in October, 1901, and is remarkable in that it is a fully realized Mature Period design created during the First Mission Period. Stickley must have been pleased with the design, since the chair was produced almost without modification until his business folded.

The term "Morris chair," though commonly used today, was rarely applied to these designs by Stickley. When Stickley first made Morris chairs he referred to them as "reclining chairs" or "reading chairs." The first Morris chairs were the adjustable-back armchairs produced by Morris and Company in England during the 1860s. These first chairs probably represented an advance in comfort over stationary-back chairs, but perhaps are better understood as good examples of the Victorians' love of novelty.

As with all of Stickley's large armchairs, Morris chairs are fairly easy to date on the basis of seat construction. The earliest examples have a loose-cushion seat supported by a caned frame. Chairs made around 1906 and 1907 use the canvas "swing" seat, and chairs made in 1909 and thereafter use a spring seat. Of course, there are other clues. The pegs supporting the adjustable back are

in the form of tapering rectangular solids on early chairs; later these pegs are simply turned. Corbels on early chairs taper down to a thickness of about ¼ inch at the bottom; corbels on later chairs flare out slightly at the bottom, as on our example.

This is perhaps Stickley's most successful Morris-chair design. It is devoid of superfluous detail without ever appearing stark. It is perfectly proportioned. And the slats, stretching from the floor to the arms, add an extraordinary sense of drama to its overall appearance.

COLLECTION OF FRANCESCO PELLIZZI

SKETCH: page 131

This sketch, taken from THE CRAFTSMAN, shows a Morris chair identical to our example in a Stickley room setting. The room clearly demonstrates Stickley's concern with the totality of interior design, with all aspects of an interior forming related parts of the whole. In addition to designing the "movables," the Morris chair, the V-back arm chair, the library table, and the side chair shown here, Stickley also designed the built-in fall-front desk, bookshelves, and cupboards, as well as lighting, decorative objects, windows, curtains, rug, and table scarf. This kind of design unity was a radical notion in Stickley's time and was a reaction against the jumbled eclecticism of the typical Victorian interior.

MORRIS CHAIR: page 132

When Stickley launched his line of spindle furniture in 1905 he created some entirely new designs. He also modified some existing designs to accommodate spindles. This Morris chair is an example of the latter, and is based on his patented chair frame design of 1901. This chair first appeared in THE CRAFTSMAN in December 1905 and was included in the 1906 catalog and the 1907 "Descriptive Price List."

Of course, the most notable modification is the use of spindles rather than slats below the arms. The appearance of these arms is somewhat deceiving: each seems to be cut from one block of wood, but that is not the case. In actuality, the cut on the lower portion continues up to the front of the chair. A wedge-shaped piece of wood has been fitted underneath the front of the arms, and is so well joined and finished that it is nearly undiscernible. In keeping with the spindles, the rails of the chair are on a somewhat lighter scale than other Stickley Morris chairs, and the corbels beneath the arms are longer and more gently curved than is normally seen. The side-rail tenons are mortised through the front legs, and the legs are mortised through the arms; however, the seat-rail tenons are not exposed as they usually are on his Morris chairs.

This chair has a swing seat, indicating a 1906 or 1907 date of manufacture.

After 1909, Stickley continued to make bent-arm Morris chairs of this design, but with slats replacing the spindles.

PRIVATE COLLECTION

CHAIR PLAN: page 133
Stickley published these plans for the slat-sided version of this Morris chair in THE CRAFTSMAN in December, 1909. Although it is doubtful that many home woodworkers actually made furniture following his patterns, publishing these plans nevertheless shows the idealistic side of Stickley's nature: how many furniture manufacturers ever encouraged people to make their own furniture? Yet the home crafts worker was an essential element of the Arts and Crafts movement, and Stickley was consistent with his philosophy by encouraging the amateur.

These plans are also useful as a means to understanding Stickley's construction techniques. The front view, for example, reveals the mortise-and-tenon joints holding the five horizontal back slats to the vertical uprights. The front rail joint shows how the tenon is mortised through, chamfered off, and pinned into place with two dowels.

ARMCHAIR: page 134
Even though Gustav Stickley design characteristics are evident in this armchair, it is still very much an original L. & J.G. Stickley design. The way the front legs join the arms and then rise above them is certainly copied from Gustav, but L. & J.G. pinned the joint from the front while Gustav would have pinned it from the side. The overall "cube" form of the chair is not unlike the Gustav Stickley armchair on page 127, but treated very differently. First, the rear legs of the L. & J.G. chair continue above the height of the arms to support the back pillow, a more comfortable if less visually exciting treatment than seen on the Gustav chair. But what makes this design so successful is that L. & J.G. Stickley chose to put the side rails close to the floor, lower than the front seat rail, and this not only gives the chair a look of stability but also adds a great deal of drama.

PRIVATE COLLECTION

MORRIS CHAIR: page 135
First appearing in THE CRAFTSMAN for April 1902, this Morris chair was produced without significant change from then on. Stickley's most effective Morris chair

designs have slat or spindle sides. His open-side Morris chairs tend to be uninspired; our example, however, is a notable exception. This is primarily because of its most distinctive feature, the arching arms, which were given their shape by being steamed and molded over a rounded form. The design is unified by the repetition of the arch motif in the front and side aprons. We tend to think of arched aprons as characteristic of Harvey Ellis's designs, which they are, but the fact is that Stickley made some use of them before Ellis came to work for him.

The separate horizontal rails running between the front and back legs are seen for the most part only on Stickley's early chairs. During his Mature Period years, he used them only rarely, as on this design. However, L. & J.G. Stickley, as well as other competitors, picked up this device from Stickley and made continued use of it.

During 1905 and 1906 (and possibly 1907) this chair could be bought made of either oak or mahogany. After that it was available in oak only.

COLLECTION OF DR. LEON BOLTER

MORRIS CHAIR: page 136

Gustav Stickley's most successful Morris-chair designs had slat sides. Except for one chair with arching arms, his open-sided Morris chairs are not particularly satisfactory. L. & J.G. Stickley, on the other hand, did create a very successful open-sided Morris chair, as can be seen by our example.

This chair evolved out of an early design first seen in L. & J.G. Stickley's 1905 Onondaga Shops catalog. The early version had arched aprons, short curving corbels, and straight thin arms. Our example is clearly a more effective design. It first appeared in the 1910 catalog. In addition to its fine proportions, this chair works so well because of the long tapering corbels, which are more purely decorative than the shorter corbels found on Gustav Stickley's work. The curved rails below the arms and the broad shapely arms also greatly add to its appearance. These details show L. & J.G. Stickley's willingness to create more obviously decorative designs than their functionalist brother.

The adjustable back of this Morris chair is supported by a bar which is fitted into notches on the arms. This bar is typical of L. & J.G. Stickley Morris chairs and makes it easy to distinguish theirs from Gustav Stickley's Morris chairs, which use adjustable pegs.

COLLECTION OF DANIEL FILIPAICHI

SETTLE: page 137

Three sources of contemporary documentation show this rare settle to be an early design. It first appeared in "Chips from the Workshops of Gustave Stick-

ley" (1901). It was exhibited at the Boston Mechanics' Fair in 1902. Greene and Greene selected a settle of this design for the living room of the Culbertson house, which they built in Pasadena in 1902. It may be seen in Makinson's GREENE AND GREENE, page 68.

Probably the most unusual design element of this settle is the combination of the curved corbels with straight slats. These curved corbels form a sort of truncated gothic arch, indicating Stickley's debt to the Gothic Revival sources of the Arts and Crafts movement.

The back and side top rails, as well as the seat rails, are molded, a technique Stickley used only briefly during his Experimental Period and in the earliest years of his First Mission Period. The gently curved apron is also an early trait which appeared only during the Experimental and First Mission Periods. The same curve may be observed on other examples found in this book: The plant stand on page 233, the magazine stand on page 243, and the side chair on page 35.

The fabric on this settle, which is not original, was designed by William Morris.

COLLECTION OF BETH AND DAVID CATHERS

SETTLE: page 138

Stickley's furniture catalog for 1901, "Chips from the Workshops of Gustave Stickley," illustrated three high-all-around settles. Two of these are shown in this book: the curved-corbel settle on the preceding page and the one illustrated on this page.

This settle, though quite small, has the kind of massiveness and rectilinearity associated with Stickley's First Mission Period. Its most interesting feature is the long stretcher running the length of the piece beneath the seat, a feature frequently found on library tables but rarely seen on his seating furniture. The stretcher's tenons are mortised through the side stretchers, which join the front and back legs. The tenons are held by faceted keys, entering them both at the front and back. This horizontal tenon is typical of Stickley's work of 1901 and 1902, and apparently was never used after this period.

ROBERT MAPPLETHORPE COLLECTION

SETTLE: page 139

We tend to think of built-in furniture as a very modern concept, but the fact is that many Arts and Crafts and Art Nouveau designers were making built-ins by the late nineteenth century. Mackintosh, Baillie Scott, Wright, and others used them frequently. So did Gustav Stickley.

This high-backed settle, made of chestnut,[1] is one of a pair which originally flanked the dining-room fireplace at Craftsman Farms. It may be seen IN SITU in Freeman's FORGOTTEN REBEL, p. 21. Stickley used locally grown chestnut in the construction of his log home at Craftsman Farms, and the furniture he built especially for the house was also made of this wood.

This settle, clearly based on eighteenth-century fireplace settles common in America and England, is constructed of chamfered boards,[2] and has flat exposed tenons on both ends. The only actual decoration is the lozenge-shaped cutout at the end, a device seen on the built-in settle illustrated in the farmhouse interior in the December 1908 issue of THE CRAFTSMAN, p. 53.

High-backed settles, though rarely found today, were almost a design cliché of the Arts and Crafts designers—no turn-of-the-century "artistic" home was complete without its fireplace inglenook furnished with a settle.

This settle is marked with a paper label approximately 1½" high by 1" wide with a joiner's compass on it. We have never seen this label on a commercially produced Stickley piece, so perhaps it was used only on special items like those he designed for Craftsman Farms.

COLLECTION OF BETH AND DAVID CATHERS

[1] Stickley published an article in the December 1908 issue of THE CRAFTSMAN in which he discussed the design for the log house at Craftsman Farms. In this article he talked about the great number of chestnut trees on the property, and his decision to use the wood to construct the building and its furniture. Though Stickley nearly always worked in oak, the furniture made for Craftsman Farms was not his first use of chestnut: six years earlier he had shown a high-backed chestnut settle in the August 1902 issue of THE CRAFTSMAN.

[2] For the most part, Stickley's use of chamfered boards was confined to his First Mission Period. However, he continued to use them on occasion throughout his Mature Period. In the January 1909 issue of THE CRAFTSMAN, he wrote: ". . . the use of these V-jointed boards is in its own way very decorative."

SETTLE: page 140

Many L. & J.G. Stickley designs derive from Gustav Stickley's work. However, some of their finest efforts are designs which they themselves originated. This settle, which is every bit the equal of any of Gustav Stickley's, is one example.

It first appeared in L. & J.G. Stickley's 1912 catalog supplement. With a price of $124, it was not an inexpensive piece of furniture. It has a sophistication and "modernity" which we rarely expect in mission furniture. All the details of the design contribute to its sleek appearance: the use of panels rather than slats, the long graceful corbels, the broad flat surface of the arms and the back, the overall long and low proportions.

We have seen only one other example of this settle.

COLLECTION OF GEORGE SILANO

SETTLE: page 141

This settle is another L. & J.G. Stickley design which equals many of Gustav Stickley's settles. This is primarily due to its proportions: it is only 60 inches wide but stands 39 inches tall, and the resultant boxiness achieves a coziness often sought after but rarely achieved in Arts and Crafts settles.

It is very much like a Gustav Stickley settle with its thick tapering posts, molded top rails, and double-pinned mortise-and-tenon joints. However, the use of thin slats in combination with broad slats[1] shows it to be the work of L. & J.G. Stickley.

COLLECTION OF TED DANFORTH, JR.

[1] The broad slats on the back are hidden by the two throw pillows. They are, however, visible at the sides.

8 Chests of Drawers

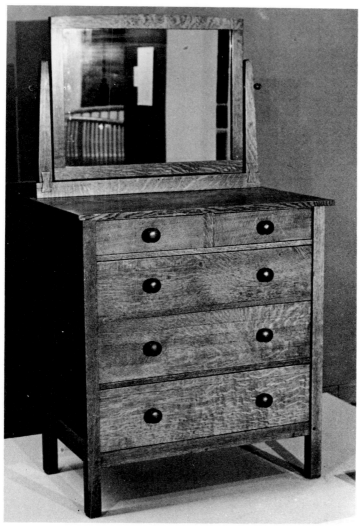

Chest of Drawers
Gustav Stickley H 65½″ W 36″ D 20″ Marking: Burned-in Stickley
joiner's compass and Eastwood paper label Ca. 1912/15 Oak

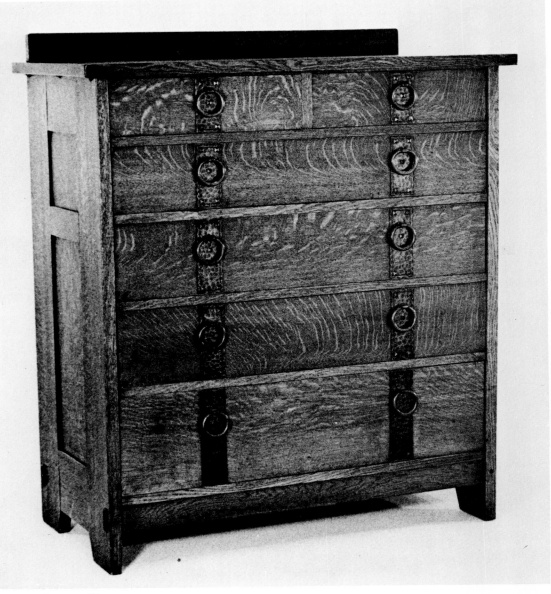

Chest of Drawers
Gustav Stickley H 46″ W 41″ D 21″ Marking: Burned-in joiner's
compass Ca. 1912/15 Oak

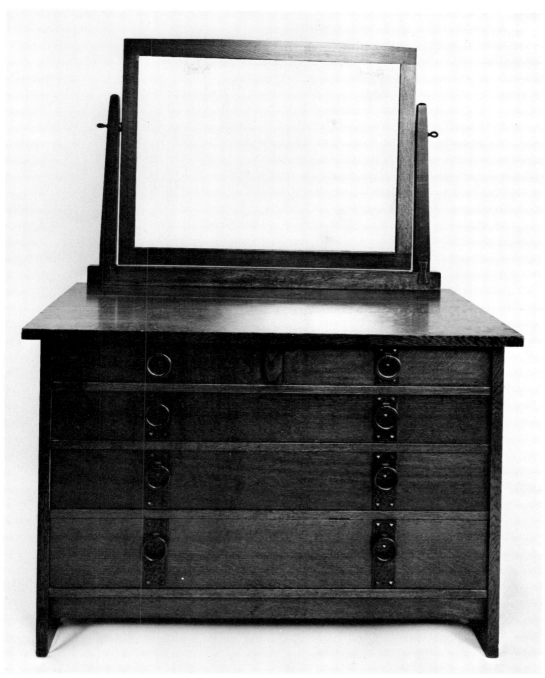

Chest of Drawers
Gustav Stickley H 65″ W 48″ D 22″ Marking: Burned-in joiner's
compass Cᴀ. 1912/15 Oak

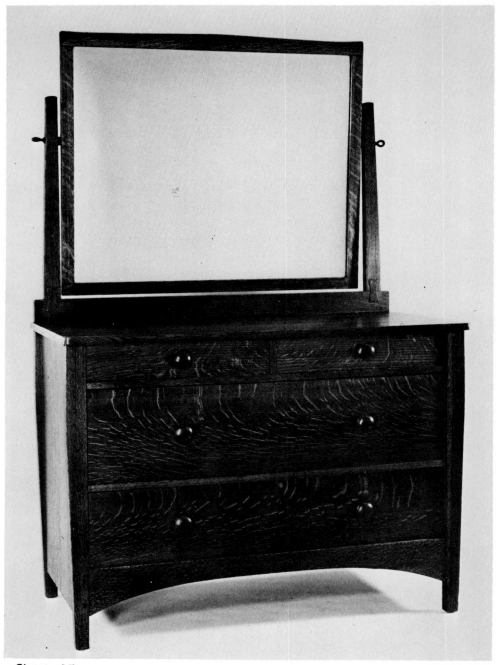

Chest of Drawers
Gustav Stickley H 51" W 36" D 20" Marking: 1¼" decal
CA. 1906/12 Oak

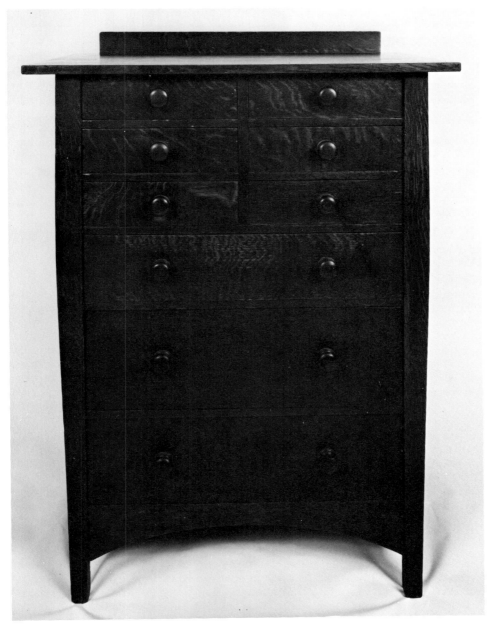

Chest of Drawers
Gustav Stickley H 66″ W 48″ D 22″ Marking: 1¼″ decal
CA. 1906/12 Oak

CHEST OF DRAWERS: page 155

Stickley's designs grew increasingly simplified as the end of the first decade of the century approached. This five-drawer chest first appeared in his 1909 catalog but from a design standpoint is more characteristic of his Final Mission Period. It was first offered for sale with a separate mirror, but by 1912 it could be bought with an attached mirror.

This piece is so severely plain that its special qualities, most notably the warmth of its mellow wood tones, are not necessarily immediately apparent. However, it is very well made, with pins securing the mortise-and-tenon joints, butterfly keys joining the mirror support, and dust barriers between all the drawers. The round wooden knobs, with their echo of Shaker designs, are characteristic of Stickley's later work.

COURTESY OF THE AKRON ART INSTITUTE

CHESTS OF DRAWERS: pages 156/57

Writing in "Chips from the Workshops of Gustave Stickley" (1901), Gustav Stickley decried the lack of attention many people paid to the furnishings of their bedrooms: "In this class of rooms, sanitation is the first law; upon which follows respect for space, regard for utility and comfort, and the quest for that repose which results from suavity of line and harmony of color. It has been a too frequent habit to eke out the furnishings of the bedroom with pieces discarded from the more public portions of the house, and thus to compose an ill-assorted, motley assemblage suggestive of a Sailor's Snug Harbor, or an Hotel des Invalides: a review anything but cheering to one awakening from sleep, or confined by illness."

The trade press of the period also gives indications that mission oak was not likely to be found in the bedroom: "For some rooms and some purpose this style is particularly adapted. In the den, the dining room, the library and the hall the Mission furniture seems to be to the manor born. It is out of place and more or less incongruous in the parlor or bedroom." [1] "Mission furniture shows to least advantage in the bedroom. The severe simplicity of its lines hardly conforms to the daintiness and grace connected, in the feminine mind at least, with the idea of a sleeping room." [2]

Consequently, given the tendency of many people to scrimp on bedroom furnishings, as well as the apparent unpopularity of mission bedroom furniture, it becomes easy to explain its present scarcity. Thus, to the modern collector of Arts and Crafts furniture, the situation has reversed itself, and bedroom furniture, on account of its rarity, has become highly desirable. We are no longer concerned, as our grandparents apparently were, with "daintiness" in our bedroom furniture.

This tall chest of drawers on page 156 is perhaps the epitome of Stickley's Mature Period. It is massive, functional, and severely rectilinear, with the apron

tenons at the bottom the only decorative structural expression. The hardware is the visual focal point of this piece, with the rectangular hammered copper plates stressing the vertical proportion.

This chest was first made in 1909 with oval pulls on small rectangular plates. The 1910 version was changed by replacing the hardware with the big circular pulls and long rectangular plates seen on our example.[3]

The chest of drawers on page 157 is of identical construction, but is lower, wider, and mirror-backed. Note how the mirror frame is joined at each side by Stickley's characteristic butterfly keys.

6 DRAWER CHEST: PRIVATE COLLECTION

5 DRAWER CHEST: COLLECTION OF BETH AND DAVID CATHERS

[1] GRAND RAPIDS FURNITURE RECORD, January 1903.
[2] FURNITURE WORLD, Sept. 10, 1903.
[3] 1910 is the year that Stickley first used these large circular pulls.

CHESTS OF DRAWERS: pages 158/59

The apparent ancestor of these chests is the low chest of drawers designed by Harvey Ellis shown in the July 1903 issue of THE CRAFTSMAN. A later version is shown in THE CRAFTSMAN for September of that year. That chest, designed for a child, relates strongly to our example, but differs from it in many important ways: the sides are paneled rather than veneered, there are five rather than four drawers, the hardware is a simple pull similar to the pull seen on the desk on page 163, and the mirror is separate. However, the bowed legs and curving apron are unmistakably the same.

Another low chest appears in THE CRAFTSMAN in June 1904. The identifying curves remain the same, and the sides are still paneled, but otherwise the form has been very much altered. It now has three small drawers across the top with two large drawers below, and round wooden knobs have replaced the earlier pulls. A gallery has been added to the top of the chest with three small drawers flanked by two small cabinet doors. Interestingly, this chest is made of maple, apparently Stickley's first use of this wood, and is decorated with a small inlay pattern on the doors of the gallery.

This four-drawer chest on page 158 appears in its final form in Stickley's 1905 catalog. It is shown there in two versions. The first, available in oak, maple, or mahogany, is identical to the 1904 version but minus the inlay. The second, also available in the same three woods, is in the final form seen on our example. Offered with either wooden knobs or hammered copper plates and pulls, the final version has lost the small gallery at the top and now has an attached mirror. Butterfly keys join the mirror-supporting frame.

The nine-drawer chest, with bowed sides and arched apron, did not appear until the 1906 catalog, showing this design to be of later origin than the woman's version. In its first appearance it had paneled sides, which were re-

placed by veneer in 1907. The design was produced thereafter with no further modification. The catalog description of this chest refers to "dustproof partitions." These are thin panels of wood set in horizontally between the drawers to enclose each one separately and protect its contents. This is a characteristic of Stickley's work which derives directly from eighteenth-century cabinetwork.

9 DRAWER CHEST: COLLECTION OF BETH AND DAVID CATHERS

4 DRAWER CHEST: COLLECTION OF MR. AND MRS. RUSSELL WILKINSON

9 Desks

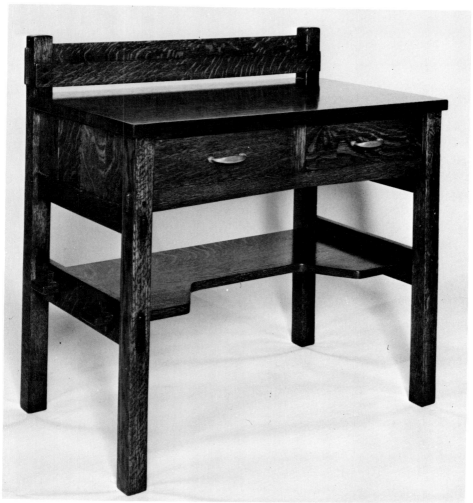

Writing Desk
Gustav Stickley H 34″ W 33″ D 20″ Marking: Decal with Stickley
in rectangle CA. 1902 Oak

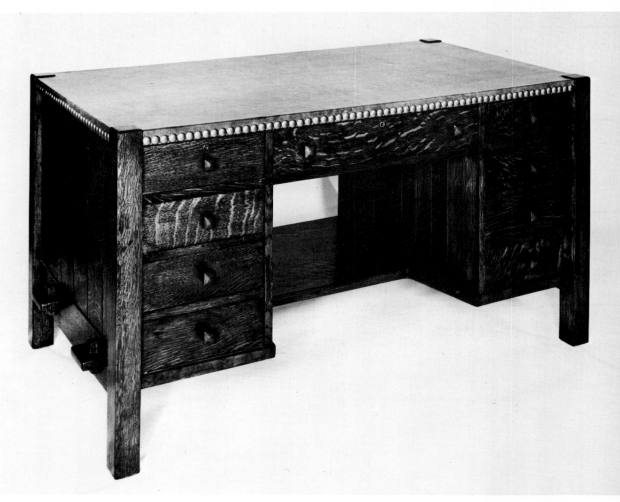

Desk
Gustav Stickley H 30″ W 52¾″ D 30″ Marking: Decal with Stickley
in rectangle CA. 1902/03 Oak

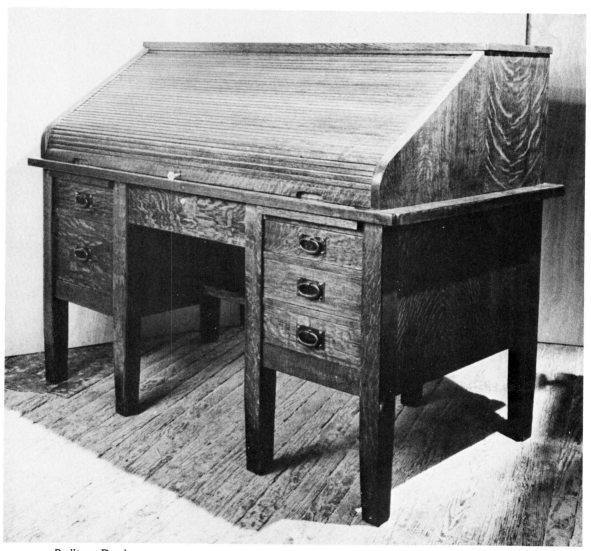

Rolltop Desk
Gustav Stickley H 46″ W 60″ D 32″ Marking: First paper label
CA. 1905/06 Oak

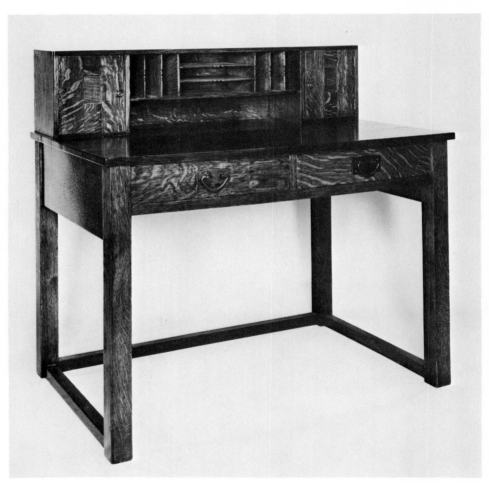

Desk
Gustav Stickley H 40½″ W 42″ D 26″ Marking: Gustav Stickley
decal CA. 1907/08 Oak

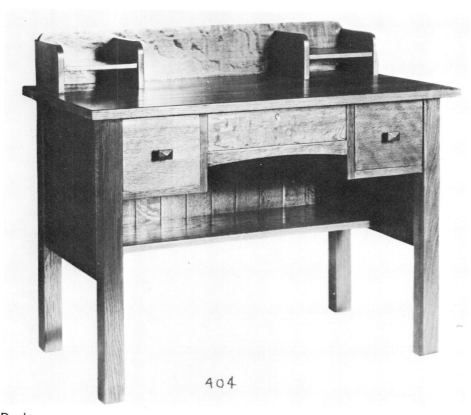

404

Desk
L. & J.G. Stickley H 36″ W 44″ D 22″ Unmarked Ca. 1910/12 Oak

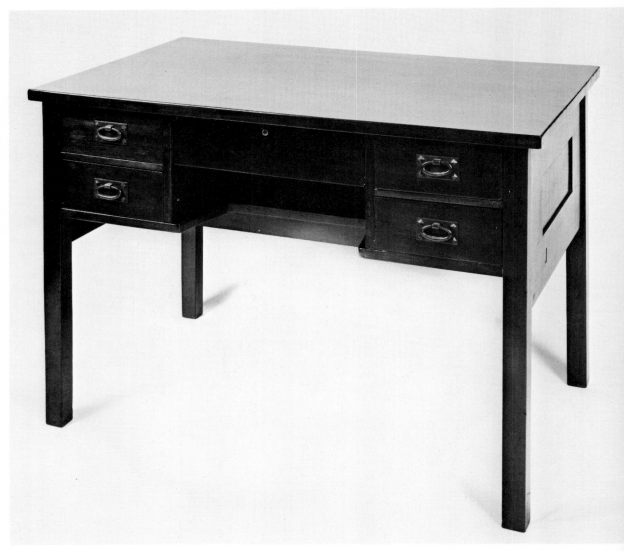

Desk
Gustav Stickley H 30″ W 44″ D 28″ Marking: Gustav Stickley decal
CA. 1906 Mahogany

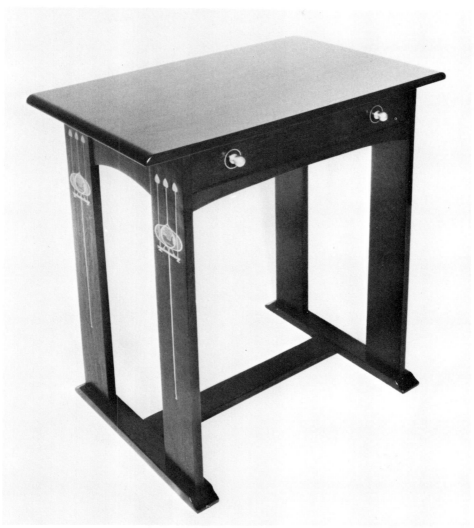

Desk
Gustav Stickley H 30″ W 29″ D 18″ Marking: Decal with Stickley in
rectangle Ca. 1903 Oak

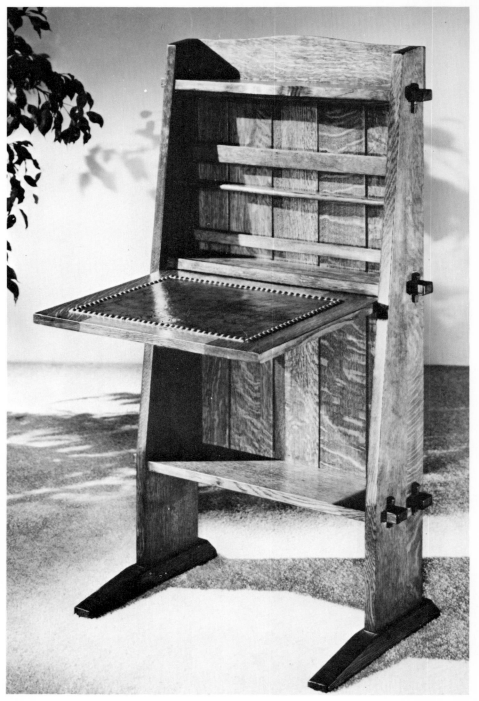

Fall-Front Desk
Gustav Stickley H 46″ W 24″ D 7″ Unmarked CA. 1900/02 Oak

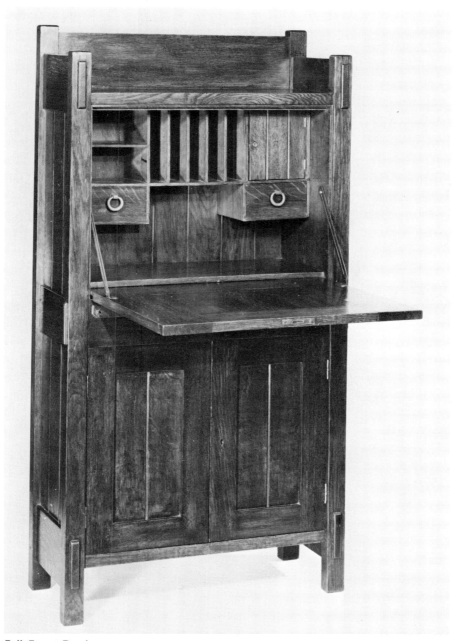

Fall-Front Desk
Gustav Stickley H 51½" W 25¾" D 11½" Marking: Decal with Stickley
in rectangle CA. 1902/03 Oak

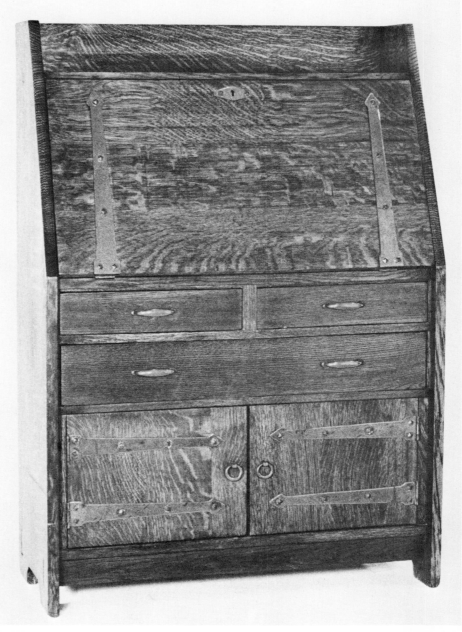

Fall-Front Desk
Gustav Stickley H 47½″ W 32¾″ D 13¾″ Marking: 2½″ decal with
Stickley in rectangle CA. 1903 Oak

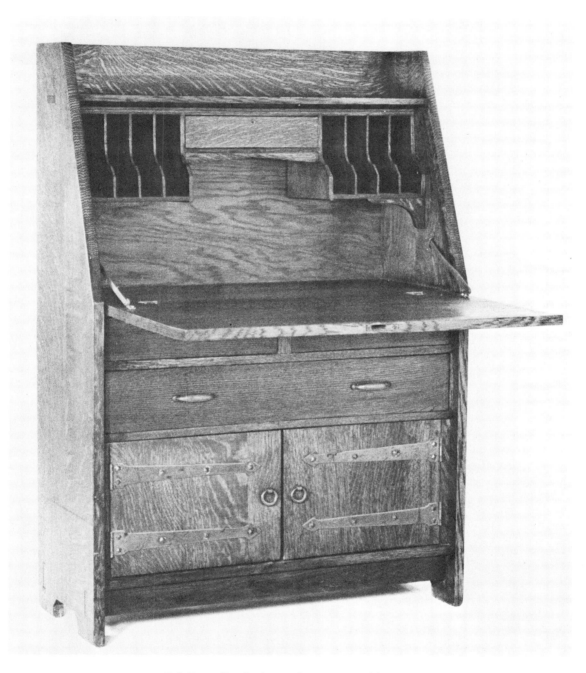

Fall-Front Desk shown in **open** position.

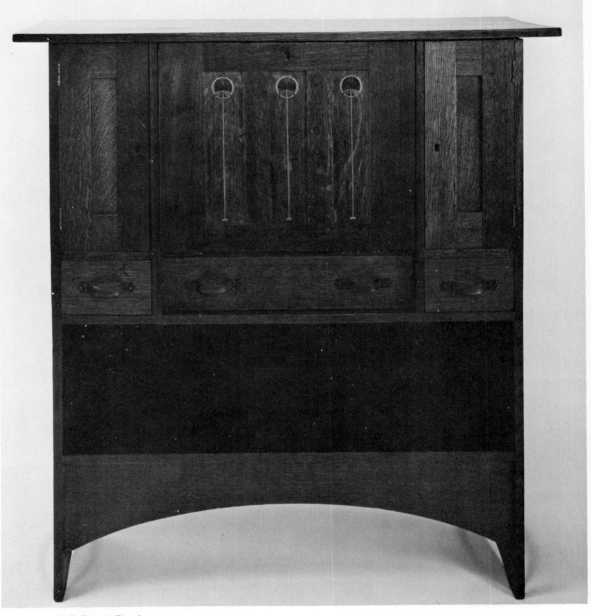

Fall-Front Desk
Gustav Stickley H 46½″ W 42″ D 11½″ Marking: Decal with Stickley
in rectangle CA. 1903/04 Oak

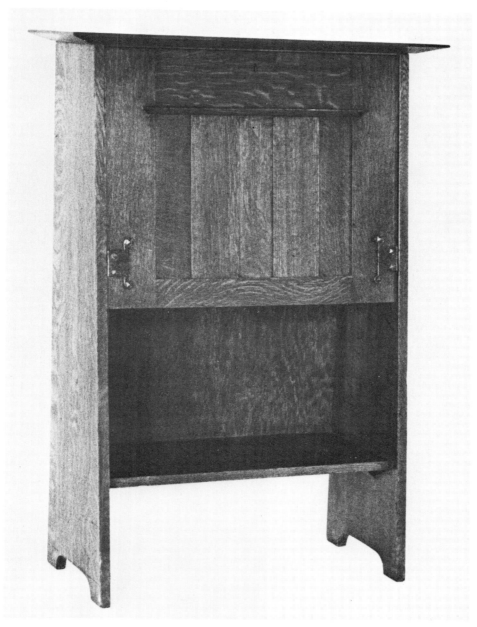

Fall-Front Desk
Gustav Stickley H 44″ W 30″ D 11″ Unmarked Ca. 1904/13 Oak

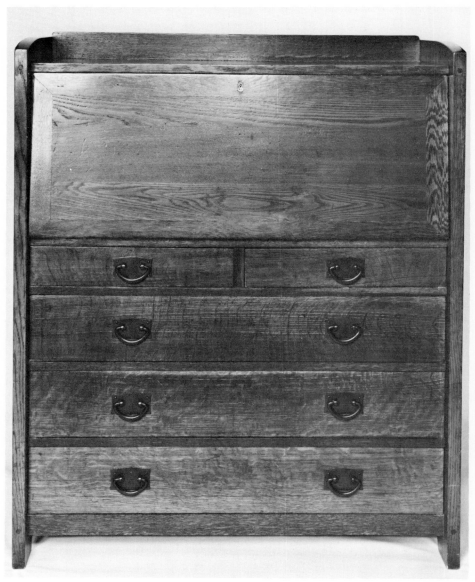

Fall-Front Desk
Gustav Stickley H 44½″ W 36½″ D 15″ Marking: Gustav Stickley decal
in drawer, New York paper label CA. 1908/11 Oak, with chestnut used
as a secondary wood

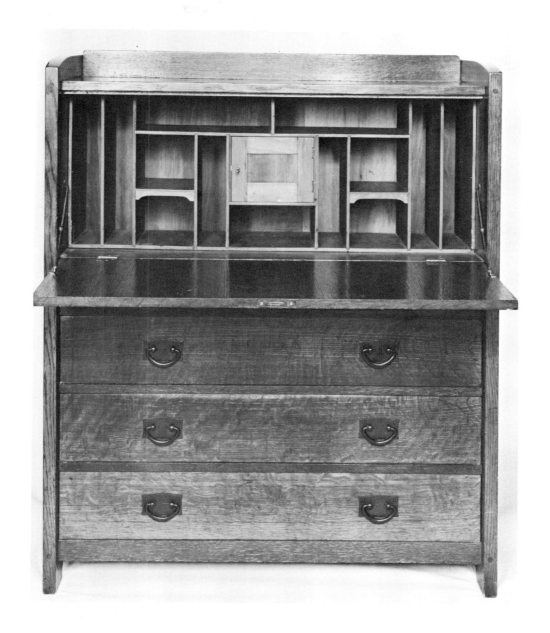

Fall-Front Desk shown in open position.

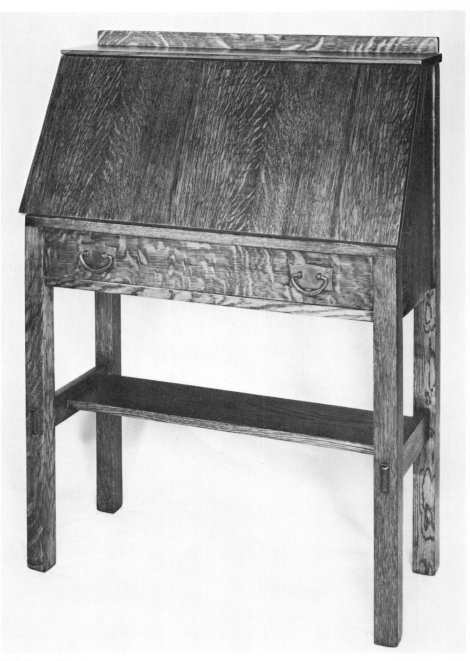

Fall-Front Desk
Gustav Stickley H 42″ W 30″ D 15″ Unmarked Ca. 1906/13 Oak

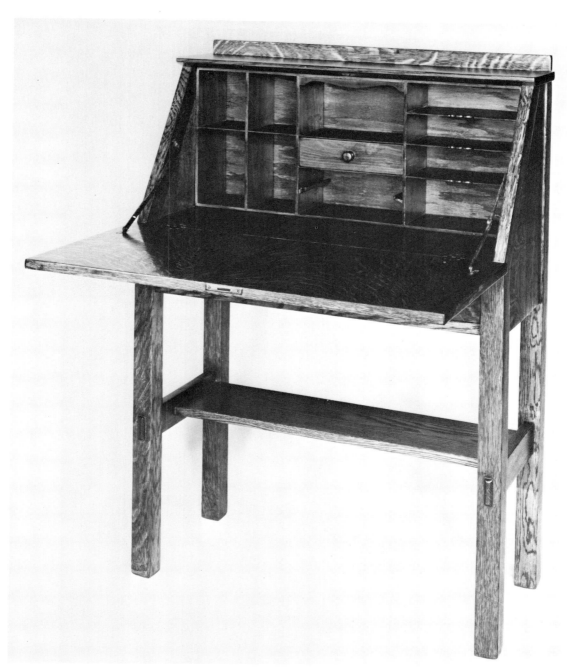

Fall-Front Desk shown in open position.

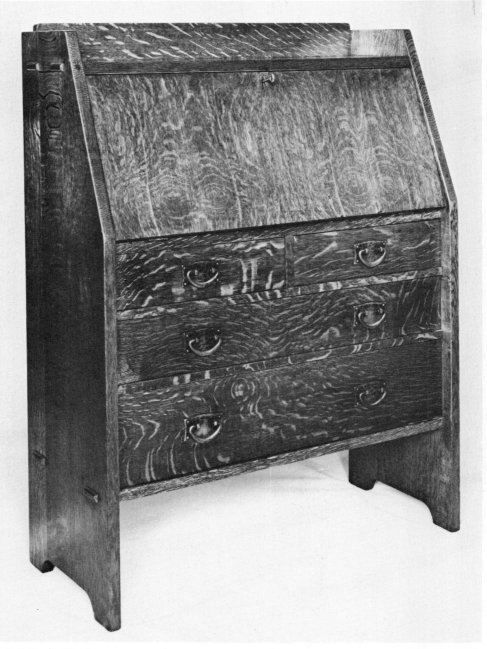

Fall-Front Desk
Gustav Stickley H 43″ W 32″ D 14½″ Marking: Eastwood paper label
and burned-in joiner's compass. CA. 1913 Oak, with poplar secondary
wood

180

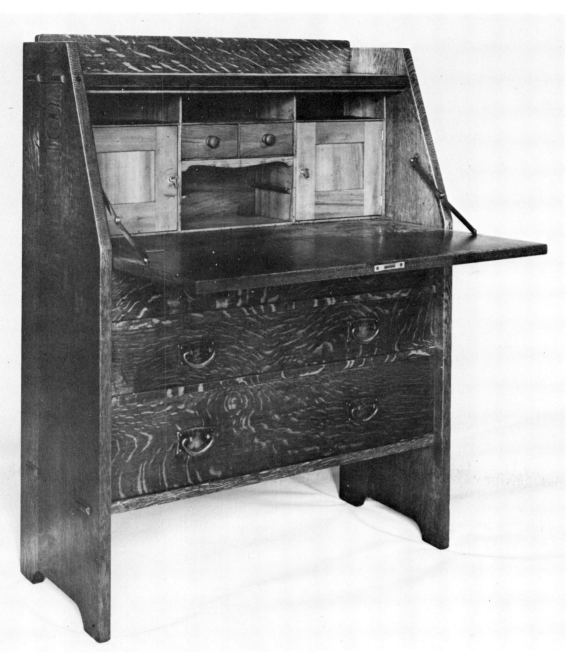

Fall-Front Desk shown in open position.

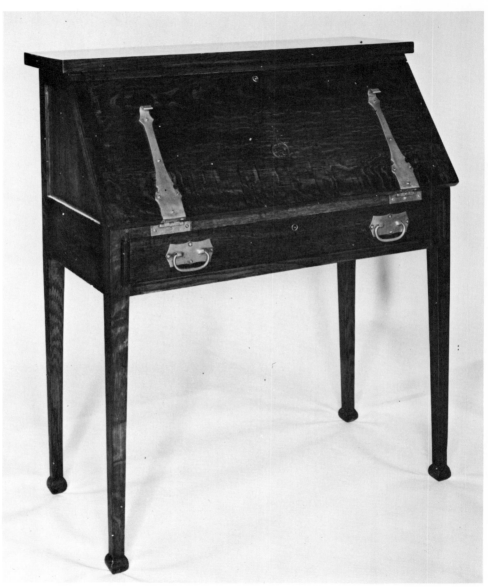

Fall-Front Desk
Roycroft H 46″ W 36″ D 18″ Marking: Orb and cross CA. 1912 Oak

182

WRITING DESK: page 163

Stickley introduced this small desk in the November 1901 issue of THE CRAFTS-MAN with this description: "Writing desk in gray oak; top in sage green leather; wrought iron pulls." In July of that year he had been granted a seven-year patent, #80044, for this "library table-desk."

It is a characteristic First Mission Period design: tenons are mortised through in no less than fourteen separate places, and the four that join the shelf to the stretchers are keyed at both sides. The sides and back of the carcass are butt-joined chamfered boards with internal splines, the apron below the drawers shows the inverted V-shape typical of this period, and the pulls are simple iron handles. The cut-in lower shelf, a practical concession to the user's shins, is an element Stickley unfortunately did not continue to use in later library tables.

The many articulated structural elements of this desk give it a massive look, yet it is actually one of Stickley's smaller-scale desks.

This is the only example of this desk we have seen.

JORDAN-VOLPE GALLERY

DESK: page 164

Like the example on the previous page, this rare desk falls into Stickley's First Mission Period. It is, however, slightly later than that piece, appearing for the first time in his February 1902 catalog. Stickley referred to it as an "office desk," boasting such features as "Two upper end drawers arranged to accommodate a 3 x 5 inch card index system." It could be purchased with wood top for $52; a leather top raised the price to $72.

The desk was apparently still in production in 1903, when it was included in a sketch of the "Great Hall" of an Adirondack mountain camp designed for THE CRAFTSMAN by Harvey Ellis. Needless to say, both the style of the desk and its dates of introduction rule out any possibility that Ellis designed it.

As for the desk itself, the legs rise above the level of the top surface, a modest emulation of Mackmurdo's 1886 flat-top desk. The front and sides are made of chamfered, or V-jointed, boards, and the tenons from the lower shelf are mortised through the lower side rails and keyed. The square faceted drawer pulls are also typical of Stickley's work at this time.

Apparently in 1904 Stickley made some modification to the design: oval pulls and rectangular metal plates replaced the wooden knobs, and the chamfered boards gave way to panels. We have not seen this later desk in a catalog, but it is shown quite clearly in "What Is Wrought in the Craftsman Workshops," a pamphlet Stickley published in 1904.

JORDAN-VOLPE GALLERY

ROLLTOP DESK: page 165

The furniture trade magazines of the first decade of this century are full of ads for oak rolltop desks. They were clearly very popular, as they are again today, and it was inevitable that Stickley would design a Craftsman version.

His rolltop first appeared in the 1905 catalog, but it was actually based on a slightly earlier design. The October 1904 issue of THE CRAFTSMAN showed a desk with a carcass identical to the rolltop's, but with a small ten-drawer cabinet on top. In essence, Stickley created his rolltop design by removing the cabinet and adding the superstructure and tambour of the rolltop.

As a rule, tambours on rolltop desks are held in either an S-curve or C-curve. Stickley, however, rethought this aspect of the design and, in good Craftsman fashion, replaced those curves with a straight line. It is interesting to compare his version of the rolltop with the one designed by L. & J.G. Stickley, which used the conventional C-curve.

One additional distinguishing feature of Gustav Stickley's rolltop is the stylish overhang of the top surface, a detail which adds an element of lightness to this large, massive desk.

YUDOFSKY COLLECTION

DESK: page 166

This desk was apparently made in 1907 or 1908. It is not in Stickley's 1906 catalog, but it is included without illustration in his 1907 "Descriptive Price List." It appears in his 1909 catalog, but without the floor-level stretchers joining the legs. Since it was Stickley's impulse to delete rather than to add details, the pre-1909 date seems certain.

Its gallery top is the desk's most interesting feature because of the exposed dovetails joining the top and sides. Though Stickley always dovetailed drawers, this is the one of only two examples we have seen on which he uses them on the carcass of a cabinet. The paneled doors flanking the open gallery are another handsome detail.

The floor-level stretchers are also worthy of our attention. Though ostensibly structural, their function is more truly visual, by defining the space enclosed within the legs. Without them, the desk becomes a bit topheavy.

The veneered sides of the desk drop below the drawer level, a characteristic Mature Period trait which, by keeping the gallery from visually overpowering the desk body, is more a stylistic than a structural element.

We know of no other example of this desk.

JORDAN-VOLPE GALLERY

DESK: page 167

The introduction of this desk can be traced back to the earliest days of L. & J.G. Stickley's work, probably 1902 or 1903. In its initial appearance, as can be seen by the early undated photograph still in the possession of the factory, its dimensions and basic shape were determined early and never altered. The arch below the blind center drawer and the vertical chamfered boards were two features found on the early version which were continued without change. However, many details are unlike those seen on our later example: the top rail at the back was straight, the galleries on either side of the desk top were simply open rectangular pigeonholes, the drawers had faceted rectangular wooden pulls, the tenons were not mortised through the legs, and the legs themselves were straight rather than tapered.

The desk next appeared in the Onondaga Shops catalog of 1905. The most important functional change to appear in the second version was the introduction of small drawers into the gallery. These drawers, as well as the two larger drawers on either side of the desk, used hand-wrought copper plates with round pulls in place of the wooden knobs. The legs still don't taper, but the side-rail tenons were now mortised through and exposed.

The desk had reached its final form by the time L. & J.G. Stickley published its 1910 catalog. The top rail was now brought to a slight peak, and a letter rack had been added in front of it. The metal hardware had been replaced by round wooden pulls, and for some reason the gallery drawers had been lifted slightly above the desk top, leaving an awkward, useless space beneath. The tenons were still exposed, and the overall appearance of the desk has been nicely improved by the added refinement of tapered legs.

The desk appeared, virtually unchanged, in the post-1912 catalog, but had been dropped from production by 1922.

DESK: page 168

This compact five-drawer flat-top desk first appeared in Stickley's 1906 catalog, though it was apparently designed earlier. In the 1906 catalog it is identical to our example, except for the pulls, which are cast brass handles like those seen on the 1903 fall-front desk on page 112. It is because of this hardware that we think 1904 or 1905 is a likely date for the introduction of this desk.

It is clearly a Mature Period design, with little forthright expression of structure. However, on both ends of the desk Stickley has chosen to expose tenons and cut them flush with the surface. Flush tenons are seen only rarely in his work. The tenons have been formed from the ends of two stretchers which run the length of the desk and support the carcass.

In 1905 and 1906 Stickley offered many of his designs in maple and mahogany, in addition to the more standard oak. Mahogany pieces, such as our

example, are found only rarely. In addition to being available in oak and mahogany, this desk was made in two sizes, 42 or 48 inches long,[1] and could be bought with a leather or a plain wood top.

COLLECTION OF DON CLARK

[1] Our example is 44 inches wide; however, Stickley's furniture frequently varies from the dimensions given in his catalogs. It was, after all, produced by cabinetmakers, not on a production line, and this kind of variation is to be expected.

DESK: page 169

This desk derives from a Harvey Ellis design which he created for "A Child's Bedroom" in the July 1903 issue of THE CRAFTSMAN. That desk has two drawers and square pulls, but is otherwise identical to our example. The July 1903 article states, "The furniture is of quartered oak, of a soft gray green, and has a smooth dull finish, agreeable to both eye and touch."

As with Ellis' other inlay designs, this desk does not depend on the decorative effects of the structural elements. Ellis gave the top a wide overhang, rounded its edges at both ends, arched the aprons below the drawer and at the sides, and dramatically placed the stretchers at floor level. These stretchers, as well as the flat rectangular legs, show the unmistakable influence of Baillie Scott.

The inlay designs on the legs are conventionalized floral motifs borrowed directly from Charles Rennie Mackintosh. A Mackintosh linen press with applied brass fittings of identical shape was shown in INTERNATIONAL STUDIO in 1897, and it is likely that Ellis saw it there. (The linen press is illustrated in Anscombe and Gere, ARTS AND CRAFTS IN BRITAIN AND AMERICA, p. 177.) Ellis clearly liked this motif; in addition to using it on this desk, he repeated it in the July, 1903 article on the front of a tall cabinet and echoed it in the rabbit-and-carrot wall frieze bordering the room.

PRIVATE COLLECTION

FALL-FRONT DESK: page 170

This diminutive fall-front desk is one of Stickley's most eccentric designs, but it is also one of his most visually exciting efforts. It might almost be considered a work of wood sculpture, since it is too small to be completely functional. The long feet are the most extraordinary aspect of this desk; it would be just as stable if they didn't project so far forward, so one can only assume they were incorporated because they pleased Gustav's eye.

186

This desk is illustrated in the Tobey Furniture Company ad in the December, 1900 issue of HOUSE BEAUTIFUL. Here it is called a "Chalet Desk" with a "weathered oak" finish. It retailed for $13. The date of this ad, of course, identifies the desk as one of Stickley's earliest designs. It is also pictured in the November 1901 issue of THE CRAFTSMAN and was still being made in 1902 when Stickley exhibited it at the Mechanics' Fair in Boston.

The most decorative structural elements are the tenon-and-key joints on both sides of the desk. The tenons, formed from the three shelves, are mortised through the sides and hold them in place. The keys are simple wedge shapes, unlike the characteristic rounded and tapered keys of Stickley's Mature Period. The gently swelling top rail is similar in shape to certain chair designs of the same period, such as the side chair on page 35.

The back of the desk is made of vertical chamfered boards, common in Stickley's early work. The drop-front portion of the desk is paneled, and the lower edge forms a multicurved apron. The bottom shelf originally held a rectangular willow basket.

COLLECTION OF DAVID WEXLER

FALL-FRONT DESK: page 171

This small fall-front desk dates from Stickley's First Mission Period. A desk of this design was included in his exhibit at the Pan-American Exposition in 1901; it can be seen (though just barely) in the photograph of his booth in the November 1901 issue of THE CRAFTSMAN. This desk was produced in two versions: one with cabinet doors, as on our example, and one with open shelves.

Perhaps one of the most extraordinary things about Stickley's early work is that as much care was devoted to the back of the piece as to the front. This care is much in evidence here, where the small chamfered boards on the front and sides are repeated on the back. The boards forming the back are sturdy pieces of wood, butt-joined, splined, and finished just as well as the rest of the desk. Note also the chamfering on the small door in the gallery. The center panels of the doors on the lower portion of the desk appear to be chamfered, but they aren't; they are actually decorated with straight incised lines which give that appearance.

In addition to the strap hinges and the chamfering, the decorative elements of this desk are purely structural. Large, double-pinned tenons pierce the front and back legs and break up the otherwise unrelieved flat surfaces. The pieces of wood making up the desk are massively overscale for such a small piece. The legs, too, are used decoratively and rise above the top of the desk, in the manner of the Mackmurdo desk discussed in the stylistic development chapter.

It is interesting that a desk of nearly identical design, but with drawers at the

bottom, was made by the Roycroft Shops and is illustrated in the 1904 Roycroft catalog. It may be derived from this Stickley model.

Very few of these desks are known to us, and this is the only one we have seen with doors over the bottom shelves.

THE BROOKLYN MUSEUM: H. RANDOLPH LEVER FUND

FALL-FRONT DESK: pages 172/73
The most prominent decorative features of this early fall-front desk are its pointed brass strap hinges. Such hinges, which are perfectly consistent with Stickley's belief that structural details are the only valid form of decoration, are characteristic of his First Mission Period designs, and link him with the English Arts and Crafts movement, with Eastlake, and with medieval oak cabinetry.

Totally devoid of curves or moldings, this desk strongly expresses Stickley's pronouncement that "Wood is made to be cut." Although it is solid and massive, the form of this desk has a strong vertical emphasis, accentuated by the upward-pointing strap hinges. To add excitement to this design, Stickley extended the sides of the desk well beyond the drawer fronts, thus creating the "agreeable play of lights and shadows" he liked to bring to his work.

The desk is extremely well made. The three broad horizontal boards composing the fall front are butt-joined and reinforced at the sides by long splines. All three drawers are nicely dovetailed, and the cabinet doors are braced on the inside with chamfered cleats. These cleats are fastened to the doors with lag screws having the same faceted tops as the ones holding the strap hinges. An interesting detail of the gallery is the flattened inverted V-form apron beneath the small drawer. This V-form is found frequently on early Stickley designs.

This desk was introduced in an ad in the April 1903 issue of THE CRAFTSMAN, and seems to be the forerunner of the fall-front desk on page 180.

FALL-FRONT DESK: page 174
The first mention of Stickley's inlaid furniture is found in the July 1903 issue of THE CRAFTSMAN in a two-page ad. This appeared just two months after Harvey Ellis joined the workshops.

Examples of the inlay designs were shown in the Ellis drawings in the same issue and again in August. A few months later, in January 1904, Stickley published an article in THE CRAFTSMAN introducing his line of inlaid oak furniture to his readers. This introductory article spent a good deal of time demonstrating

that the new decorative effect achieved by the inlay was consistent with his principles of simplicity and structural truth. The decorative value of the inlay, Stickley said, was to "make interesting what otherwise would have been a too large area of plain, flat surface. It, in every case, emphasizes the structural lines; accenting in most instances the vertical elements, and so giving a certain slenderness of effect to a whole which were otherwise too solid and heavy."

He further pointed out that the inlay did not look as if it had been applied, since he had so many times attacked applied ornament in his earlier writings. ". . . this ornament . . . bears no trace of having been applied. It consists of fine markings, discs, and other figures of pewter and copper, which, like stems of plants and obscured, simplified floral forms, seem to pierce the surface from underneath."

The inlaid furniture that Ellis designed for Stickley was frequently finished with a black stain, darker than most other Stickley furniture. It is probable that Ellis preferred the darker finish for two reasons: to make the inlay patterns contrast more forcefully with the surrounding wood, and also to minimize the wood grain, whose patterns could detract from the inlay.

Although this desk is the work of Harvey Ellis, the basic form of the desk had been worked out by Stickley by the time Ellis came to the Craftsman Workshops in May 1903. A fall-front desk in that month's issue of THE CRAFTSMAN must have served as a model for this desk: both share wide overhanging tops and flat sides. However, there are important differences. First, the bottom shelf of the May 1903 desk is joined to the desk's sides by tenon-and-key joints. Second, there is no apron and no drawers. Third, the gallery is characteristic of those found on Stickley's early fall fronts and is suspended from the top of the desk. Finally, of course, it does not have inlay.

Next, a desk very similar to the inlaid desk was illustrated in the August 1903 issue of THE CRAFTSMAN, in the above-mentioned Ellis renderings. This August 1903 desk showed several important developments over its May predecessor, and all point clearly to Harvey Ellis. First, the tenon-and-key joints are gone. This is a point worth developing: one of the most important tenets of Stickley's design philosophy was the emphasis on articulated structure as the only valid form of decoration. It is for this reason that his work commonly exhibited massive tenon-and-key joints, exposed tenons, pins, chamfered butt-joined boards, strap hinges, and the like. Ellis, on the other hand, clearly did not completely share Stickley's enthusiasm for expressed structure. His work in general, and this inlaid desk in particular, shows the subordination of the structural to color and purity of form. By removing the tenon-and-key joints from his modification of the May 1903 desk, Ellis was working in perfectly characteristic fashion. The August 1903 desk differed on other points as well: Ellis added a graceful arching apron below the bottom shelf, to stiffen the structure but also to add a sense of lightness to the design. He added two drawers with square pulls, as well as a gallery with gracefully curved shelf brackets, which completely filled the inside of the desk.

Our example represents a further refinement of the August desk. In it, Ellis

has given the design a greater unity by doing things in threes. There are three inlay patterns on three panels. The wide central fall front is flanked on either side by doors, making three access points to the upper portion of the desk. There are three drawers, with a wide central drawer flanked by smaller ones. And the back of the desk is formed of three oak panels, with a broad central panel and two thinner panels on either side.

Finally, it is worth noting that the center drawer is recessed about an inch. There is no apparent functional reason for this; it would seem that it was done simply to break up the flat plane of the desk front and add further interest to the design.

COLLECTION OF BETH AND DAVID CATHERS

FALL-FRONT DESK: page 175

An example of this desk, identical except for the addition of an inlay design, first appeared in the January 1904 issue of THE CRAFTSMAN. It was subsequently produced without inlay, and the design continued to be made for some time: it appears in Stickley's catalogs for 1905, 1906, 1907, 1909, 1912, and 1913. It was made in oak, maple, and mahogany in 1905 and 1906.

The desk has a very English Arts and Crafts look about it, and it is clear that Harvey Ellis was responsible for the design. The top extends well beyond the sides of the desk, and is beveled on the underside, a feature found on designs by both Mackintosh and Voysey. Another distinctive element is the horizontal "lip" attached to the fall-front portion of the desk. This "lip," in the strictest sense, might be said to violate Stickley's own dictum against applied ornament. However, its presence can be justified on three counts: it's functional, since it provides a handle, admittedly small, to grasp to open the desk; the slight overhang of this lip breaks up the flat plane of the desk front; and its shape nicely echoes the shape of the desk top.

The hammered copper hardware, fastened with faceted screws, provides an additional decorative note, and also holds the writing surface steady when the desk is open.

JORDAN-VOLPE GALLERY

FALL-FRONT DESK: pages 176/77

Stickley developed a number of subsidiary designs out of the general configuration of the "basic" bookcase: a china closet, two sideboards, a music cabinet, and other pieces as well. One of the most successful is this fall-front desk.

It first appeared in THE CRAFTSMAN for December 1905, and made its first catalog appearance in 1906. Apparently, it developed out of a similar desk which is shown in the 1905 catalog. The earlier desk has the same slab side topped with the "basic" bookcase curve, but the sides of the piece recede at a slight angle and give the design a somewhat awkward look. Further, it has open shelving rather than drawers at the bottom.

Our example shows this design to be the essence of Stickley's mature style. It is pinned top and bottom, and chamfered tenons pierce the sides. However, these structural elements are clearly subordinated to the overall form of the piece. The fall front itself is oak veneer on chestnut, a wood Stickley frequently used under veneer.

COLLECTION OF LOU HOLLISTER

FALL-FRONT DESK: pages 178/79

This one-drawer fall-front desk was first made in 1906, appearing in Stickley's catalog that year.

The simplicity of the design would seem to indicate that it was developed fairly late in Stickley's career, but this is not the case. A desk of the same basic shape and dimensions, but with one deep drawer and stretchers rather than a shelf joining the legs, appeared in December 1900 in the Tobey Furniture Company ad in HOUSE BEAUTIFUL. This, then, is one of those rare Stickley designs whose origins may be traced back to the Experimental Period and which continued to be produced almost without change for the duration of his Arts and Crafts furniture production.

PRIVATE COLLECTION

FALL-FRONT DESK: pages 180/81

First made in 1910, this fall-front desk is another prime example of Gustav Stickley's Final Mission Period. Its overall form is reminiscent of the earlier fall-front desk on page 172, though here the proportions are boxier and less dramatic, and the strap hinges and cleated doors are gone.

As we would expect of a desk designed this late in Stickley's career, its shape is quite severe. Except for the tenons mortised through both sides, there is no structural decoration. Yet Stickley relieves the severity with the warm patina and textured surface of the hand-hammered copper pulls and plates, the dramatic "flake" of the quartersawn oak, and the matching grain patterns on the veneered fall front.

PRIVATE COLLECTION

FALL-FRONT DESK: page 182

This Roycroft desk, which was made in both oak and mahogany, was shown in the 1912 catalog and identified as a "Ladies' Writing-Desk." Its top is a very thick board slightly protruding over the fall-front portion of the desk. It has long strap hinges which curl away from the surface to form handles, and sliders flank the drawer to support the fall front when it is open. The legs are long and tapering and terminate in the typical swelling Roycroft foot.

It is interesting to compare this desk with the one-drawer Gustav Stickley fall front on page 178. They are essentially the same form, yet the Roycroft version differs greatly from Stickley's. Stickley's desk is handsome but uninspired, a routine application of Craftsman principles to the small fall-front desk. The Roycroft desk, with its deep, bulky carcass and long tapering legs, runs the risk of eccentricity and inharmonious proportions but it has a drama which the Stickley effort clearly lacks.

All Roycroft furniture is fairly rare, and this desk is no exception. We have seen only four examples.

JORDAN-VOLPE GALLERY

10 Servers and Sideboards

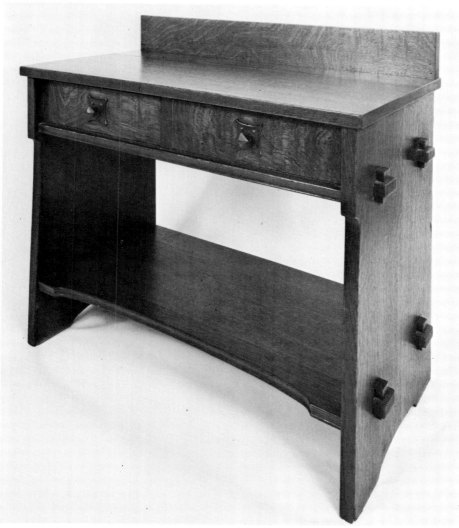

Server
Gustav Stickley H 37¾″ W 41¾″ D 20¾″ Marking: 1½″ decal with
Stickley in rectangle Ca. 1901/02 Oak

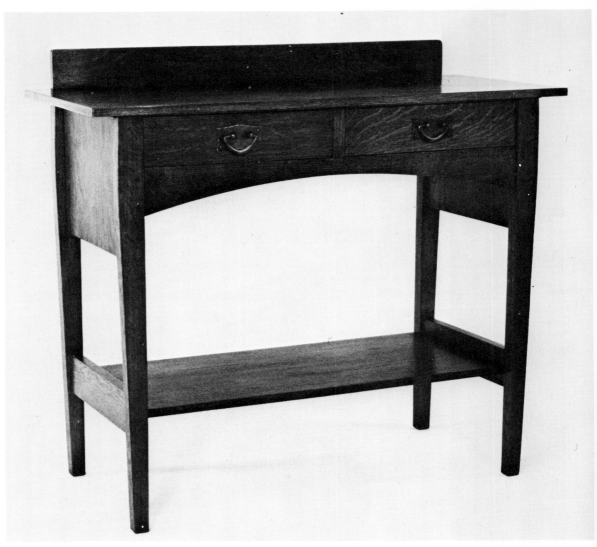

Server
Gustav Stickley H 36″ W 42″ D 18″ Marking: New York paper decal
and Gustav Stickley decal CA. 1907/11 Oak; chestnut secondary wood

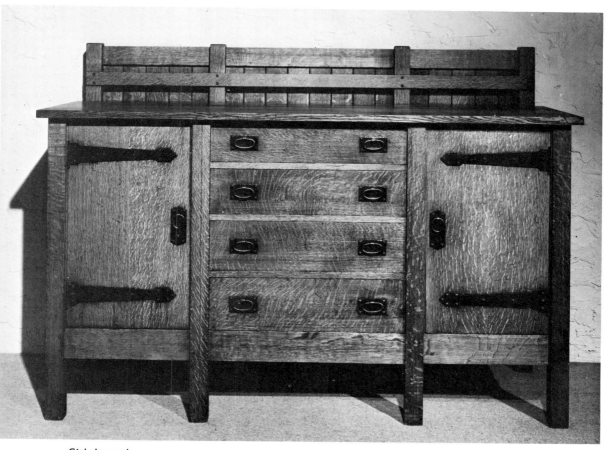

Sideboard
Gustav Stickley H 39″ W 54″ D 21″ Marking: Gustav Stickley decal
Cᴀ. 1904-1910 Oak, with chestnut secondary wood

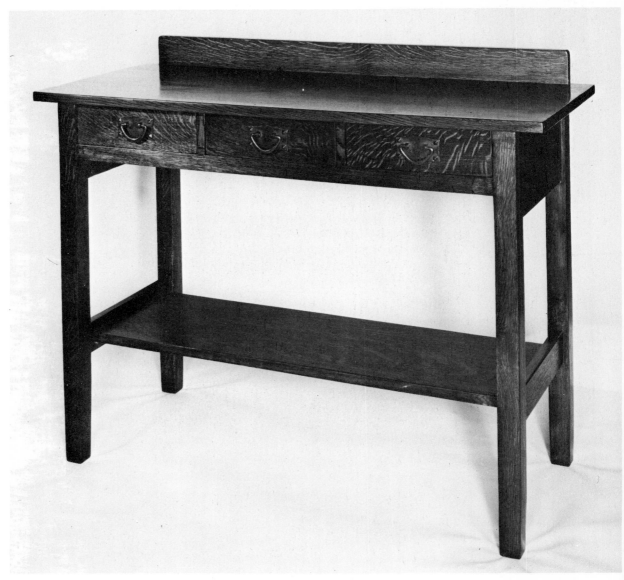

Server
Gustav Stickley H 38″ W 42″ D 18″ Marking: Gustav Stickley decal
CA. 1910 Oak

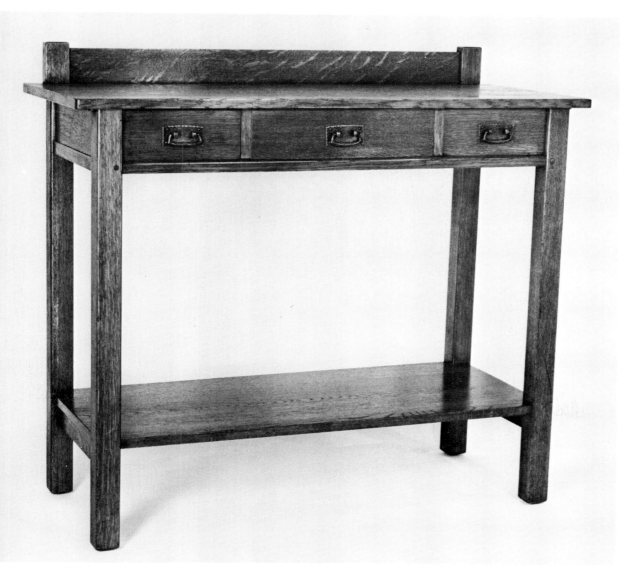

Server
L. & J.G. Stickley H 39½″ W 44″ D 18″ Marking: The Work of L. & J.G.
Stickley decal CA. 1912 Oak

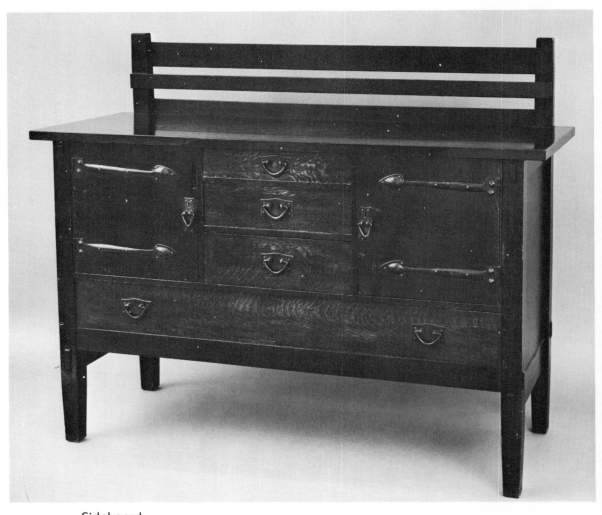

Sideboard
Gustav Stickley H 49″ W 60¼″ D 21″ Marking: Gustav Stickley decal
Cᴀ. 1905/08 Oak

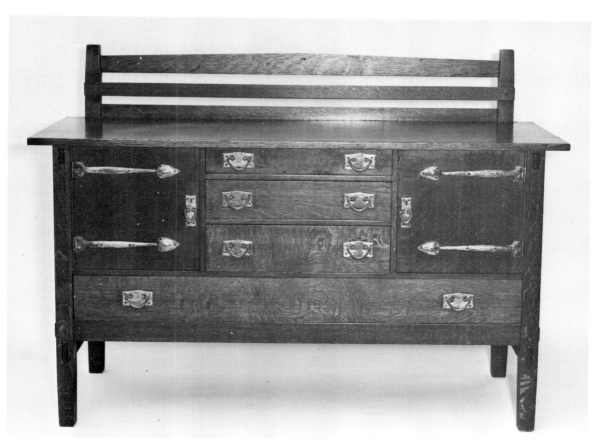

Sideboard
Gustav Stickley H 49″ W 66″ D 24″ Marking: Gustav Stickley decal
CA. 1907/12 Oak

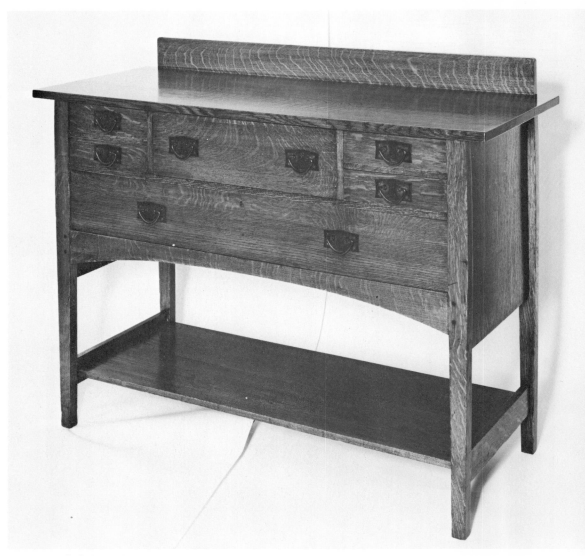

Sideboard
Gustav Stickley H 50″ W 70½″ D 26″ Marking: Decal in drawer,
New York paper label CA. 1908 Oak

200

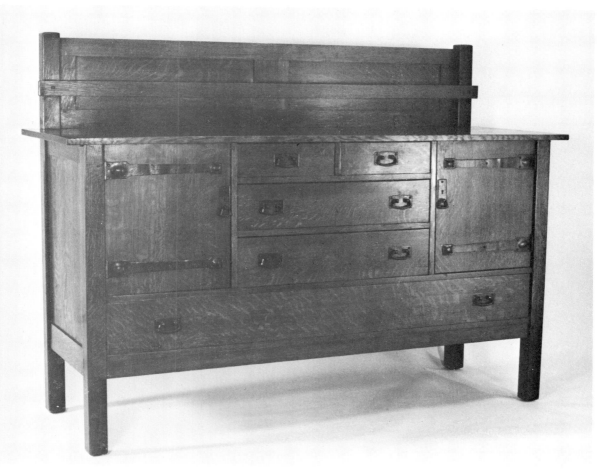

Sideboard
L. & J.G. Stickley H 48″ W 66″ D 22″ Marking: "The Work of L. & J.G. Stickley" decal CA. 1912/15 Oak

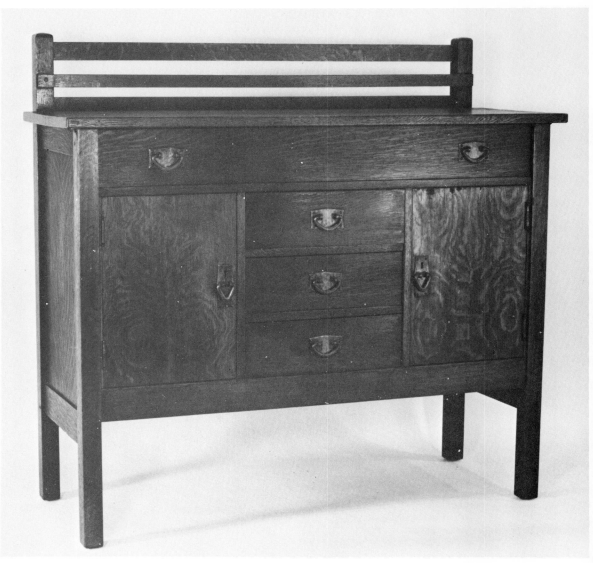

Sideboard
Gustav Stickley H 48″ W 48″ D 18″ Marking: Burned-in mark
CA. 1912 Oak

SERVER: page 193

This server exhibits the massive scale and articulated structural details of Stickley's First Mission Period, yet it retains some characteristics of his first experimental designs. No documentation has yet been found for this design: it does not seem to be pictured in any of Stickley's publications, and we have not seen another example. It is similar to a small sideboard pictured in "Chips from the Workshops of Gustave Stickley" (1901).

Many details indicate a 1901 manufacturing date. This hardware first appears in "Chips" on the above-mentioned sideboard. The backplate is cast iron in the form of a squared-off butterfly and retains filing marks. The square faceted pull is a form found only on pieces made between 1901 and 1903, in either wood or metal.

This massive piece has four tenon-and-key joints on each side, and the keys are simple wedge shapes. The front of the stretcher has a sweeping concave curve, which is molded. The same molding is repeated on the apron beneath the drawers. By 1903, writing in the December issue of HOUSE BEAUTIFUL, Stickley had determined that molding was improper for furniture: "The final justification of the structural style of cabinetmaking lies in its treatment of wood as wood: it respects the medium with which it deals, taking full advantage of its qualities, yet making no demands on it which it is not able to meet. The straight lines follow and emphasize the grain and growth of the wood. . . . Wood is designed to be cut, and metal to be molded."

COLLECTION OF BETH AND DAVID CATHERS

SERVER: page 194

An entire dining-room set with bowed sides on all the case pieces appeared for the first time in the October 1903 issue of THE CRAFTSMAN. As we have indicated elsewhere in this book, these graceful pieces derive from the work of Harvey Ellis, although it cannot be said with certainty that he actually designed them. Even though he was still alive when this dining-room set first appeared in THE CRAFTSMAN, the drawings of the set are not his work. Because of this fact, it seems most likely that Stickley designed these pieces himself, but that Ellis was the source of his inspiration.

The server, in its first appearance, was almost identical to our example, the only difference being that it had simple pulls, identical to those on the desk on page 172. The server next appeared in THE CRAFTSMAN in October 1904, where it had attained its final form with the standard hammered copper hardware of Stickley's mature style. It was subsequently produced unchanged until 1911; by 1912 Stickley had stopped making it.

PRIVATE COLLECTION

SIDEBOARD: page 195

During the writing of this book we have examined four different examples of this sideboard. We found that the heights varied from 48¾ to 50 inches, the lengths from 67½ to 70½ inches, and depths from 24 to 26 inches. It is understandable that these dimensions might shift over a period of years, but that is an inadequate explanation. This design first appeared in THE CRAFTSMAN for November 1901 and in Stickley's catalog for 1902. It was still in production in 1913 when he issued that year's catalog. In every catalog where this sideboard is shown, the dimensions are given as H 50″, W 70″, D 25″. In other words, the catalogs show that the dimensions did not shift over a period of years. Instead, it is clear that they vary from piece to piece, a fact which we have observed on other examples of Stickley furniture. How can this variation be explained?

Perhaps the total answer will never be known, but most likely it can be attributed to Stickley's manufacturing methods. Although he believed in using machines to make furniture, we must remember that it was nonetheless hand-made by skilled cabinetmakers. It was not made on a production line, and therefore we should expect variation rather than uniformity of dimension.

As to the sideboard itself, it is an exciting example of Gustav at his medieval best. It is a monumental piece of furniture, massive and strong, but with carefully adjusted proportions which save it from clumsiness. When it was introduced in 1901, it exhibited the traits we have come to recognize as typical of Stickley's First Mission Period. Tenons were exposed on the legs and at the sides of the plate rack. The cabinet doors, as well as the back of the carcass, were made of chamfered boards. On the center drawers, Stickley used square wooden knobs, while each door carried a key escutcheon and sharply pointed strap hinges of iron or copper.

In the May, 1902 issue of THE CRAFTSMAN, Stickley showed a sideboard with an open cupboard top; the body of this piece is identical to the sideboard under discussion. Already some important details have changed: tenons are no longer exposed, the chamfering has disappeared from the doors, and the strap hinges have assumed a sort of hammerhead shape. Then in THE CRAFTSMAN for March 1903 the sideboard appears again, unchanged except for the strap hinges, which have taken on the blunted-arrow shape of our example. It is seen again, unchanged, in the April 1904 issue of THE CRAFTSMAN.

The sideboard appears in its final form in the November 1908 issue of THE CRAFTSMAN. Only the hardware has changed from when we last saw it: there are now oval metal pulls on the drawers and round metal pulls on the doors, and the ends of the strap hinges have become rectangular.

One thing that didn't change about this massive sideboard is the price: it remained at $84 all the years it was made.

COLLECTION OF JOHN BUTTON

SERVERS: pages 196/97

These two serving tables are basically of the same design, but the many differ-ences between them clearly contrast the work of Gustav Stickley and L. & J.G. Stickley. They are both in the mature style of the makers: they are strongly rectilinear, are devoid of dramatic structural detail, and use the hand-hammered hardware typical of this period. Both are excellent examples of American Arts and Crafts furniture, but the small differences between them show the Gustav Stickley piece to be superior.

The back rail of the Gustav Stickley server is one piece of wood, fastened to the back of the carcass with countersunk screws. On the L. & J.G. Stickley server, the back rail looks as if it is a continuation of the rear legs, but in actuality it is simply three pieces of wood doweled into the top surface. The Gustav Stickley back rail is thus better integrated with the piece as a whole, and is also more honestly expressed than the L. & J.G. Stickley back rail.

The three drawers of the Gustav Stickley server are of equal size, while the center drawer on the L. & J.G. Stickley server is larger than the two drawers flanking it. By making the drawers all the same size, Gustav Stickley has given his server a unified look, and makes it more functional as well, since the side drawers on the L. & J.G. Stickley server are a bit small to be fully functional.

The apron below the drawers on the Gustav Stickley server is flush with the drawer fronts and extends downward well over an inch. The sides of the car-cass extend even lower, a purely decorative detail which heightens the effect of massiveness. The apron below the drawers on the L. & J.G. Stickley server protrudes slightly and is chamfered back to the drawer fronts. The same cham-fering is found on the sides, all of which detracts from a sense of unified design.

The legs of the Gustav Stickley server, with characteristic crisp, sharp corners, taper slightly to the floor. The L. & J.G. Stickley legs, with their typical rounded corners, have no taper, and are simply too heavy for such a light-looking piece of furniture. Further, the lower shelf of the Gustav Stickley server is basically a stretcher, deep enough to be functional but not so big as to overpower the rest of the server. This is not the case with the L. & J.G. Stickley server, whose lower shelf fills the entire area between the legs and is too big in relation to the top.

To the untutored eye, these pieces might be nearly indistinguishable from each other. But careful examination of the details of design and proportion show how different they really are.

GUSTAV STICKLEY SERVER: COLLECTION OF MR. AND MRS. LARRY SHAR

L. & J.G. STICKLEY SERVER: COLLECTION OF JOHN GOLDMAN

SIDEBOARDS: pages 198/99

Gustav Stickley introduced the Mature Period sideboard on page 198 in 1905; it appeared in that year's catalog as well as in his 1905 pamphlet "The Crafts-man's Story." His 1906 catalog also carried it.

With the exceptions of the tenons, which are mortised through the legs, it exhibits the plainness characteristic of his mature style, its good looks depend-ing more on right proportion than expressed structural detail. The handsome graining on the doors and sides is achieved by the use of carefully matched oak veneers. The strap hinges are the only real throwback to the First Mission Period.

1908 was the last year this 60-inch-wide sideboard was produced. This can be documented by the fact that it appeared in the November 1908 issue of THE CRAFTSMAN but does not appear in the 1909 catalog—indicating that it had been dropped from the line at the end of 1908.

It was replaced by a sideboard of nearly identical design, but 4 inches shorter. This version, 56 inches wide, first was made in 1909 and was included in that year's catalog. The earlier 60-inch sideboard and the later 56-inch sideboard are nearly impossible to distinguish without measuring; however, there are differences which become apparent upon careful examination. The 60-inch sideboard has a flat plate rail, while the rail on the 56-inch version rises to a slight peak. Further, the 60-inch sideboard always has tenons mortised through the front legs; this detail appears only on some of the later 56-inch examples.

The 66-inch sideboard on page 199 first appeared in the 1907 "Descriptive Price List." It is easily differentiated from the 56-inch and 60-inch designs by its overall larger size (H 49″, W 66″, D 24″), its horizontal proportions, and its use of two pulls on each center drawer.

66-INCH SIDEBOARD: MUSEUM OF FINE ARTS, HOUSTON
60-INCH SIDEBOARD: ST. LOUIS ART MUSEUM

SIDEBOARD: page 200

The first version of this diminutive sideboard appeared in the October 1903 issue of THE CRAFTSMAN. It was shown in an article entitled "A Simple Dining Room," which also included a serving table (page 194), a china closet, a hang-ing plate rack, a five-legged table, and chairs. In its first appearance, this side-board had cast brass pulls similar to those on the fall-front desk illustrated on page 172, but was otherwise identical to our later example.

This piece, indeed the entire dining-room set of which it is a part, was designed for small homes and consequently was lighter in actuality and ap-

pearance than most Craftsman furniture. As the article in THE CRAFTSMAN pointed out: ". . . the buffet has been so constructed as to present no solid front of wood."

As with the other pieces in this dining-room set, the piece clearly evolved out of Harvey Ellis's work. It has the same characteristics he developed for Stickley's inlay line: broad overhanging top, bowed sides, arched apron, veneered sides (oak over chestnut), and paneled back.

Our example shows how Stickley took Ellis's design vocabulary and translated it into his own Craftsman idiom. Note the sturdy hammered copper drawer pulls and plates, the exposed pins locking the mortise-and-tenon joints which hold the apron to the front legs, and the richly figured, fumed quartersawn oak.

This sideboard achieved its ultimate form with the appearance of the "standard" hammered copper hardware in 1904, and appeared unchanged in Stickley's catalogs for 1905, 1906, and 1910. It was phased out of production in 1910.

WIGMORE COLLECTION

SIDEBOARD: page 201

This late-designed L. & J.G. Stickley sideboard was introduced in the post-1912 furniture catalog. It was still in production in 1922, when it appeared in that year's catalog, unchanged except that the strap hinges had pointed rather than squared-off ends. It is a very handsome piece which this photograph does not do justice to.

It is very similar to the 66-inch-long Gustav Stickley sideboard on page 195. Not only does it have the same basic dimensions, it also has the same drawer arrangement (except that the top center drawer has been divided into two) and the same hardware setup. It also has a similar overhanging top which helps counter the bulkiness of the carcass. It is different from the Gustav Stickley sideboard in that its plate rack is paneled rather than open, its legs are straight rather than tapered, and its horizontal rails are not mortised through the legs.

Despite the similarities which these two sideboards share, they really look nothing alike. The carcass of the Gustav Stickley example sits up relatively high on its legs, and that, combined with the open plate rack and tapered legs, provides a sense of lightness to this massive piece. In contrast, the carcass of the L. & J.G. Stickley sideboard is closer to the floor, and, with its paneled plate rack and straight legs, has a somewhat ponderous look that Gustav Stickley's design was able to avoid.

COLLECTION OF DAN FLAVIN

SIDEBOARD: page 202

By the beginning of his Mature Period, Gustav Stickley was becoming increasingly concerned with producing smaller-scale furniture—furniture to fill the needs of families living in smaller homes. This sideboard represents one of his attempts to reach what he perceived as a growing market.

It was first offered in his 1906 catalog, and first appeared in THE CRAFTSMAN for February 1906. The first version had a slightly curved apron and an open shelf below two center drawers. By 1907, the open shelf had been replaced by a third drawer. Then, in 1912, the curved apron gave way to a straight one, as on our example.

Though a modest piece, and not an especially exciting design, this sideboard is as well made as any of Stickley's furniture of his Final Mission Period, showing that he lavished as much attention on lesser pieces as he did on his more costly work.

COLLECTION OF MR. AND MRS. JEFFREY OPPENHEIM

11 Tables

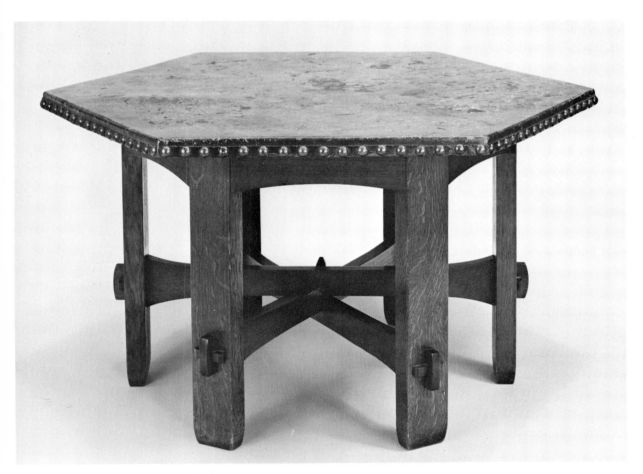

Hexagonal Library Table
Gustav Stickley H 30″ W 48″ at smallest point; 55″ at widest
point Marking: Decal with Stickley in rectangle CA. 1902/03 Oak

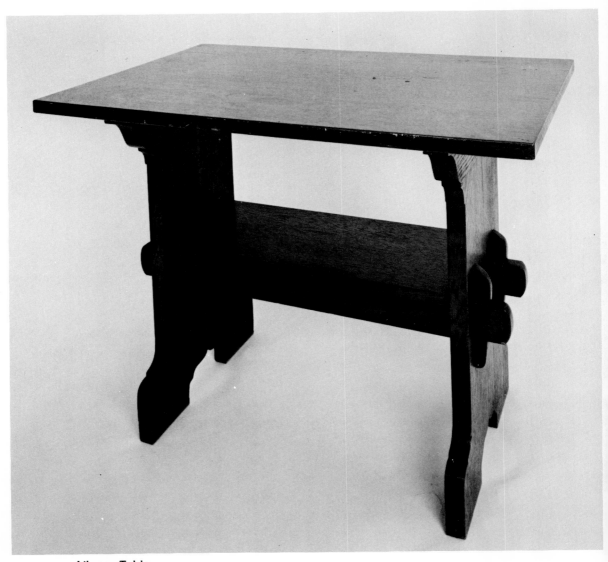

Library Table
Gustav Stickley H 28″ W 36″ D 24″ Marking: Joiner's compass decal
in rectangle CA. 1902/03 Oak

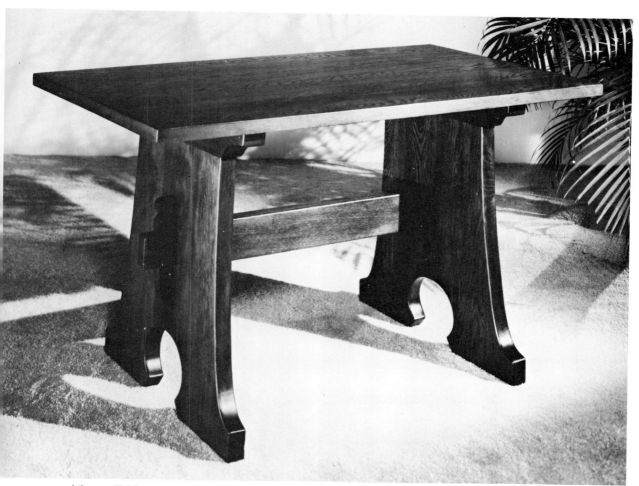

Library Table
L. & J.G. Stickley H 29″ W 48″ D 30″ Unmarked
CA. 1912/22 Oak

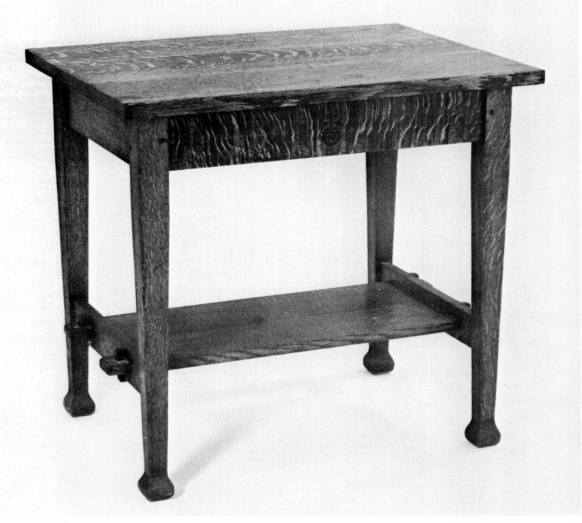

Library Table
Roycroft H 28″ W 30″ D 22″ Marking: Orb and cross CA. 1912 Oak

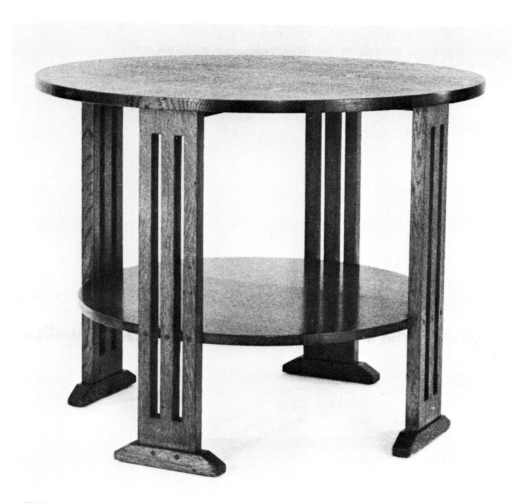

Table
Gustav Stickley H 30″ Dia. 30″ Marking: New York paper label
CA. 1907/08 Oak

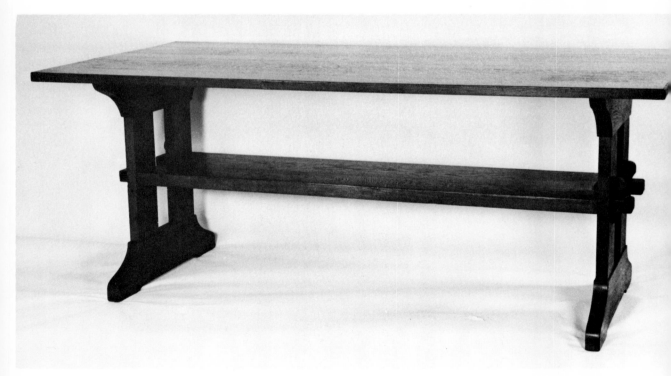

Library Table
Gustav Stickley H 29½" W 35½" L 72" Unmarked CA. 1909/12 Oak

214

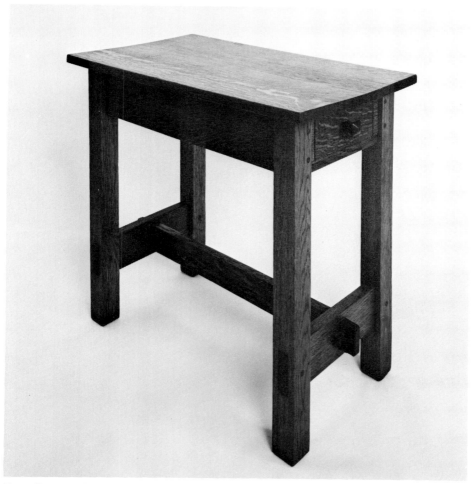

Two-Drawer Table
Gustav Stickley H 29″ W 17¾″ D 30″ Marking: 1½″ decal with Stickley
in rectangle Ca. 1902 Oak

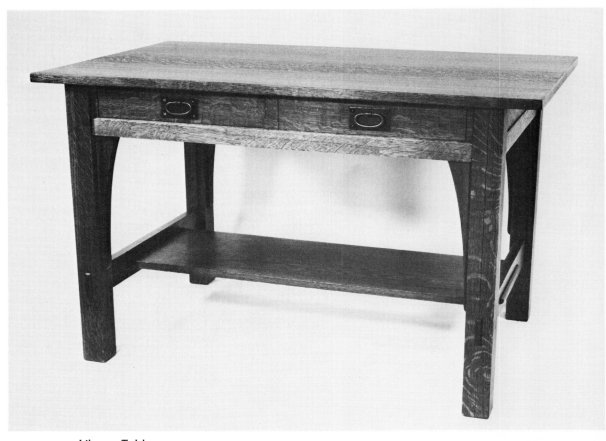

Library Table
Gustav Stickley H 30″ W 42″ D 30″ Marking: Gustav Stickley decal
Cᴀ. 1909 Oak

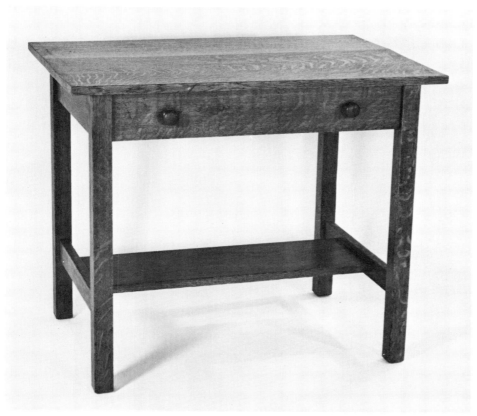

Table
Gustav Stickley H 30″ W 36″ D 24″ Marking: Gustav Stickley decal
Ca. 1910 Oak

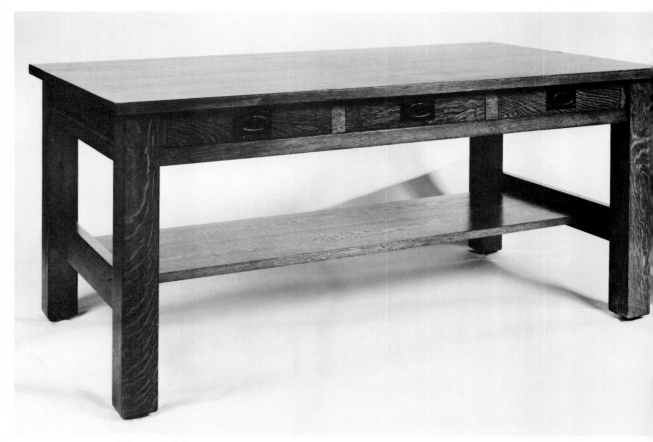

Library Table
Gustav Stickley H 30″ W 66″ D 36″ Marking: Gustav Stickley decal
CA. 1904/12 Oak

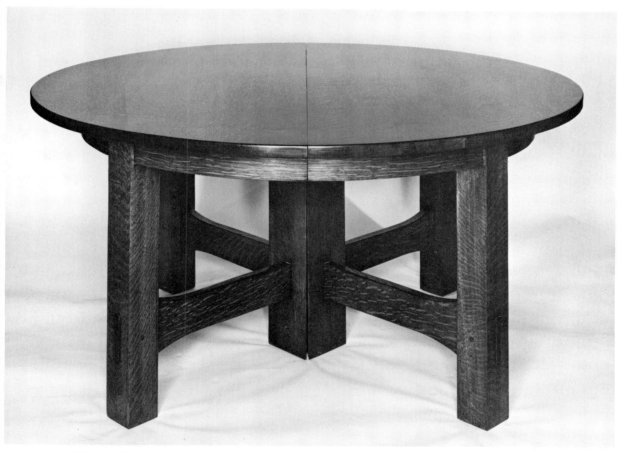

Dining-Room Table
Gustav Stickley H 29″ Dia. 60″ Marking: First paper label
CA. 1906 Oak

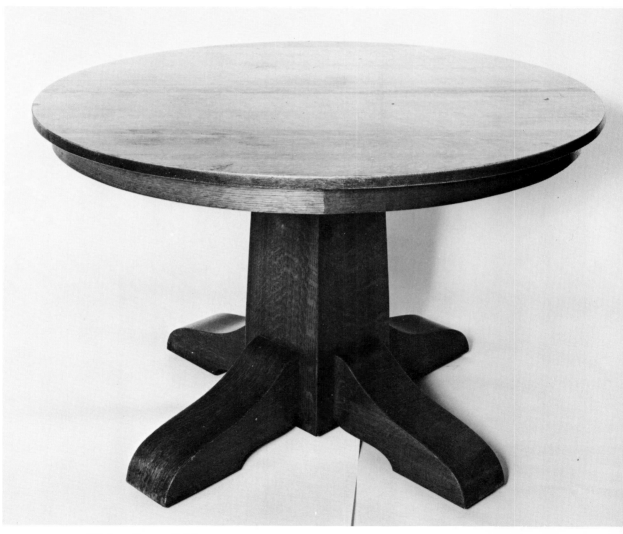

Dining-Room Table
Gustav Stickley H 30″ Dia. 54″ Marking: First paper label
CA. 1906 Oak

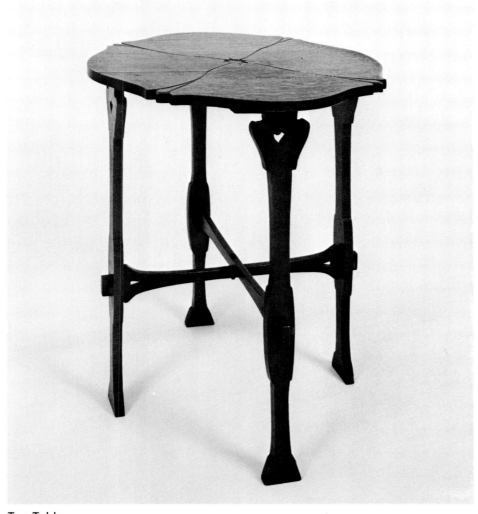

Tea Table
Gustav Stickley H 24″ Dia. 20″ Unmarked CA. 1900/1901

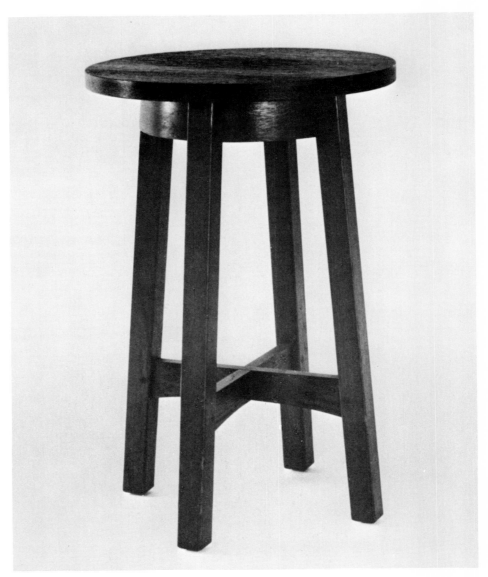

Drink Stand
L. & J.G. Stickley H 28″ D 18″ Unmarked Ca. 1910 Oak

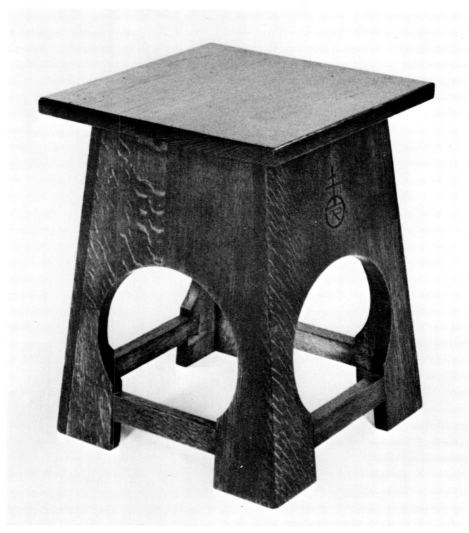

Tabouret
Roycroft H 21″ Top 16″ square Marking: Orb and cross CA. 1912 Oak

HEXAGONAL LIBRARY TABLE: page 209

Originally part of the furnishings of Craftsman Farms, Stickley's home in Morris Plains, New Jersey, this table is now in the collection of the Metropolitan Museum of Art in New York.[1]

The design first appeared in Stickley's 1901 furniture catalog, and was produced unchanged until 1909. It is an exciting design, because of the hexagonal shape of the top and the massive stretchers joining the six legs. The flaring stretchers, the faceted vertical dowel pinning them together at the center of the table, and the tenon-and-key joints on each leg all relate this design back to the fragile, diminutive Celandine tea table of 1900, seen on page 221. With this hexagonal table, however, Stickley had arrived at the kind of massive proportion, durability, and strength which characterized his best work.

He introduced a modified version of this table in the 1910 catalog. The most obvious difference in the later table is the absence of tenon-and-key joints fastening the stretchers to the legs. There are other changes: the arched aprons were now straight, the legs became square in section rather than rectangular, and the three cross stretchers are replaced by six half stretchers joined at the center.

This later version first appeared in THE CRAFTSMAN in June 1910. The illustration there is worth noting because it is the work of Victor Toothaker, an artist who had previously been employed at the Roycroft Shops in East Aurora.

THE METROPOLITAN MUSEUM OF ART, GIFT OF CYRIL FARNY IN MEMORY OF PHYLLIS HOLT FARNY, 1976.

[1] This is the same table pictured in Clark, ARTS AND CRAFTS MOVEMENT IN AMERICA, p. 43.

LIBRARY TABLE: page 210

This rare Gustav Stickley library table shows the strength, scale, and decorative structural characteristics of his First Mission Period. It first appeared in the October 1900 issue of HOUSE BEAUTIFUL in an article on Stickley furniture entitled "Some Sensible Furniture." The article is the result of a publicity effort by the Tobey Furniture Company of Chicago, which was then distributing Stickley's work under the name "New Furniture." The table was described as follows: "Another table is characterized by the strength and simplicity which are the salient features of the "New Furniture," achieving a result distinctive and impressive. It is the Belgian construction of slot and pin—a table one feels would have delighted the soul of Ruskin, its genuineness is so apparent."

A longer version of this library table was pictured in the November 1901 issue of THE CRAFTSMAN and in Stickley's April 1902 catalog. Also, a table of this design was used by Greene and Greene in the Culbertson house, which they built in Pasadena in 1902. It is shown in Makinson's GREENE AND GREENE, p. 124.

Writing in "Chips from the Workshops of Gustave Stickley" (1901), Stickley

acknowledged his debt to early American furniture design. This table, which shows such a strong similarity to trestle tables of seventeenth-century America, demonstrates his debt.

COLLECTION OF BETH AND DAVID CATHERS

LIBRARY TABLE: page 211

This L. & J.G. Stickley library table has a basic similarity to the Gustav Stickley table on the preceding page and would therefore appear to be of the same vintage. This, however, is not the case, since it did not appear until 1912.

L. & J.G. Stickley's 1905 Onondaga Shops catalog does show a library table very similar to the Gustav Stickley example. It has two stretchers supporting a shelf, with large rounded keys piercing exposed tenons at either end. Unlike the Gustav Stickley table, it has splayed legs and minimal cutouts at both ends forming small feet. But it has an overall similarity with our example, and is probably its stylistic ancestor.

This library table was included in L. & J.G. Stickley's 1912 catalog supplement, and appeared unchanged in their post-1912 (on the cover) and 1922 catalogs. It was made in three sizes: 32" x 48", 32" x 54", 32" x 60". In 1922 an even larger version, 42" x 84", was introduced, which had two stretchers rather than one.

It is a very bold design, with its long medial stretcher and tenon and tenon-and-key joints. The rounded keyholelike cutouts at each end and flaring feet also contribute to the table's dramatic appearance.

It is important to remember that this table was first produced during Gustav Stickley's Final Mission Period, a time when his work was characterized by rectilinearity and lack of expressed structure. Although L. & J.G. Stickley's furniture, during the years of their Arts and Crafts furniture production, demonstrated the same increasing tendency toward simplicity and purity, this table shows that they were also perfectly willing to bring diversity and boldness to their later designs.

JORDAN-VOLPE GALLERY

LIBRARY TABLE: page 212

The most prominent features of this Roycroft table are the tapering legs terminating in a swelling foot, the tenon-and-keying which joins the stretchers, and the pinned mortise-and-tenon joints.

Many Roycroft library tables were sold without drawers, like our example, or for $2.50 to $3.50 more they were sold with drawers. Though we have not

seen an example of this particular design with a drawer, it is likely that it was offered in that form.

Despite the articulated structure of this library table, it is probably fair to say that the richly figured quartersawn oak is its strongest point. This is most apparent on the apron, seen in this photograph, where the Roycroft orb and cross has been incised.

COLLECTION OF MR. AND MRS. RUSSELL WILKINSON

TABLE: page 213

This round table is very different from Stickley's other spindle pieces because each group of spindles is formed out of one piece of wood. He has pierced the four flat legs with long rectangular reticulations, a technique totally unlike his normal practice of making separate spindles and joining them to upper and lower rails. It could be argued that this is not a spindle piece at all, were it not for the fact that Stickley uses the term to describe this table in the January 1907 issue of THE CRAFTSMAN and his 1907 "Descriptive Price List."

Broad, flat legs with surface decoration are frequently seen in Baillie Scott's furniture, and Harvey Ellis incorporated them into many of the inlay pieces he designed for Stickley. It is most likely that the inspiration for our example came from a round table Ellis designed in 1903, but here the inlay has been replaced by the rectangular cutouts.

This design must also have been influenced by a round English table which was illustrated in the April 1904 issue of THE CRAFTSMAN. A table very similar to our example, but smaller in scale and enameled white, was shown in the article "Recent Examples of English Decoration." A year later, in his monthly feature "Home Training in Cabinet Work," Stickley showed a table very like the English one along with plans showing how to make it. Our example clearly derives to some extent from the English model, but Stickley has finished it in warm brown tones and made it more robust and structural.

COLLECTION OF SIDNEY AND FRANCES LEWIS

LIBRARY TABLE: page 214

This rectangular trestle table is perhaps one of Stickley's most successful designs. In appearance it relates to his mature period of 1904–1910, but in actuality it was designed in 1900 or possibly earlier. It first appeared in the HOUSE BEAUTIFUL article in October 1900, along with the library table shown on page 210. The table appeared again in the December 1900 issue of HOUSE BEAUTIFUL in the Tobey Furniture Company ad. In both instances it was shown with a variety of Stickley pieces, most of which would be classified as Experi-

mental Period work. The Tobey ad identified the piece as a "Bungalow Library Table," available for $19.50. It appeared again, unchanged, in the April, 1904 issue of THE CRAFTSMAN and in Stickley's 1905 catalog.

When it appeared in the 1909 catalog, one change had been made. The earlier version of the table had a stepback in the leg at the stretcher level. The later version had straight legs, without the stepback. Otherwise, it was produced with no modification throughout Stickley's years of Arts and Crafts furniture production.

The table itself is quite handsome, with large keys at both ends forming the primary decorative feature. Another interesting feature is the repetition of the shoe feet, upside down, where the legs join the table top.

Stickley's competitors must have agreed that the design was effective. Both L. & J.G. Stickley and Stickley & Brandt (whose mission line was called "Modern Craft") copied it directly. And Elbert Hubbard bought one of these tables for use in the "Ruskin Room" at the Roycroft Inn in East Aurora. It can be clearly seen in the photograph of this room in THE BOOK OF THE ROYCROFTERS, published in 1907.

COLLECTION OF FRANCISCO PELLIZZI

TWO-DRAWER TABLE: page 215

This small table epitomizes Stickley's Early Mission Period. By the time it was made, he had begun to shed his more derivative experimental style and was boldly following his own course. Here, at last, was the true "structural style."

Writing in the December 1903 issue of THE CRAFTSMAN, Stickley proudly spoke of his designs as "crude," by which he meant vigorous and strong: "This reversion to severe simplicity in cabinet-making has been criticized as pointing to a reversion to log houses and homespun, to a crudity of life incompatible with our actual ideas of culture. The criticism is based on appearance rather than fact. It is true that our severe and simple style now errs upon the side of crudeness. Yet this very crudity, absolutely structural, is a proof of vital power, and in itself a promise of progress, since chaos, that is formlessness, precedes, never follows, crudeness, and since decadence is the natural sequence of over-refinement. Coming after the historic styles, the simple and structural arrests and commands attention, as it could not do did it resemble its predecessors, or seek to compromise with them. But it is yet in its formative period. . . ."

This table clearly embodies the "vital power" Stickley refers to. It is small, but the structural members are massively overscaled for a piece this size. Each leg is pinned to the carcass in four places, as well as to the heavy medial stretcher. For added strength, the stretcher is joined at both ends by tenon and key. Note also the square faceted pulls on the drawers.

The drawers, only one of which is visible in the photograph, are extremely

well made of thick oak boards, carefully dovetailed front and rear. The drawer bottoms are chamfered as they join the sides.

The top is fastened to the table with hardware Stickley called "table irons." These are iron fasteners in the shape of a figure-8, which hold two screws: one goes up into the table top and the other down into the carcass. These "table irons" are worth mentioning because they are a characteristic Stickley fastener. They were also commonly used, in a slightly different form, by Roycroft and L. & J.G. Stickley.

The legs of this table show another typical Stickley characteristic. Each leg is one piece of wood, and the edges of the legs are sharp and crisp. Legs on many L. & J.G. Stickley pieces are composed of four pieces of laminated wood wrapped around a central core, with the edges rounded and softened.

As far as we know, this table is not pictured in any Stickley catalog.

COLLECTION OF BETH AND DAVID CATHERS

LIBRARY TABLE: page 216

The most important design element of this library table is the corbel, the tapering bracket which stiffens the frame and helps visually integrate the carcass and the legs. Stickley first used corbels on a library table in 1901; the shape of these early corbels was similar to the curved slats seen on the early settle on page 137. He subsequently employed corbels on a variety of two- and three-drawer library tables, before arriving at a final form, as on our example, in 1905.

COLLECTION OF ROBERT MANGOLD

TABLE: page 217

This severely plain little table is not one of Gustav Stickley's most exciting designs, but it is nonetheless of very high quality. It demonstrates, more than most of his pieces, his acknowledged admiration for Shaker furniture.

It is made of first-rate quartersawn oak, constructed with mortise and tenon throughout, and the drawer is dovetailed. Note the round wooden knobs, which Stickley preferred to metal hardware. The most surprising detail of this desk is the siderunner arrangement of the drawer, a trait normally associated with fine eighteenth-century furniture.

JORDAN-VOLPE GALLERY

LIBRARY TABLE: page 218

As with many of Gustav Stickley's furniture designs, this three-drawer library table went through a series of evolutionary changes. The earliest version we know of was made in either 1902 or 1903. We found a photograph of it in a group of pictures of Stickley furniture taken in the Craftsman Building in Syracuse.[1] Stickley opened this Craftsman Building in the fall of 1902, and the photographs, showing First Mission Period designs, must have been taken shortly thereafter. This first version of the three-drawer library table is very much like our example, except that it employs pulls like those on the fall-front desk on page 172, the legs do not appear to be veneered, and the top edge of the apron beneath the drawers is not beveled.

Another version of this library table appeared in "What Is Wrought in the Craftsman Workshops," which Stickley published in 1904. That version has hammered copper oval pulls on rectangular plates, tenons mortised through the legs, and corbels, and is substantially longer than our example. It is likely that it is a special piece made just for Stickley's use in the editorial offices of THE CRAFTSMAN, but it nonetheless has taken on an appearance closer to the final form of this library table.

The final form appeared in THE CRAFTSMAN for May 1904 and made its first catalog appearance in 1905. As can be seen from our example, it evolved into a perfect example of Stickley's mature style; it is of massive plain form with minimal structural expression, the legs are veneered but the pins joining the legs to the carcass are left exposed, and the top of the apron has been beveled.

COLLECTION OF GEORGE SILANO

[1] These photographs are in the possession of Alfred Audi at the L. & J.G. Stickley factory.

DINING-ROOM TABLE: page 219

This is Stickley's most dramatic round dining-room table, because of its five legs joined by flaring cross stretchers and the wide overhanging top.

The first rather crude version of this table appeared in "Things Wrought by the United Crafts," a catalog published by Stickley in April 1902. It was available with either round or square top. The exposed tenons on the legs were keyed and the top barely extended beyond the apron. It was apparently sold with either a round or a square top until 1904; a square version with exposed (but not keyed) tenons and flaring stretchers was shown in THE CRAFTSMAN in April 1904. By 1905 it had reached its final form, as shown by our example, and was made unchanged thereafter.

COLLECTION OF MR. AND MRS. LARRY SHAR

DINING-ROOM TABLE: page 220

Stickley's pedestal dining-room table first appeared in his 1906 catalog, and was produced without change thereafter. It was sold in three sizes and in 1906 could be bought in either oak or mahogany.

Like the rolltop desk, the pedestal dining-room table was a common sight in early-twentieth-century homes. The golden-oak variety, usually with machine-carved claw feet, was made by the thousands, and is frequently seen today.

As we would expect, Gustav Stickley produced his own Craftsman version of the pedestal table, with a massive tapering pedestal and long shoe feet. The pedestal and the feet are oak veneered on oak, and together are reminiscent of the trunk and roots of an oak tree.

At the top of the pedestal, not visible here, are brackets supporting the top which repeat the form of the feet. The inner rim of the apron running the circumference of the top is rounded, a common characteristic on Stickley's round dining-room tables. The top itself is formed by boards fastened together by tongue-and-groove joints.

COLLECTION OF MR. AND MRS. WILLIAM GOODMAN

TEA TABLE: page 221

This little tea table is a fine example of Stickley's work during his experimental phase. Admittedly it is a bit delicate, but as we will point out, it is a harbinger of things to come.

This table was probably made in 1900. It represents Stickley's attempt to produce an American version of the Arts and Crafts and Art Nouveau furniture he saw in England and on the Continent. Pictorial documentation for this table may be found in the Tobey Furniture Company[1] ad in the December 1900 issue of HOUSE BEAUTIFUL. In the Tobey ad, it is identified as the "Celandine Tea Table,"[2] finished in Gunmetal Green and priced at $6.

This is obviously the table described in the October 1900 issue of HOUSE BEAUTIFUL in the article on Stickley Furniture, "Some Sensible Furniture": ". . . the motive of decorations is based on natural forms, and in many instances the stem, leaf, and flower have been used in the construction of the smaller pieces. This is noticeable in some of the small tables, where the legs suggest the stem of a plant, while the tops reproduce the lines of the open flower. This idea is quaintly illustrated in the Poppy tables, and again in the Celandine tabourette."

Interestingly, John Crosby Freeman, in THE FORGOTTEN REBEL, illustrates a variant of this table, but captions it "Art Nouveau table by Stickley, never manufactured." However, on page 53 of his book, Freeman quotes Stickley describing this very table: "In 1900 I stopped using the standard patterns and finishes, and began to make all kinds of furniture after my own designs, independently of what other people were doing. . . . My frequent journeys to Europe . . . in-

terested me much in the decorative use of plant forms, and I followed the suggestion. . . . AFTER EXPERIMENTING WITH A NUMBER OF PIECES, SUCH AS SMALL TABLES GIVING IN THEIR FORM A CONVENTIONALIZED SUGGESTION OF SUCH PLANTS AS THE MALLOW, THE SUNFLOWER, AND THE PANSY, I abandoned the idea. Conventionalized plant forms are beautiful and fitting when used solely for decoration, but anyone who starts to make a piece of furniture with a decorative form in mind, starts at the wrong end. The sole consideration at the basis of the design must be the thing itself and not its ornamentation." (Emphasis added.) This passage not only sheds light on this table, it also provides an important insight into Stickley's design philosophy as a whole.

The example here has a floriform top with shallow relief carving of undulating lines. The top is braced underneath by a chamfered cleat, to prevent warping; this cleat is identical to the cleats used by Stickley for many years. The legs form a reticulated shield shape near the top, swell to accommodate the tenon-and-keyed stretchers, and terminate in a hoof-shaped foot. The reticulated cross stretchers, pinned together where they join at the center of the table, swell as they join the legs. While the overall effect of this table is somewhat anemic, it shows us the shape of Stickley designs to come: the stretchers clearly look forward to the kind of powerful stretchers found on his later efforts, such as the hexagonal library table on page 209.

COLLECTION OF DAVID AND BETH CATHERS

[1] The Tobey Furniture Company was located in Chicago, where this table was discovered a few years ago. Another example, marked with the early form of the joiner's compass, recently came to light in California.
[2] Celandine is a type of poppy plant.

DRINK STAND: page 222

This drink stand, sold with either a wood, leather, or copper top, shares many characteristics with similar Gustav Stickley tables. For example, the undersides of the cross stretchers are arched, and the top extends dramatically beyond the circular apron. However, this piece also exhibits definite L. & J.G. features: the overall form tapers toward the top, there is no finial where the stretchers cross, and the corners of the legs are rounded rather than squared off.

It is interesting that a nearly identical table was manufactured by the Lifetime Chair and Bookcase Company, showing that lesser mission makers imitated not only Gustav, but L. & J.G. Stickley as well.

COLLECTION OF MR. AND MRS. FRANK DIMNICKI

TABOURET: page 223

This Roycroft tabouret was shown in the 1912 catalog in both oak and mahogany. In overall form, it is reminiscent of the Gustav Stickley magazine pedestal on page 243. Even its circular cutouts seem traceable to those on the early Gustav Stickley pedestal.

It has one extraordinary feature rarely seen on American Arts and Crafts furniture: the stretchers joining the "legs" are fastened by blind dovetails.

JORDAN-VOLPE GALLERY

12 Individual Pieces

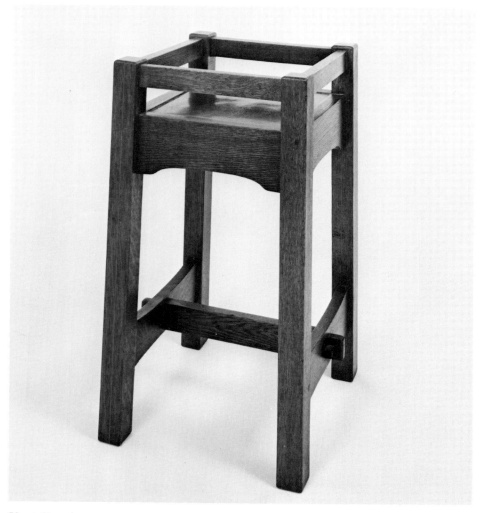

Plant Stand
Gustav Stickley H 26¼" Top 13" square Marking: 1" decal in
rectangle Ca. 1902/03 Oak

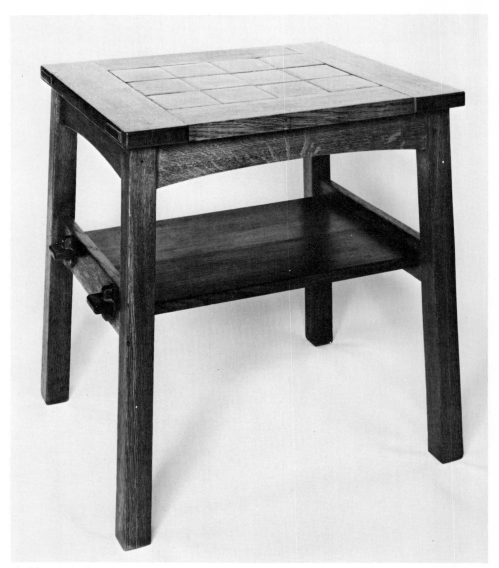

Table, with Grueby-tile top
Gustav Stickley H 26″ W 24″ D 20″ Marking: Joiner's compass in
rectangle CA. 1902/03 Oak

234

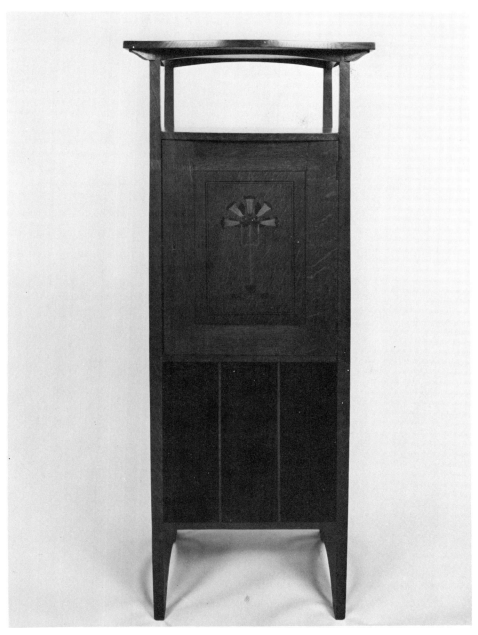

Music Cabinet
Gustav Stickley H 57¼″ W 22¾″ D 17″ Marking: Gustav Stickley
decal CA. 1904 Oak, with cedar used as secondary wood

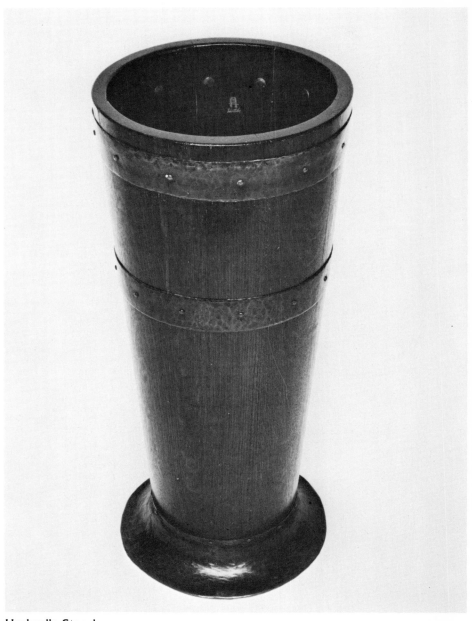

Umbrella Stand
Gustav Stickley H 27″ Dia. 12″ Marking: First paper label. Gustav Stickley
decal CA. 1906/07 Oak with copper

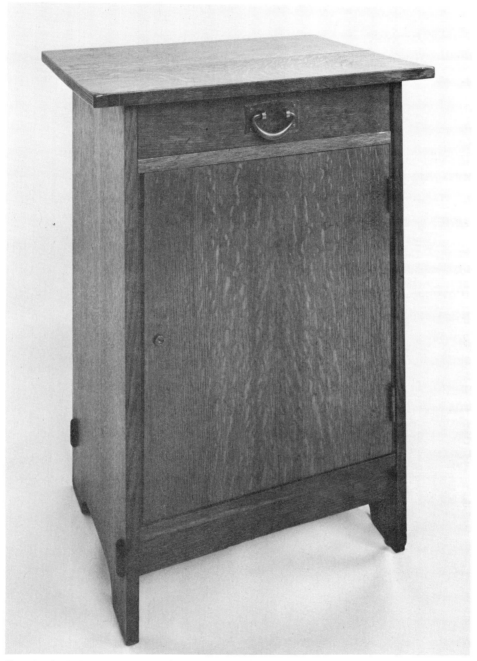

Smoker's Cabinet
Gustav Stickley H 29″ W 20″ D 15″ Marking: Gustav Stickley decal and
New York paper label CA. 1912 Oak

Tall-Case Clock
Gustav Stickley H 70″ W 18″ D 12″ Unmarked CA. 1902 Oak

Tall-Case Clock
L. & J.G. Stickley H 78" W 19½" D 12" Marking: Handcraft decal
Ca. 1910 Oak

Costumer
Gustav Stickley H 71¼″ W 13″ D 22″ Marking: Burned-in joiner's
compass Ca. 1913 Oak

Plate Rack
Gustav Stickley H 24″ W 45¼″ Marking: Decal with Stickley
in rectangle Ca. 1902 Oak

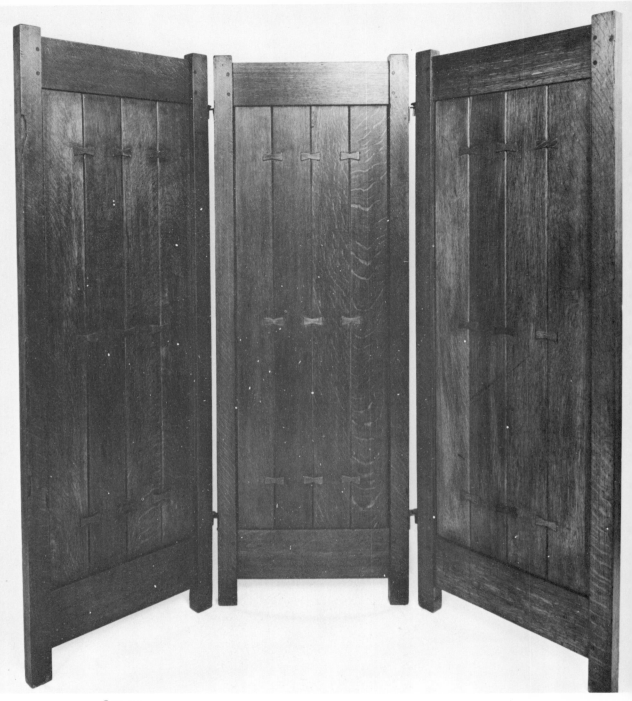

Screen
Gustav Stickley H 65¾" W 22½" (each panel) Unmarked
Ca. 1913/15 Oak

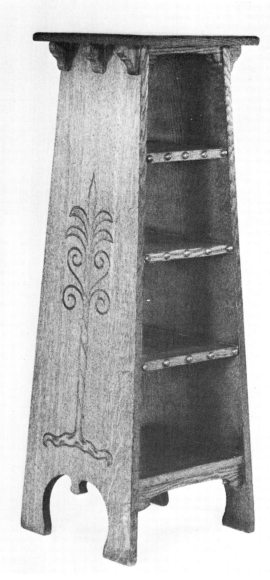

Magazine Stand
Gustav Stickley H 43″ W 13½″ D 14″ Unmarked CA. 1900 Oak

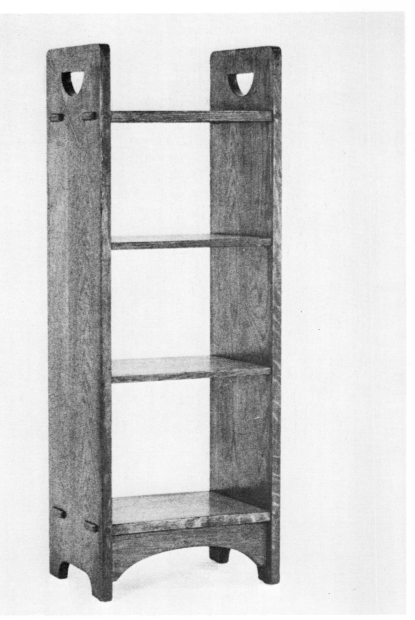

Magazine Stand
Gustav Stickley H 40″ W 14″ D 10″ Unmarked Ca. 1905/15 Oak

PLANT STAND: page 233

At the Buffalo Pan-American Exposition in 1901, Stickley displayed his Crafts-man Furniture designs in a booth he shared with Grueby Pottery. One of the items he showed was a plant stand with a Grueby-tile top, of the same design as our example. Stickley incorporated Grueby tiles into some of his designs for their beauty as well as practicality. Writing in "Chips from the Workshops of Gustave Stickley" (1901), he discussed "the now-famous Grueby tiles, in rich Veronese greens and blues and vivid orange which we employ to make spots of positive intense color upon our negative backgrounds; also, with the more practical purpose of affording cleanly and sanitary surfaces for the tops of wash-stands, plant-stands, and tabourets."

This plant stand is pictured in "Chips," in the November 1901 issue of THE CRAFTSMAN, and in Stickley's 1902 catalog. It was priced at $4.50 with wood top and $7.75 with tile top. Even though this plant stand has none of the massive-ness that typifies Stickley's output during this period, it nonetheless has many traits of the First Mission Period: the curved aprons are similar to the aprons on the settle on page 137, the stretchers flare as they meet the legs, and they are fastened at both ends with a tenon-and-key joint.

Stickley furniture incorporating Grueby tiles is found only rarely.

COLLECTION OF BETH AND DAVID CATHERS

TABLE: page 234

This small rectangular table first appeared in THE CRAFTSMAN in May 1902, where it was illustrated holding a chafing dish. It was also shown in the June 1904 issue of THE CRAFTSMAN in a photograph of an actual Stickley-furnished dining room.

Although it is in many respects a First Mission Period design—note, for example, the tenons and wedge-shape keys joining the lower shelf to the stretchers—it is unusually graceful. This may be attributed to the slightly splayed tapering legs and the gently arched (pre-Ellis) aprons.

The joinery of the top is very well conceived and executed. Four rails frame the twelve green Grueby tiles. The front and back rails are joined to the larger side rails by means of long tenons, which are mortised through the sides and chamfered off. Two vertical pins lock each of the four mortise-and-tenon joints.

COLLECTION OF LOU HOLLISTER

MUSIC CABINET: page 235

This inlaid music cabinet is a significant example of Gustav Stickley's Arts and Crafts furniture, because it prefigures his entire line of furniture with bowed

sides and paneled backs. Further, in a larger and more important sense, it points the way out of the medievalism of Stickley's Early Mission designs and toward the purity of his Mature Period.

Harvey Ellis illustrated an article in the July 1903 issue of THE CRAFTSMAN entitled "A Child's Bedroom."[1] In this article we see the first examples of Stickley furniture with inlaid decoration, bowed sides, paneled backs, and arched aprons. It is clear from the illustrations that the entire room, including the furniture, is Ellis's conception, because it so strongly shows the influence of Mackintosh and Baillie Scott. The frieze, based on an inverted heart motif, and the decorative wall pattern of tiny squares point directly toward Mackintosh. A high-backed chair, with a broad center slat punctuated by an inlaid oval device, is reminiscent of Baillie Scott, and to an extent, Voysey. An example of this chair, with a slightly different inlay pattern, is illustrated on page 47 in the stylistic development chapter.

The August 1903 issue of THE CRAFTSMAN featured Harvey Ellis's second contribution to the magazine, an article entitled "An Urban House." This house design, strongly influenced by Voysey and Mackintosh, is typical of the beautifully designed and exquisitely rendered structure Ellis created for THE CRAFTSMAN magazine. Among Ellis's renderings of its interior are two views of a music room, and both clearly show this cabinet.

The music cabinet has the kind of delicate, attenuated form which we see on many of Ellis's designs. Its legs extend well above the top of the carcass and support a separate space-defining canopy top, which is bordered with arched aprons and extremely delicate corbels. The canopy top itself has a serpentine front, a truly extraordinary feature to find on a piece of Stickley furniture and one which apparently was never repeated.

The floral inlay on the door is of copper and light woods. It is a highly stylized floral pattern, rigidly controlled and completely symmetrical. Two bands of string inlay frame the design. At the time this cabinet was made, Stickley's furniture tended to rely on vigorously expressed structural details to create the decorative effect. Here, the structural details are totally subordinated to the clean lines of the piece itself and to the inlay pattern. The inlay, however, while the one element which makes this piece so desirable to modern collectors, is perhaps not the detail most worthy of our attention. Stickley's inlay, unquestionably beautiful and seen but rarely, was made briefly and made no lasting impact on the furniture which followed. However, the curved sides, paneled back, and veneering of this music cabinet strongly influenced his designs until 1910. These details in a broad sense led to his Mature Period style, and demonstrate the powerful influence Ellis had on Stickley's subsequent work. In the years following, Stickley produced an entire line of curve-sided furniture, examples of which are seen throughout this book.

COLLECTION OF BETH AND DAVID CATHERS

[1] One drawing from this article is reproduced on page 46.

UMBRELLA STAND: page 236

Gustav Stickley did much more than simply design and produce furniture; his Craftsman Workshops created nearly everything for the home—lamps, chandeliers, wastebaskets, copper trays, and so on. Even the prosaic umbrella stand came to his attention: he designed one with four tapering oak posts and a metal drip pan, others of hammered copper in cylindrical form, and this one, which combines oak and copper. It first appeared in THE CRAFTSMAN in 1905 and was in production until 1909, the last year it was carried in Stickley's catalog.

PRIVATE COLLECTION

SMOKER'S CABINET: page 237

Although it has a fairly straightforward design, the smoker's cabinet went through a series of major changes before it arrived at its final form.

The first Stickley smoker's cabinet was shown in the November 1901 issue of THE CRAFTSMAN. It was framed with four massive legs pierced by exposed tenons. The door and sides were made of chamfered boards. It had no drawer.

It next appeared in the May 1904 issue of THE CRAFTSMAN, where it began to assume a shape similar to our example. By this time it had acquired a paneled door, a drawer, and an arched apron.

In the December 1905 issue of THE CRAFTSMAN the smoker's cabinet appeared for the first time with a paneled door and the "standard" Mature Period handwrought copper hardware. The arched apron remained. It appeared again, virtually unchanged, in Stickley's furniture catalogs for 1906, 1909, and 1910. It sold for $12.

It first appeared in its final form in the 1912 catalog. The hardware on the door has been replaced by a small round key escutcheon. The arched apron has given way to a straight one, a common development during Stickley's Final Mission Period. As in earlier examples, the apron is mortised through the sides of the piece, providing the only structural decoration. The back of this cabinet is made of a solid oak panel, as well finished as the rest of the piece. A dust barrier separates the drawer bottom from the area inside the door, another instance of Stickley's constant concern for detail.

As we have said before, this smoker's cabinet is a simple, straightforward design, yet its fine proportions and attention to detail are graphic examples of Stickley's high standards of workmanship throughout his years of Arts and Crafts furniture manufacture.

COLLECTION OF BETH AND DAVID CATHERS

TALL-CASE CLOCKS: pages 238 and 239

The Gustav Stickley tall-case clock first appeared in a sketch in THE CRAFTSMAN for April 1902 and then in a photograph in the following issue. It was described there as "appropriate for use in an entrance hall, or on a stair landing." A clock of the same design was shown in the editorial office of THE CRAFTSMAN in Stickley's 1904 pamphlet "Things Wrought in the Craftsman Workshops." Our example on page 238, which was part of the original furnishings of Craftsman Farms, was illustrated in MORE CRAFTSMAN HOMES, which Stickley published in 1912.

The overhanging top is beveled on the underside and its glass door reveals the weights and pendulum. Otherwise, it is a very different conception from the L. & J.G. Stickley tall-case clock. The face is formed from a sheet of brass with applied numerals. Its sides are paneled in the manner characteristic of Stickley's work of 1902 and 1903. The sides flare out slightly the entire length of the carcass, creating both visual and actual stability.

L. & J.G. Stickley seem to have begun making clocks later than their older brother Gustav, the first ones appearing in the 1910 catalog. This clock, on page 239, which appears only in the 1910 catalog, was probably designed by Donald Hansen.

It has the same kind of beveled top seen on the Gustav Stickley clock. Its face is hammered copper with repoussée numerals. A rectangular slot is cut into the sides where they flank the face, creating a severely Arts and Crafts echo of the free-standing quarter columns found on period tall-case clocks. The recessed door is four members joined by double-pinned mortise-and-tenon joints. Below the door, the base is stepped outward to enhance stability.

The design of this clock is startlingly pure: it is totally devoid of curves and expressed structural detail, with its appearance dependent solely on its right proportions and the quality of materials and workmanship.

Stickley clocks, whether by Gustav or L. & J.G., are very rare.

GUSTAV STICKLEY CLOCK: CYRIL FARNEY

L. & J.G. STICKLEY CLOCK: COLLECTION OF KEN HARPER

COSTUMER: page 240

The costumer, or hall tree as it is more commonly known, is a piece of furniture which time has passed by; it has been replaced by the hall closet. Hall trees of the late nineteenth and early twentieth centuries were often quite good-looking pieces made of brass tubing or bent wood, though they were frequently not well enough made to withstand years of supporting heavy coats. As we would expect, Stickley rethought the hall tree along Craftsman lines, and produced a design unlike any other, though very much of a piece with his own furniture efforts.

Stickley's costumer is first and foremost functional. The two short, massive

crosspieces are mortised through the uprights and secured by oak pins. The two uprights, with their characteristic Stickley taper, are clearly strong enough to hold heavy clothing, but light and graceful enough to make the piece quite handsome. Note, too, the shoe feet, which stabilize the costumer both visually and functionally.

Stickley seems to have made his first costumer in 1905, when it appeared in his catalog for that year. The earliest version was identical to our example, except for the hardware, which was hand-wrought iron and had a flattened form. By 1912, the hardware was changed to cast copper finished with hammermarks and had assumed the rounded shape seen in this illustration.

COLLECTION OF BETH AND DAVID CATHERS

PLATE RACK: page 241

Although Stickley usually incorporated a plate rail into his sideboard designs, he also made separate plate racks to hang on the wall. This particular plate rack is an early effort, first appearing in Stickley's catalog for 1901. The chamfered boards, inverted V of the lower edge, and molded shelf fronts all place this piece firmly in Stickley's First Mission Period.

COLLECTION OF BETH AND DAVID CATHERS

SCREEN: page 242

This very structural-looking screen would appear to be an early design, but it wasn't introduced until 1913.

It provides a perfect example of structural details used for decorative effect. The vertical members are chamfered and butt-joined and held together with Stickley's characteristic butterfly keys. However, while the keys do serve a structural function, the vertical boards are actually secured to each other by means of internal splines, which run their entire length. In other words, the keys serve a more decorative than structural function.

The pins holding the mortise-and-tenon joints in the framing members are also interesting to consider. These members are oak with oak veneer. Traditionally, cabinetmakers, when they are working with veneer, will conceal pinned joints under the veneer. Stickley, however, clearly wanted to emphasize the pinning, so he carefully left the dowel ends exposed.

This screen was once a part of the furnishings of Craftsman Farms.

COLLECTION OF BETH AND DAVID CATHERS

MAGAZINE STAND: page 243

This magazine pedestal, which first appeared in the Tobey Furniture Company ad in the October 7, 1900 issue of THE CHICAGO TRIBUNE, is an excellent example of Stickley's experimental work. It is not particularly "structural," except perhaps for the small corbels joining the top with the sides. Its most prominent decorative element is the relief carving on either side in the form of a stylized tree. This sort of decoration was clearly unsatisfactory to Stickley, since he used it only briefly during his experimental period and then dropped it for good. Though basically rectilinear, the piece is full of curves, from the rounded cutout on both sides to the curved aprons and the corbels at the top. The aprons are identical to those seen on the Experimental Period side chair seen on page 35 in the stylistic development chapter.

The round nail heads on the front and back of the three shelves originally held leather strips, or valances, which extended about ½ inch below the lower edges. The purpose of these strips was to form a dust barrier to protect the book stored in the stand, an expedient recommended for use on open bookcases by Charles Locke Eastlake in HINTS ON HOUSEHOLD TASTE: "A little leather valance should always be nailed against . . .[the shelves'] outer edges. This not only protects the books from dust, but when the leather is scalloped and stamped in gilt patterns, it adds considerably to the general effect" (Dover edition, p. 129). Fortunately, Stickley resisted Eastlake's suggestions about gilding and scalloping his leather valances.

COLLECTION OF JOHN EULLER

MAGAZINE STAND: page 244

This magazine stand, which was introduced in 1905, falls into Stickley's mature phase and forms a telling comparison with the earlier Experimental Period magazine stand on the preceding page. With little more than a few plain oak boards, Stickley created, in this stand, a functional yet elegant piece of furniture.

The sides rise vertically, not only creating a cleaner design than the earlier stand, but also making the shelves better able to hold books or magazines. The relief carving has disappeared. The plain slab sides are now punctuated by modest exposed tenons and half-circle cutouts which make the piece easy to lift. Here is decoration formed by structural and functional necessity as Stickley believed.

COLLECTION OF DYLAN CATHERS

Appendix A
A Conversation with Barbara Wiles

Perhaps the most enjoyable part of the research we did for this book was our two conversations with Barbara Wiles. Born in Binghamton, New York, in 1887, Mrs. Wiles was the daughter of Gustav and Eda Simmons Stickley. Mrs. Wiles proved to be a lively, intelligent woman with a good sense of humor and clear recollections of her famous father. Her reminiscences provide us with some unique insights into Gustav Stickley as a furniture designer, businessman, and father. She died in August, 1980, at the age of ninety-three.

Q. Many collectors pronounce your father's name "Goostav." Is that how he pronounced it?

A. No. He always pronounced it as "Gustav."

Q. What kind of father was he?

A. He was the kind of father who was never very interested in his children. To give you an example, he felt that after you graduated from high school you were on your own. He didn't want to send us to college. And Mildred [another Stickley daughter] was his favorite. He made ten or eleven trips to England and always brought her a present. She was the only one who ever got one.

When I finished high school I went to Smith College for a while, but I left there to live in New York City and work on The Craftsman magazine. That was around 1905, after the magazine got going. I also put together two of father's catalogs. I think that must have been around 1908.

Q. Did your father issue a new furniture catalog every year?

A. I don't think so. We made new catalogs when there were enough new items being made for us to need to issue one.

Q. Were pictures from one catalog reused in later catalogs?

A. Oh, yes.

Q. Why did your father choose the joiner's compass and "Als ik Kan" as his shopmark?

A. He got the trademark from [William] Morris; he read a great deal

of Morris, and Ruskin too, for that matter. He chose this mark because he always wanted to do everything as best he could. He started using the mark when he made his first mission furniture.

Q. Leopold Stickley worked for your father when he began making his first Craftsman furniture. Did Leopold ever design furniture for him?

A. No. Lee never designed any furniture while he worked for my father.

Q. Did Harvey Ellis design furniture for your father?

A. Poor Harvey. He was a drinker and died so young. He designed the inlay furniture, but I think my father had a hand in it, too. My father wanted to make a lighter line of furniture, because homes were getting smaller and smaller. I don't think the inlay furniture was ever put on the market. We displayed it at merchandise marts and made samples to show in stores, but it was never put into production.

Q. Besides Harvey Ellis, did your father ever employ a furniture designer?

A. No. He designed it all himself. He had a fine eye for detail, and he always talked about the importance of proportion. He called it "pro-PAW-tion."

Q. One of the most distinguishing features of your father's furniture is its right proportion. Unlike so much of his competitors' work, its proportions are always right. Did your father have a systematic approach to proportion? Did he follow certain rules?

A. Oh, no. He just had a good eye. He'd experiment until a thing looked right.

Q. Did he make the furniture himself?

A. No, his cabinetmakers did. But he was a very good craftsman himself; he made the Shaker-style chair I still have.

Q. Where did your father get wood for furniture making?

A. He owned a lumber company in the Adirondacks, and it came from there.

Q. Did your father know Adelaide Robineau?

A. Oh, yes. That's a name I haven't thought of for years. He designed lamps and chandeliers for her, and she had Stickley furniture in her home. She displayed her pottery at the Craftsman Building. My father was also very friendly with [Frank] Lloyd Wright. And he knew Elbert Hubbard well. Hubbard was a great talker and attracted great artists who came and worked for him. But, unlike father, he was not an artist himself.

Q. Why did your father start publishing THE CRAFTSMAN magazine?

A. The magazine was his baby. Making furniture wasn't enough for

him. He needed to publish something to express his ideas and his philosophy, and so he started THE CRAFTSMAN.

Q. Do you remember Irene Sargent?

A. She was really the one who discovered father. She saw his early work, his experiments, and she saw its great potential—perhaps even more than father did. She was a brilliant woman, but a bit peculiar and homely. She was the one who persuaded father to start the magazine —of course she wrote it all in the beginning, though father wrote a great deal for THE CRAFTSMAN, too.

Q. Do you remember when your father first started making Craftsman furniture?

A. I think in 1898. He was running the furniture shop at Auburn prison—that was in the mid-'90s—and then he and Symonds started a furniture company in Syracuse. That didn't last long, so Father must have started his experiments around 1898.

Q. What do you best remember about the Craftsman Building in New York?

A. Ben [Mrs. Wiles's husband] told my father not to commit himself to that building. He said that the upcoming war would slow the furniture business and that it was not a good time for expansion. Ben worked for my father, but left when he went into the Craftsman Building. Ben told my father, "There's no use for us both to go under." After that, Ben and I moved back to Syracuse and eventually bought the house my family had lived in until they moved to Craftsman Farms in New Jersey. Nearly all the original furniture was still in the house when Ben and I moved back in.

Q. How well did your father get along with his brothers?

A. We were very friendly with George, who was the salesman for L. & J.G. Stickley and lived in New York. We were also friendly with Charlie [Charles Stickley of Stickley and Brandt] and Al [Albert Stickley of Stickley Brothers Grand Rapids]. But Father did not get along with Lee [Leopold Stickley].

Q. We have seen late L. & J.G. Stickley furniture marked with your father's joiner's compass and their Handcraft clamp conjoined. Did he work for them after he went bankrupt?

A. I think he did, but it couldn't have been for very long. All the brothers in that family were too strong-willed to work for anybody, except George, who was really just a salesman for Lee.

Q. After his bankruptcy, your father lived on until 1942. What did he do during those years?

A. He was very depressed for a few months after the bankruptcy. I

guess he had a nervous breakdown, and was hospitalized briefly. Then he came to live with me for two weeks, but he stayed twenty-five years! My mother died shortly after the bankruptcy. He spent most of his time working on wood finishes. He experimented constantly. Even when he was in business, he was always trying to develop new and better finishes. Father was not a drinker, but if he ran out of wood alcohol during an experiment he'd use gin instead.

Ben and I had a large family, and father was very involved with our children. He knew a great deal about opera. He had played the bass viol for years as a younger man. He'd listen to the opera radio broadcasts on Saturday afternoons and explain them to the children. He also knew everything about botany, and could teach the children all about plants and animals. He became a very happy man.

During the summer, when he stayed at our summer place in Skaneateles, Father used to walk for miles. Up until he reached his eighties he walked five or ten miles a day.

He got to know all the neighbors there. He'd walk up to their houses and act interested in buying them. He had people all around the lake convinced he had the money to buy their houses.

He made a set of twelve early-American-style chairs late in life, but other than that he never made furniture after he went bankrupt. . . . He's buried here in Oakwood Cemetery along with my mother. . . .

Appendix B
Glossary of
Furniture-Making Terms

apron The bottom rail between the legs of a case piece or below the seat rails of a chair. Stickley used the term "under rail."

bevel An angle cut at the edge of a board. See **chamfer.**

butterfly key A small decorative piece of wood used to hold two boards together. Sometimes referred to as a "bow-tie."

butt joint A method of joining two or more boards by gluing their flat sides together. Butt joints are characteristic of Gustav Stickley table-tops.

carcass The basic structure of a piece of furniture.

chamfer A beveled edge. Butt-joining two boards with chamfered edges created what Stickley referred to as "V-joints," frequently found on his early period designs.

cleat A light wood member fastened across two or more boards to hold them together and reduce the likelihood of warping, usually found under tabletops and inside cabinet doors. Gustav Stickley always chamfered the edge of cleats used on his furniture.

corbel A bracket applied to the leg of an armchair or desk, to strengthen the support of the arm or desk top.

dovetail A method of joining two pieces of wood at right angles by cutting wedge-shaped projections in one piece and equivalent slots in the other.

dowel A round wooden rod, used to pin together a mortise-and-tenon joint.

dustboard A thin panel of wood separating adjacent drawer spaces. An eighteenth-century development used by Gustav Stickley.

escutcheon Key plate.

fume A method of coloring wood by exposing it in an airtight chamber to the fumes of an acid solution.

glue block A small wooden block, in the form of a rectangular or triangular solid, glued to the underside of a case piece to add strength.

hardware The metal hinges, plates, and pulls on a piece of furniture.

inlay A decorative technique in which woods or metals of contrasting colors are set into grooves or channels on the surface of a piece of furniture.

key A small wedge-shaped piece of wood, inserted through a slot in an exposed tenon to add strength. It is, of course, also a decorative feature. Also referred to as "tusk and tenon" and "slot and bolt."

lap joint A joint formed by lapping one piece of wood over another. Usually found on the doors and sides of Gustav Stickley and L. & J.G. Stickley case pieces.

molding An ornamental contour cut into or applied to the edge of a board.

mortise A rectangular opening cut into a piece of wood to receive a corresponding projection, a tenon, from another piece of wood, to form a mortise-and-tenon joint.

mullion Lightweight vertical strips of wood used to divide the lights in a glass-doored bookcase or china cabinet.

muntin Lightweight strips of wood, either vertical or horizontal, used to divide the lights in a glass-doored bookcase or china cabinet.

pin A rounded rod, used to lock together a mortise-and-tenon joint. Made from a dowel.

patina The color or finish of wood or metal, usually acquired through years of use. It can be created artificially, as both Stickley and Roycroft did on their metalwork.

planish To smooth a metal surface by hammering.

quartersawn Board cut from a log which was first cut lengthwise into quarters, to emphasize the wood's grain.

rail A horizontal structural member of a piece of furniture, such as a "seat rail" or "top rail."

relief carving Carving with little depth, performed on a flat surface.

secondary wood Wood used in the internal construction of a piece of furniture.

side runners A method of supporting a drawer by cutting a channel into its sides and fitting them into corresponding projections on the drawer walls within a case piece.

slat A horizontal or vertical member, rectangular in section.

spindle A thin vertical piece of wood, rounded on a lathe. However, on Stickley furniture, spindles are square in section.

spline A flat strip of wood glued into grooves cut into two butt-joined boards. The spline strengthens the joint by increasing the surface area covered by glue. Frequently seen on tabletops of L. & J.G. Stickley and Stickley Brothers pieces.

stile A vertical structural member.

strap hinge A hinge extended with a flat strip of metal for decorative effect.

table iron An iron fastener, shaped like a figure-8, used to hold the top of a piece of furniture to the sides of the carcass.

tenon A rectangular projection cut into the end of a board, which fits into a mortise to form a mortise-and-tenon joint. Tenons may end with a mortise, they may be brought through the mortise and cut flush with the surface of the piece, they may project beyond the mortise and be chamfered off, or they may be extended 2 or 3 inches beyond the surface, slotted, and pierced by a key.

tongue-and-groove A method of joining wood by fitting a small projection on a piece of wood into a corresponding channel on another.

transom A horizontal strip of wood dividing the lights of a window.

veneer A thin layer of wood used to cover the flat surface of a piece of furniture.

V-joint The shape created by butt-joined boards with chamfered edges.

Appendix C
"The Tattler"

"The Tattler" was a column which appeared in every issue of FURNITURE JOURNAL for many years. It was not devoted to gossip, as the name implies, but to subjects of interest to the furniture trade which were not strictly news.

The column on December 25, 1906, was devoted entirely to the five Stickley brothers: Gustav, Leopold, J. George, Albert, and Charles. Though it used Gustav Stickley's 1906 pamphlet "Chips from the Craftsman Workshops" as a point of departure, the appeal this column has for us is the insight it offers into their obviously difficult entry into the furniture trade. And it reminds us just how extraordinary a man Gustav Stickley really was.

This is the column in its entirety:

In this department in the issue of November 10 there was published what purported to be comments of Gustav Stickley on certain phases of furniture making which had come under his observation during his long connection with the industry. The comments fitted in nicely with an article which was printed in the same number, and which was written by George E. Walsh, of New York. As a matter of fact Mr. Stickley's contribution to the symposium was found in a little booklet which he has recently published, and was not communicated by word of mouth, as might have been inferred. In this little pamphlet Mr. Stickley tells how he got his introduction into the chair making industry in the little town of Brandt, just outside of Binghamton. The statement has been repeatedly published that the Stickley brothers, five of whom are now engaged in the furniture business in four different establishments which bear the Stickley name, were brought up in Stillwater, Minn. Stillwater has always been chiefly a lumber town, and about the only distinction which has ever been given to it in the furniture line has been through the good store which the Simonet Brothers have always run there. Now, The Tattler, who himself was long a resident of Minnesota, has always been curious to know how the Stickleys managed to get away from Stillwater, and what chain of circumstances resulted in the whole family drifting into the furniture manufacturing business, in which they have attained a place of no mean distinction. After reading Gustav Stickley's booklet he was more than ever

curious. The booklet, while a cleverly disguised boost for the Stickley furniture and THE CRAFTSMAN, is intensely interesting and thoroughly worth reading. It will be found especially interesting to the students of the growth and development of furniture making in this country.

The pamphlet is illustrated with types of furniture in the production of which Mr. Stickley has played some part, and the contrasts are as striking as some recent examples of good and bad furniture which have been published in the LADIES' HOME JOURNAL. In the introduction of the story Mr. Stickley tells how, together with his brothers, he went as a boy to Brandt, a little town outside of Binghamton, where he got his first introduction to the furniture business. Inquiry develops that Brandt was a suburb of Binghamton, where the firm of Brandt & Schlager operated a tannery. The senior member of this firm was the father of Schuyler C. Brandt, now of the Stickley & Brandt Chair Co., and for him the town was named. There happened to be a little chair factory in the town and in the course of events Brandt & Schlager were compelled to take the chair factory on a debt. Now there is usually a good, big gap between tanning and chair making, although over in Holland George P. Hummer seems to get along nicely in his West Michigan Furniture Co., with a big tannery just across the street. About the time that Brandt & Schlager took over the little chair factory the father of the Stickley boys died and their mother, who was a sister of Mr. Schlager, turned naturally to her brother. Three of the boys were old enough to work, and the chair factory needed hands. It was a far cry from Stillwater to Binghamton, but the trip was made, and Gustav, Charles and Albert Stickley were put to work in the factory, while Leopold and J. George, who were then too young, were sent to school. The rest is told in Gustav Stickley's pamphlet—how the factory began to develop; how a retail store was established in Binghamton, and all that. In due course of events Gustav became the general foreman of the factory; Charles became skilled in the weaving of rush fiber seats, then much used in chair making, while Albert showed skill in decorating old Boston rockers, which were among the products of the factory. You will remember that even in this day and age a Boston rocker is not exactly correct if it does not bear a landscape or two, and if its arms are not decorated with floral designs. To make these decorations was Albert's stunt.

One who has known the Stickley boys ever since these boyhood days, in supplementing the little history contained in Gustav Stickley's pamphlet, said: "After the boys got into the retail business they used to sleep in the store. They had already established their credit, but the margin on the right side of the ledger was none too large. But they were able to buy goods in Grand Rapids, and were large customers of Nelson, Matter & Co., who at that time were represented in the east by W. H. Fitch. Now Fitch used to make Binghamton and made a practice of coming round to the store in the evening. I have heard the boys tell since how Fitch used to sit around waiting

for the boys to close up; how the boys in turn waited for Fitch to leave before they began to close up, too proud to let him know that they slept in the store, and apprehensive that if he knew they could not really afford to live somewhere else their credit might be impaired with the manufacturing firms from whom they bought goods. Fitch and the Stickley boys have laughed over it many times since, and now that they have all been out of the woods for many years I presume I can tell it also.

"Gustav Stickley is a genius," went on this same informant. "He has always been about twenty years ahead of his time. 'Way back in the '80s he made complete plans for a department store. This was before the department store had been developed in the big cities. He proposed to establish it in Binghamton. Of course if he had he would have gone broke on the scheme, for Binghamton was not large enough for it. He built and operated for a time almost the first electric railway in the country. I remember it well. In place of the trolley now used on the modern car he rigged up an old horse car with a sort of flexible rope or tube, not unlike the things the dentists now use. This was run out of a window of the car to a wheel which hung from the overhead wire, instead of running under the wire, as the trolley wheel now runs. The whole thing was crude, but he was able to operate about two miles of road in Binghamton some of the time. The road is out of existence now, but it demonstrated what a versatile fellow he is. With comparatively little opportunity to acquire an education he has learned to write exceedingly well, and the CRAFTSMAN is certainly a great credit to him. For a long time a large part of the big profits which he was able to make out of his Mission furniture idea went into the magazine, but they tell me that this is no longer a losing game. I trust that this is so. His socialistic tendencies as reflected in the CRAFTSMAN? Oh, that is simply the German of it. Gustav Stickley is both dreamer and thinker, one of the most delightful fellows in the world when you come to know him, and entitled to the credit of being the father of the Mission furniture idea in this country. The men who sell his goods tell me that they cannot get them fast enough to meet the demand, and that the price is no barrier to the sale. He ought to have made a lot of money out of the rage for which he has been so largely responsible. You know the rest about the brothers? Charlie is still in Binghamton, the manager of the Stickley & Brandt Chair Company; Albert made an advantageous business connection out of which the Stickley Brothers Company, of Grand Rapids, has grown, and four or five years ago Leopold and J. G. Stickley went over to Fayetteville and launched out for themselves. It has always seemed a pity to me that these five brothers could not have combined their forces and worked together, but as it is they have made the name Stickley pretty prominent in the chair making industry." Gustav Stickley now spends most of his time in New York so as to be near the place of publication of the CRAFTSMAN.

Bibliography

AMERICAN CABINET MAKER AND UPHOLSTERER. 1900–1920. Trade magazine published in Chicago.

Anscombe, Isabelle, and Charlotte Gere. ARTS AND CRAFTS IN BRITAIN AND AMERICA. New York: Rizzoli International Publications, 1978.

Binstead, Herbert E. THE FURNITURE STYLES. Chicago: Trade Periodicals, 1909.

Blasberg, Robert W. "The Old Oaken Mark," SPINNING WHEEL, October, 1971, pp. 10–13.

Boger, Louise Ade. FURNITURE PAST AND PRESENT. New York: Doubleday, 1966.

Bohdan, Carol L., and Todd M. Volpe. "The Furniture of Gustav Stickley," THE MAGAZINE ANTIQUES, May, 1977, pp. 989–998.

C.F.A. VOYSEY: ARCHITECT & DESIGNER. London: Lund Humphries, 1978.

Chander, Lyman. "The Roycroft Shops." THE GRAPHIC ARTS, August, 1912, pp. 117–132.

Champney, Freeman. ART AND GLORY: THE STORY OF ELBERT HUBBARD. New York: Crown, 1968.

Clark, Robert Judson, ed., THE ARTS AND CRAFTS MOVEMENT IN AMERICA 1876–1916. Princeton: Princeton Univ. Press, 1972.

Covell, Alwyn T. "The Real Place of Mission Furniture." GOOD FURNITURE, March, 1915, pp. 359–368.

THE CRAFTSMAN. 1901–1916.

Eastlake, Charles Locke. HINTS ON HOUSEHOLD TASTE. New York: Dover Publications, 1969 (reprint of 1878 edition).

Edgewood, Margaret. "Some Sensible Furniture." HOUSE BEAUTIFUL, October 1900, pp. 653–655.

Farrar, Francis, and Abigail Farrar. THE BOOK OF THE ROYCROFTERS. East Aurora, N.Y.: Roycroft, 1907.

Freeman, John Crosby. THE FORGOTTEN REBEL: GUSTAV STICKLEY AND HIS CRAFTSMAN MISSION FURNITURE. Watkins Glen, N.Y.: Century House, 1966.

FURNITURE JOURNAL. 1900–1920. Trade magazine published in Rockford, Illinois.

FURNITURE WORLD. 1900–1920. Trade magazine published in New York.

HOUSE BEAUTIFUL. Chicago. 1897–1905.

Howarth, Thomas. CHARLES RENNIE MACKINTOSH AND THE MODERN MOVEMENT. London: Routledge & Kegan Paul, 1952.

Hubbard, Elbert. LITTLE JOURNEYS TO THE HOMES OF THE GREAT.—Memorial Edition. New York: William Wyse, 1916.

INTERNATIONAL STUDIO. New York.

Koch, Robert. "ELBERT HUBBARD'S ROYCROFTERS AS ARTIST-CRAFTSMEN," WINTERTHUR PORTFOLIO, 1967, pp. 67–82.

Kornwolf, James D. M.H. BAILLIE SCOTT AND THE ARTS AND CRAFTS MOVEMENT. Baltimore: Johns Hopkins Press, 1972.

Makinson, Randell L. GREENE & GREENE: ARCHITECTURE AS A FINE ART. Salt Lake City: Peregrine Smith, 1977.

Naylor, Gillian. THE ARTS AND CRAFTS MOVEMENT. London: Studio Vista, 1971.

19TH CENTURY AMERICA: FURNITURE AND OTHER DECORATIVE ARTS. New York, Metropolitan Museum of Art, 1971.

Norberg, Deborah Dorsey. "Charles P. Limbert: Maker of Michigan Arts and Crafts Furniture."

A REDISCOVERY—HARVEY ELLIS: ARTIST, ARCHITECT. Rochester, N.Y.; Memorial Art Gallery of the Univ. of Rochester, 1972.

Roycroft Shops. "Handmade at the Roycroft Shops." Catalog of Roycroft Books, Furniture, and Leather and Copper Goods, CIRCA 1916.

– – –. "Roycroft Furniture." The Roycroft furniture catalog for 1906.

– – –. "Roycroft Handmade Furniture." The Roycroft furniture catalog for 1912.

– – –. "Some Books for Sale at Our Shop." The Roycroft book catalog for 1900.

– – –. "Some Furniture Made at the Roycroft Shop." The Roycroft furniture catalog for 1904.

Shay, Felix. ELBERT HUBBARD OF EAST AURORA. New York: Wm. Wyse, 1926.

Stickley, Gustav. "Cabinet Work from the Craftsman Workshops." Stickley's furniture catalog for 1905.

– – –. "Catalog of Craftsman Furniture." Stickley's 1909 catalog. Paperback reprint available from American Life Foundation, Watkins Glen, N.Y.

– – –. "Catalog of Craftsman Furniture." Stickley's 1910 catalog. Paperback reprint with a new introduction by David Cathers available from Dover Publications, New York.

– – –. "Chips from the Craftsman Workshops." New York: Kalkoff, 1906. (Clark incorrectly dates this pamphlet as 1907.)

– – –. "Chips from the Craftsman Workshop." Number II, 1907.

– – –. "Chips from the Workshops of Gustave Stickley." Stickley's 1901 catalog.

– – –. "The Craftsman Department of Home Furnishings." New York: Craftsman Publishing Co., circa 1915.

– – –. "Craftsman Furnishings." Stickley's 1906 catalog.

– – –. "Craftsman Furniture." Stickley's 1912 catalog.

– – –. "Craftsman Furniture." Stickley's 1913 catalog.

– – –. CRAFTSMAN HOMES. New York: Craftsman Publishing Co., 1909.

– – –. "Craftsman Houses." New York: Craftsman Publishing Co., 1913.

– – –. "The Craftsman's Story." Syracuse: Mason Press, 1905.

– – –. "Descriptive Price List of Craftsman Furniture." Stickley's 1907 catalog,

published with a separate portfolio of photographs showing his products.

— — —. MORE CRAFTSMAN HOMES. New York: Craftsman Publishing Co., 1912.

— — —. "The Structural Style in Cabinet-Making," HOUSE BEAUTIFUL, December, 1903, pp. 19–23.

— — —. "A Summary of Craftsman Enterprises." New York: Craftsman Publishing Co., CIRCA 1914.

— — —. "Things Wrought by the United Crafts." Stickley's 1902 catalog.

— — —. "What Is Wrought in the Craftsman Workshops." Syracuse: Gustav Stickley, 1904.

L. & J.G. Stickley. "Furniture in Craftsman and Handcraft Designs." L. & J.G. Stickley furniture catalog for 1922.

— — —. "Handcraft Furniture." L. & J.G. Stickley 1910 catalog.

— — —. "The Onondaga Shops." L. & J.G. Stickley 1905 catalog.

— — —. "The Work of L. & J.G. Stickley." Supplement to the 1910 catalog, published in 1912.

— — —. "The Work of L. & J.G. Stickley." L. & J.G. Stickley catalog, CIRCA 1914.

STUDIO, THE. London. 1893–1910.

White, J.P. "Furniture Made at the Pyghtle Works, Bedford, by John P. White, Designed by M.H. Baillie Scott." Catalog of Baillie Scott furniture, 1901.

Young, Andrew McLaren. CHARLES RENNIE MACKINTOSH (1868–1928) ARCHITECTURE, DESIGN AND PAINTING. Edinburgh, 1968.

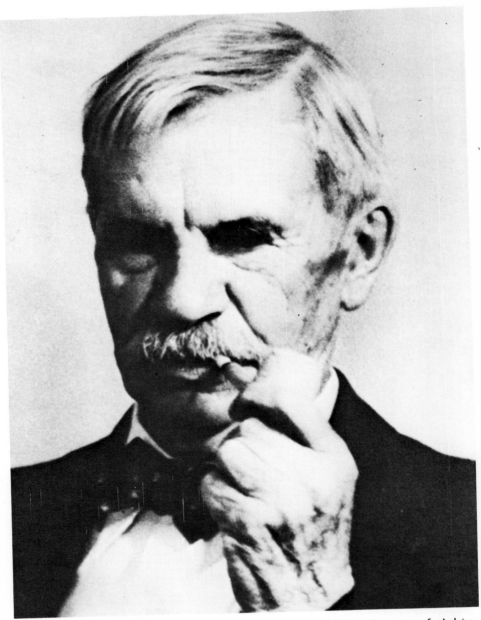

Gustav Stickley a few months before his death in 1942 at the age of eighty-five. COURTESY OF MR. AND MRS. GEORGE W. FLACCUS

Index

1902, **163,** 183
1902/03, **164,** 183
1903, **169,** 186–87
1903, Ellis, **169,** 186
1905/06 rolltop, **165,** 184
1906, **168,** 185–86
1907/08, **166,** 184
1910/12, L. & J.G. Stickley, **167,**
　185
Roycroft, 93, **94**
shopmark on, 61, 62
Dining-room tables, **see** Tables
Doors
bookcase, **103, 104, 106,** 113–15
clock, **238,** 248
Mature Period, 51
painted, 41
smoker's cabinet, **237,** 247
See also Muntins
Dovetails, desk, **166,** 184
Doweled joints, 34
See also Tenons
Drawers
shopmark on, 63, 64
smoker's cabinet, **237,** 247
table, 225–27
See also Chest of drawers
Dressers
Eastlake designed, **25**
1906/12, woman's, **158,** 161
1912/15, **157,** 161
Drink stand, 1910 L. & J.G. Stickley,
　222, 231

Early Mission Period
music cabinet from, **235,** 245–46
table from, **215,** 227–28
Eastlake, Charles Locke, 24
Eastwood chair, 1905/13, **123,** 144
Ellis, Harvey
armchair by, 146
chest of drawers by, 48, **159,** 161
as designer, 46–47
desk by, 114, **169,** 183, 186, 190
influence of, 51, 53, 207

inlay by, **47,** 48, 49, 51, 147, 189
　(**see also** Inlaid furniture pieces)
leg design by, 226
Morris chair by, 150–51
rendering of interior by, 246
server by, 203
side chair by, **47,** 48, 142
table by, 62
Escutcheons, **44**
L. & J.G. Stickley, **109,** 116
Experimental Period, 33–35, 38
desk from, **170,** 186–87, 191
settle from, 152
side chair from, 34, **35,** 73, **135,**
　152
table from, **214, 221,** 224, 226–
　27, 230–31

Fall-front desks
1900/02, **170,** 186–87
1902/03, **171,** 187–88
1903, **172,** 188–91, 203, 229
1903/04, **174,** 188–90
1904/13, **175,** 190
1906/13, **178,** 191, 192
1908/11, **176,** 190–91
1912, Roycroft, **182,** 192
1913, **180**
Feet
claw, table, 230
shoe, on costumer, **240,** 249
shoe, on table, **214,** 227, 230
Final Mission Period, 33, 53–56
armchair from, **55, 126, 127,** 146–
　47, 150
chest of drawers, **155,** 160
china closet from, 55, **110, 111,**
　117
desk from, 191
side chair from, **54,** 55
sideboard from, 208
smoker's cabinet from, **237,** 247
table from, 225
Finish, Roycroft, 95
First Mission Period, 33, 38–41, 43–49